LISA MINTZ MESSINGER studied art histo[ry]
and Boston Universities and subsequently j[o]
staff at The Museum of Modern Art, New Yor[k]
Assistant Curator of Modern Art at The Metro[politan Museum]
of Art and is a noted authority on Georgia O'[Keeffe.]
Her many publications include an earlier boo[k for]
Thames & Hudson, an essay for the Georgia O'Keeffe Museum's
inaugural catalogue, and the exhibition catalogue *Abstract
Expressionism: Works on Paper, Selections from the
Metropolitan Museum of Art*.

Thames & Hudson world of art

This famous series provides the widest available
range of illustrated books on art in all its aspects.

If you would like to receive a complete list
of titles in print please write to:

THAMES & HUDSON
181A High Holborn
London WC1V 7QX

In the United States please write to:

THAMES & HUDSON INC.
500 Fifth Avenue
New York, New York 10110

Printed in Italy

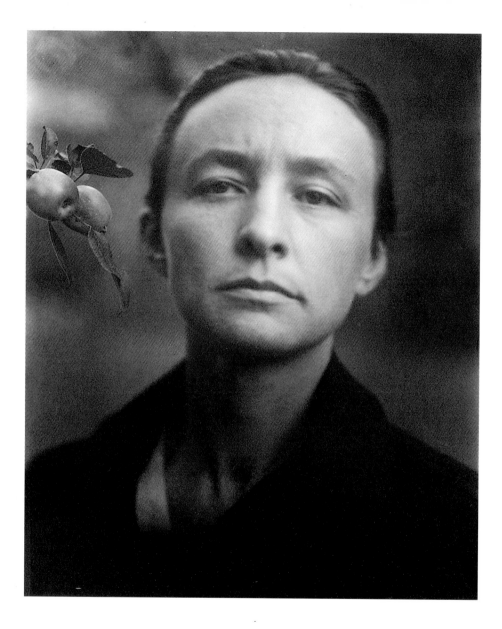

1. **Alfred Stieglitz**, *Georgia O'Keeffe: A Portrait – Head*, 1920.

Lisa Mintz Messinger

Georgia O'Keeffe

121 illustrations, 68 in color

Thames & Hudson world of art

Acknowledgments

This book is dedicated to my own two independent-thinkers,
my children, Dana and Adam

Thanks must be given to Stanley Baron at Thames & Hudson for initiating this
project and guiding it through to completion; to The Georgia O'Keeffe Foundation
for providing the necessary permissions; to Barbara Buhler Lynes at The Georgia
O'Keeffe Museum for providing valuable information in the O'Keeffe catalogue
raisonné and in conversation; and to my colleagues at The Metropolitan Museum
of Art for their continued support and assistance.

First published in the United States of America in 2001 by
Thames & Hudson Inc., 500 Fifth Avenue, New York, New York 10110

thamesandhudsonusa.com

Library of Congress Catalog Card Number 00-107990
ISBN 0-500-20340-7

Printed and bound in Italy by Artegrafica

Contents

Preface

For seven decades Georgia O'Keeffe (1887–1986) was a major figure in American art who, remarkably, maintained her independence from shifting artistic trends. She painted prolifically, and almost exclusively, the flowers, animal bones, and landscapes around her studios in Lake George, New York, and New Mexico, and these subjects became her signature images. She remained true to her own unique artistic vision and created a highly individual style of painting, which synthesized the formal language of modern European abstraction and the subjects of traditional American pictorialism.

Her vision, which evolved during the first twenty years of her career, continued to inform her later work and was based on finding the essential, abstract forms in the subjects she painted. With exceptionally keen powers of observation and great finesse with a paintbrush, she recorded subtle nuances of color, shape, and light. Subjects such as landscapes, flowers, and bones were explored in series, or more accurately, in a series of series. Generally, she tested the pictorial possibilities of each subject in a sequence of three or four pictures produced in succession during a single year. But sometimes a series extended over several years, or even decades, and resulted in as many as a dozen variations.

By the mid-1920s, after an initial period of experimentation with various media, techniques, and imagery, O'Keeffe had already developed the personal style of painting that would characterize her mature work. During the 1930s she added an established repertory of color, forms, and themes that reflected the influence of her visits to New Mexico. For the most part, her work of the 1950s, '60s, and '70s relied on those images already present in her art by the mid-1940s.

Through her repeated reworkings of familiar themes she produced an enormous body of work that is intensely focused and unusually coherent. Some 1,000 paintings, an equal number of drawings and watercolors on paper, and just a few sculptures, have been documented in a catalogue raisonné of the artist's work published in 1999, and still others are unrecorded because they were destroyed by the artist. Works illustrated in this text can be

found in the catalogue raisonné through the "CR" numbers given in the list of illustrations at the end of the book. As the extant works attest, O'Keeffe's fertile imagination and masterly technique produced an oeuvre that includes some of the most original paintings done in the United States.

The subjects O'Keeffe painted were taken from life and related either generally or specifically to the places where she had been. Through her art she explored the minute details of a setting's or an object's physical appearance and thereby came to know it even better. Often her pictures convey a highly subjective impression of an image, although it is depicted in a straightforward and realistic manner. Such subjective interpretations were frequently colored by important events in the artist's personal and professional life. Their impact on her work was often unconscious, as the artist acknowledged late in life: "I find that I have painted my life – things happening in my life – without knowing."

O'Keeffe's words, like the ones above, were often poetic and allusive, but rarely spoke directly about her paintings in any concrete way. Although she disliked the interpretations that resulted, her reluctance to analyze her own work led others to do it for her. In spite of living to the age of 98 O'Keeffe made few public statements and published only about a dozen short catalogue introductions and two articles. The two books she collaborated on later in life (*Some Memories of Drawings*, 1974, and *Georgia O'Keeffe*, 1976) contained mainly illustrations of her art, but were especially notable for their inclusion of her commentaries on selected works (albeit written from the perspective of an octogenarian).

Throughout her life, O'Keeffe was emphatic in her belief that art could not be explained adequately with words: "Colors & line & shapes seem for me a more definite statement than words." "I think I'd rather let the painting work for itself than help it with the word." Yet, despite her protestations, there are some candid writings from every period in the artist's vast correspondence with family, friends, and associates (more than 350 letters from O'Keeffe are known to exist); fortunately, 125 of these letters, spanning the years 1915 to 1981, were published after her death (in *Georgia O'Keeffe: Art and Letters*, 1987). Following the artist's idiosyncratic syntax, spelling and punctuation, the quotes in this book keep the form of her original writings as much as possible. In addition to charting her activities and travels, these letters provide valuable insights into her personality and her thoughts about art in general, and sometimes illuminate the specific sources or meanings behind the pictures in her oeuvre.

Introduction

O'Keeffe's early biography is typical for a young woman with artistic talent growing up in the United States in the first decades of the twentieth century. Born at home on November 15, 1887, to Ida and Francis O'Keeffe, Georgia Totto O'Keeffe was the second of seven children (2 boys, 5 girls). She spent her first fourteen years on the family's dairy farm near Sun Prairie, Wisconsin (population 704 in 1890), and later attended high schools in Madison, Wisconsin, and Chatham, Virginia. O'Keeffe's artistic talent was recognized early and she and her sisters received some private art lessons during those years. By the age of 12 O'Keeffe declared to a friend, "I am going to be an artist." Her formal art training, however, did not begun until she was 18 years old. In 1905 she attended the fall semester at the School of the Art Institute of Chicago, studying with John Vanderpoel. Later, from fall 1907 through spring 1908, she continued at the Art Students League in New York where she studied under the noted American painter William Merritt Chase, F. Luis Mora, and Kenyon Cox. Both schools offered a classical European curriculum in which students drew from plaster casts and live models and painted still-life arrangements. One of her most accomplished early paintings, *Dead Rabbit with Copper Pot* (1908), which echoes Chase's style, was awarded the Art Students League's Still Life Scholarship; as the winner, she attended the League's summer school at Lake George, New York (in 1908).

Rather than preparing her to make a living as a painter, O'Keeffe's studies directed her towards a career as a graphics designer or art teacher. For a brief time she worked as a freelance commercial artist in Chicago (fall 1908-10). Then, between 1911 and 1918, she taught in various elementary schools, high schools, and colleges in Virginia (Chatham Episcopal Institute and the University of Virginia, Charlottesville), Texas (Amarillo public schools and West Texas State Normal College, Canyon), and South Carolina (Columbia College), taking time off only intermittently for illness, or to resume her own teacher training. In the summer of 1912 she enrolled in a drawing class at the University of Virginia in Charlottesville taught by Alon Bement (1876-1954), and the following summer she returned as his assistant; she continued to teach

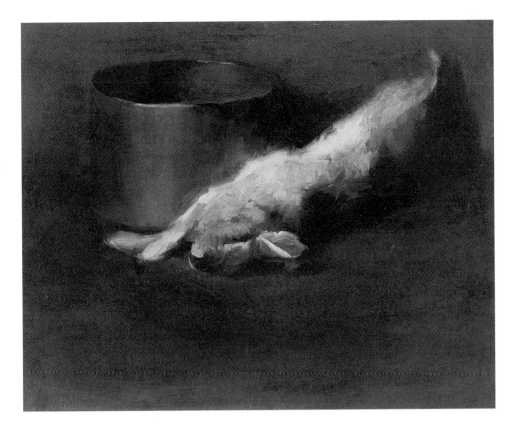

2. *Dead Rabbit with Copper Pot*, 1908. At age 21, while attending art school in New York, O'Keeffe still followed the traditional methods of still-life painting taught there by William Merritt Chase. It was not until 1915 that O'Keeffe began to experiment with modernism.

summer classes there through 1916. Bement, a disciple of the innovative arts-educator Arthur Wesley Dow (1857-1922), had studied at the Boston Museum of Fine Arts School, and at the Ecole des Beaux-Arts and Académie Julian in Paris before taking a teaching position at Columbia University's School of Practical Arts at Teachers College in New York, where Dow was head of the Art Department. Bement's introduction of a more modernist approach struck a responsive chord in O'Keeffe. Later, in fall 1914–spring 1915 and spring 1916, she studied with Dow himself at Teacher's College and learned first-hand about his system of instructive exercises, and his design theories. His "Methods of Teaching" class was a prerequisite for her new teaching position at West Texas State Normal College in Canyon, Texas (fall 1916-spring 1918).

These courses awakened her creativity and strongly influenced her own teaching practices and artwork of this period. In her classroom at West Texas State, for example, O'Keeffe incorporated Dow's multicultural approach in the artwork she put on

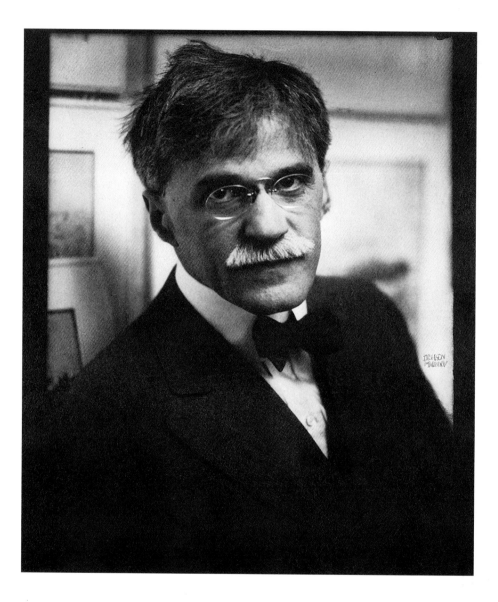

display for her students' benefit. Photographs of this room show Mission Style wooden furniture and contemporary American art pottery surrounded on the walls by reproductions of Greek vase painting, Persian plates, Japanese prints, and block-printed textiles, among other things.

Unlike most of her American contemporaries, who attended French and German academies, O'Keeffe did not go abroad until she was 65 years old. Her work developed wholly on American

soil, although the influences of European modernism, as imparted by current exhibitions and publications, did not escape her attention. As early as 1908, when she was living in New York, O'Keeffe had seen the work of Auguste Rodin (January) and possibly that of Henri Matisse (April), at two of the earliest exhibitions of European modernism to be held anywhere in the United States. Both were shown at Alfred Stieglitz's first gallery, The Little Galleries of the Photo-Secession, known as "291" from its address at 291 Fifth Avenue. Although the impact of Rodin's and Matisse's expressionist figuration was not evident in O'Keeffe's art until the mid-1910s, these exhibitions did expose her to an artistic approach that was radically different from the one she had initially been taught in school. In 1914–15, when O'Keeffe returned to New York for further study, she frequently visited 291 where she saw exhibitions of other European and American modernists, including Georges Braque and Pablo Picasso (December 1914–January 1915), Francis Picabia (January 1915), Marion Beckett and Katherine Rhoades (January–February 1915), and John Marin (February–March 1915).

While teaching at Columbia College in South Carolina (from fall 1915 through spring 1916), O'Keeffe suddenly shifted course and began seriously to consider pursuing a career as an independent artist. As she wrote a few years later:

I grew up pretty much as everybody else grows up and one day…found myself saying to myself – I can't live where I want to – I can't go where I want to – I can't do what I what I want to – I can't even say what I want to –. School and things that painters have taught me even keep me from painting as I want to. I decided I was a very stupid fool not to at least paint as I wanted to.…

Following her artistic instincts, she began to experiment with a totally new style, one that produced a series of daringly abstract charcoal drawings. Lines, shapes, and tonal values based on the forms and rhythms found in nature, and charged with emotion and imagination, were orchestrated into highly original abstract compositions. When these radical departures from her earlier academic work were brought to the attention of Alfred Stieglitz (1864–1946) in January 1916, he immediately offered to show them later that year at 291. Stieglitz, who was at the time a prominent photographer and publisher of an avant-garde magazine on art and photography, was also one of the most adventurous and influential gallery owners in New York. Since 1907 he had exhibited paintings, sculpture, and drawings at 291,

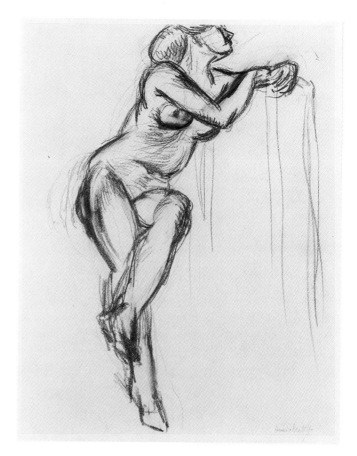

4. **Henri Matisse**, *Nude*, 1908.
O'Keeffe saw drawings by Matisse
at Stieglitz's gallery in 1908. This
one, which Stieglitz acquired for
his personal collection, and others
like it, informed O'Keeffe's later
series of figure studies in 1917.

in addition to the photographs that had been the sole focus
of the gallery when it first opened in 1905. He championed artists
– both European and American – who challenged traditional
notions about art, and consequently, the gallery and Stieglitz
were at the center of the heated debate about modern art. Even
before the 1913 Armory Show, he had introduced European
artists like Cézanne, Matisse, and Picasso to American audiences,
as well as showing the work of younger Americans of the
avant-garde. Later, when he opened The Intimate Gallery, and
afterwards in An American Place, Stieglitz concentrated on
exhibiting a smaller circle of American artists almost exclusively.

 O'Keeffe's professional career as an artist began, in effect,
with her first exhibition at 291 and with her subsequent meeting
with Stieglitz. In May 1916, for the first time O'Keeffe's work
was exhibited in a group show at 291. Again later that year, he

displayed some of her pieces in an informal group show. It was also Stieglitz who presented her first solo exhibition there the following year from April to May 1917, which resulted in her first sale (*Train at Night in the Desert,* 1916, charcoal on paper, purchased for $400 by a Mrs. Dewald). With his enthusiastic support and the promise of financial assistance, O'Keeffe made the momentous decision to move to New York in June 1918. At the age of 30, she gave up teaching permanently, and committed her life to being an artist. O'Keeffe's personal and professional relationship with Stieglitz, then 54 years old, deepened upon her arrival. Almost immediately after relocating to New York, she and Stieglitz began to live together; six years later, in 1924, after he divorced his wife of thirty years (Emmeline Obermeyer Stieglitz, with whom he fathered his only child, Kitty), O'Keeffe and Stieglitz were married.

Stieglitz was unquestionably the single most important figure in O'Keeffe's life for thirty years, despite their intermittent periods of estrangement. As mentor, he gave O'Keeffe the confidence to pursue her early artistic ideas. Throughout their association he also vigorously promoted her work, providing her with almost annual exhibitions at his galleries: 291 (1905-17), The Intimate Gallery (1925-29), and An American Place (1929-50). In all, he included her work in twenty-two one-person shows and innumerable group installations. His photographs of these exhibitions are sometimes the only record of what was on view. Not only was Stieglitz a promoter of her art, which he guided like a protective father, but also the originator of her public image, which he almost single-handedly shaped through his celebrated photographic portrait cycle, made over the course of twenty years (1917-37). In more than 300 black-and-white photographs Stieglitz defined O'Keeffe's persona and the public's perception of her art that was to last for generations to come. His photographs revealed to the world O'Keeffe's strengths and vulnerabilities, or at least his perception of them.

From her first show of drawings at Stieglitz's gallery in 1916, her public persona was that of an independent pioneer. Through his photographs, he also showed her to be a woman of great spirit – mysterious, strong, and somehow unapproachable – an image that continued throughout her life. The stern and forbidding face she portrayed to the public was intended to discourage unwanted intrusions into her personal life, and helped deflect attention when the strains of exhibiting annually and the accompanying publicity took their toll on her health each year. Contrary to her

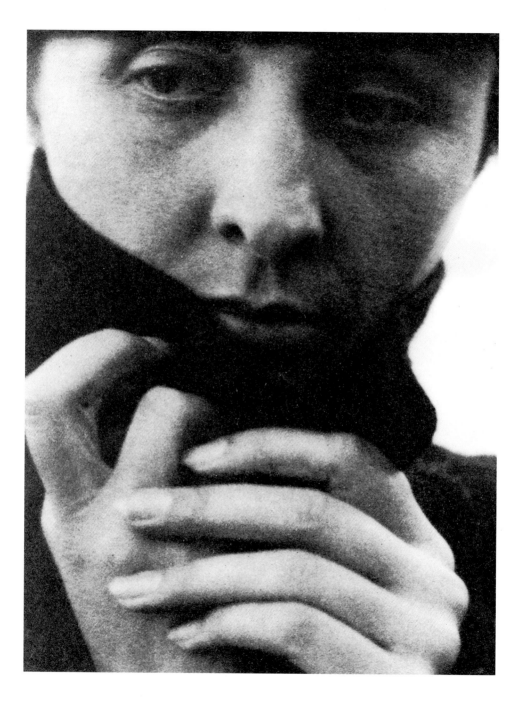

public façade, however, many of Stieglitz's more intimate photographs of her from the 1910s and '20s (some of them candid shots; many more of them staged, showing her nude and provocatively posed) reveal a more human portrait – that of a woman who was warm, humorous, sensual, and vulnerable. When some of these nudes were shown in Stieglitz's large retrospective at the Anderson Galleries in February 1921, they caused quite a sensation with the critics and public (among the 145 photographs taken between 1886 and 1921 were 45 of O'Keeffe). In his remarkable portraits Stieglitz captured the ups and downs of this long, complex association that bridged the personal and professional lives of both artists. The photographic series began when O'Keeffe was 30 years old and Stieglitz 54, and ended when ill health caused him to put down his heavy camera permanently at 73.

O'Keeffe's early years in New York, from 1918 through 1929, proved crucial to her maturation as an artist. As a new member of Stieglitz's inner circle, she associated with some of America's most distinguished early modernists – painters such as Arthur Dove, John Marin, Marsden Hartley, and Charles Demuth; and photographers such as Paul Strand and Edward Steichen, as well as influential art critics and writers. Their discussions about art, often held in her presence at Stieglitz's gallery, and the example presented by their work both validated and influenced what O'Keeffe was doing on her own. As a result, her art changed dramatically when she came to New York. Rather than continuing to make large charcoal drawings and small, lyrical watercolors on paper, as of 1918-19 she worked almost exclusively with oil paint on generally larger canvases. Within a relatively short time after her arrival, and despite the fact that she was a woman, O'Keeffe's own ideas and imagery became a reciprocal source of inspiration for the other artists of the Stieglitz circle.

Essential to her artistic process was her exploration of the myriad nuances found in a relatively limited number of subjects, predominantly landscapes, flowers, and bones. As she explained, "I work on an idea for a long time. It's like getting acquainted with a person, and I don't get acquainted easily." The pictorial potential of a subject was examined in a series of canvases – generally three or four, but sometimes as many as a dozen – that were painted over the course of several months or even years. During this time she would rework different elements of the picture – an image, a color scheme, or an entire compositional arrangement – to raise new problems or suggest alternate solutions to those already studied. Throughout her extraordinary career, there was

always this ebb and flow of imagery, a cyclical working and reworking of ideas.

For O'Keeffe, the subject's essential form was derived from her radical simplification of shape and detail. Although her paintings of landscapes, flowers, and bones were the result of intense direct observation and familiarity with a particular locale or subject, they do not produce a sense of specificity. Rather, these images seem to be abstract symbols for nature – generalized representations – despite their frequent anatomical and geological accuracy. They are idealized objects suspended in time – permanent records of a fleeting moment. They transcend particular categories to become universal motifs that can be used in other contexts. Thus, motifs and imagery first generated in O'Keeffe's earliest paintings and drawings reappear decades later in paintings of completely different subject matter.

In pursuing a subject intensively and repeatedly, O'Keeffe tried to capture its essence – both of its spirit and of its form. The spirit as expressed through color and line was an idea she first encountered in 1914 in Wassily Kandinsky's influential treatise on abstraction of 1912, *Concerning the Spiritual in Art* (originally published in German as *Über das Geistige in der Kunst*, English translation published 1914), recommended to her by Alon Bement. As Kandinsky wrote: "form is the outward expression of…inner meaning."

Clive Bell's influential book *Art* (1913), which she received in November 1916 as a gift from Stieglitz and from then on used as the text for her classes at West Texas State Normal College, also advocated similar ideas about expressing emotion through "significant form."

Kandinsky wrote that "color directly influences the soul" and can "produce a correspondent spiritual vibration." O'Keeffe was a brilliant colorist whose palette ranged from subtle modulations in tone to raucous, unusual contrasts. Often, however, her choice of color was dictated by her immediate surroundings, as were the forms she reproduced. In New York City, for example, which remained her official residence for all or part of each year until 1949, she used somber tones of brown and black and deep blue, spotted with flashes of yellow and red, and large geometric shapes to depict the city's streets and buildings. Although the city's geometry inspired some of her strongest and most architectonic compositions, she was most profoundly influenced by the organic shapes and colors found in landscape. Every year she made time to retreat to nature, where she found a wider range of

colors and forms to work from. Her Lake George paintings from the 1920s frequently display the dark green tones associated with summer foliage, and the rainbow colors of the flowers in the garden. Surrounded there by a lush rural setting of rolling green hills and reflecting lakes, O'Keeffe created a large number of quiet, soft-focus paintings.

In 1929, she made her first trip to New Mexico. By this time she had grown weary of the monotonously green Lake George setting and felt equally oppressed by the man-made city. New Mexico, a vastly different terrain with a seemingly endless number of natural wonders from which to work, provided the invigorating inspiration she needed. Her colors naturally changed to reflect the rusts, browns, and ochers found in the Southwest geography, and her shapes reflected the hulking scale of the mountains. The visit had a lasting impact on her life, and an immediate effect on her work.

Over the next twenty years, from 1929 to 1949, O'Keeffe traveled West almost every year, spending up to six months painting in relative solitude. She returned to New York each winter with the fruits of her labor, ready to exhibit her new paintings at Stieglitz's gallery. This division of her time continued until she took up full-time residence in Abiquiu, New Mexico, in 1949, three years after Stieglitz's death. New Mexico remained her home and the subject of her work for the next thirty-seven years of her life. On March 6, 1986 Georgia O'Keeffe died in Santa Fe at the age of 98.

She left behind a rich legacy of American images that were tied to the land. These images, and her own pioneering spirit, established an illustrious reputation in America very early in her career. With each new decade that has passed, more American museums and private collectors acquire her art, giving the public greater access to it through an increased number of exhibitions, publications, and commercial products (e.g., posters and postcards). The printing of her own book in 1976 was a brilliant strategy for revitalizing interest in her art and life. Now elevated to the status of a "cult figure," the beauty and resonance of her paintings continues to attract new audiences in America, and has more recently gained a remarkable following in Europe and Asia. It is a phenomenon that shows no signs of waning as we begin the twenty-first century.

Chapter 1: Early Work: Finding Her Own Voice

In O'Keeffe's early charcoal drawings and watercolors of 1915-16, we witness her breakthrough from the academic training she had received toward modern abstraction. These early drawings are significant, not only as examples of American modernism, but as compositional sources for her later paintings. She abandons traditional tenets about composition and subject matter in order to create instead evocative images devoid of identifiable content.

Rather than depicting human figures or still-lifes, she orchestrated lines, shapes, and tonal values into harmonious compositions. With simple, abstract forms she expressed feelings and experiences. Often, her organically flowing lines and forms seem derived from Art Nouveau examples and the Arts and Crafts movement that was in vogue at that time in American design (architecture, furniture, ceramics, and metalwork). To permit the full exploration of these forms O'Keeffe eliminated the distraction of color, working exclusively with black charcoal applied to large white sheets of paper, at least for the moment. She began to create these charcoal drawings only a few months after studying with Alon Bement and Arthur Wesley Dow, whom she affectionately called "Pa Dow," and his influence is strongly felt in her first independent trials.

Although Dow's reputation as an artist (he was a landscape painter and printmaker) was fairly limited in his own day, and even more so today, he exerted a tremendous force on younger American artists in the first decades of the twentieth century as a teacher and writer. For over thirty years he taught art students in New York at Pratt Institute (1895-1903), the Art Students League (1898-1903), and Teachers College at Columbia University (1904-1922), as well as in his own summer school (Ipswich Summer School of Art) on Cape Anne near Boston, Massachusetts (1891-1907). His treatise on design theories, *Composition: A Series of Exercises in Art Structure for the Use of Students and Teachers*, first published in 1899, radically reformed art education in the United States. The book had wide repercussions, as it was used as a textbook by hundreds of students, and over the years it was reprinted in twenty editions. It marked the

culmination of almost a decade of teaching and outlined the exercises Dow taught in the classroom. Dow first had students create simple harmonies with only a straight line dividing the space on the sheet, then building in complexity he added concepts of *notan* (light and dark tonal contrast), and color.

Dow's book contained many illustrations from all cultures and periods, including examples of Asian, Aztec, African, Egyptian, Oceanic, Persian, and pre-Columbian art, as well as Western art. He found examples of good design in the work of Hokusai, Giotto and James McNeill Whistler, to name a few. And likewise, his lessons integrated various media and fostered an appreciation of painting, printmaking, pottery, design, and photography as equal artistic expressions. Of primary importance was his belief that objects (both crafts and fine arts) should be well made and beautifully rendered. As he explained, art was the most valued thing in the world because "it is the expression of the highest form of human energy, the creative power which is nearest to the divine." "The power," he wrote, "is within – the question is how to reach it and use it."

Dow's design formulas were in large part developed from his knowledge of Asian art, particularly eighteenth- and nineteenth-century Japanese woodcuts, and from his experience painting in France in the late 1880s under the influence of Paul Gauguin and the Nabis, whose compositions were also influenced by Japanese prints. His ideas about Asian aesthetics were shaped by his association with Ernest Fenollosa (1853-1908), a scholar on Japanese art and curator at the Boston Museum of Art, whom he met in 1891. O'Keeffe's library contained Fenollosa's two-volume book, *Epochs of Chinese and Japanese Art: An Outline History of East Asiatic Design*, which was used as a text in Dow's course in art appreciation at Teachers College. After several years, Dow too became an expert in the field, and succeeded Fenollosa as curator of Japanese art, a position he held from 1897 to 1899.

Dow taught that through the artist's selective orchestration of format and compositional elements (line, shape, color, value) each subject's true identity could be revealed, something that he felt could not be achieved through the representational imitation of nature. Realism, he declared, was "the death of art." And elsewhere he wrote: "...art lies in the fine choices, not in the...likeness to nature, meaning, story-telling or finish....The artist does not teach us to see facts: he teaches us to feel harmonies...." Harmony and balance were the key words in his theories and led to the desired synthesis. As O'Keeffe later said in an interview

(1962): "This man had one dominating idea; to fill a space in a beautiful way – and that interested me. After all, everyone has to do just this – make choices – in his daily life when only buying a cup and saucer. By this time I had a technique for handling oil and watercolor easily; Dow gave me something to do with it."

It is not too strong to say that Dow's lessons altered the course of O'Keeffe's work thereafter. His principles of design led her toward an art that abstracted from nature, and formed the foundation upon which she built her later accomplishments. So ingrained were Dow's teachings that at various times throughout her life she seemed to reach back to those early experiences, no doubt unconsciously, to find new avenues for exploration, including the use of photography to help define compositions, and her propensity to rework compositions in a series. Just as Dow had done in his own work, O'Keeffe throughout her career produced primarily serene images of nature that relied on her sensitive arrangement of elements for their emotive power.

In the 1915-16 drawings she seems to have adopted many of the vegetal shapes and graphic patterns found in Dow's own representational work and in the illustrations to his book. Where O'Keeffe asserted her personal vision was in her application of these design concepts and visual motifs to an abstract idiom. (Dow had been shocked by the extreme abstraction displayed in the work of the artists who had exhibited at the 1913 Armory Show in New York, although he had nevertheless encouraged O'Keeffe to continue her own experiments in this direction while she was under his tutelage.) Moreover, the 1915-16 drawings exude a sense of vital energy and movement that was never an issue in Dow's theories. As Elizabeth Hutton Turner noted: "O'Keeffe claimed that her aesthetic awakening, an artistic rebirth of sorts, occurred in December [1915] while she was on her hands and knees filling papers on the floor with swaths of charcoal. Her marks indicate movements made with the whole arm, from the shoulder, holding the stick upright, touching down with keen control and concentration, as Dow recommended, 'without resting the hand.'... Gone are the rhyme and meter of foreground, middle ground, and background to organize the illusory space behind the picture plane. What remains is a sense of things unfurling in motion and motion coiled in things. O'Keeffe wrote to her friend Anita Pollitzer that October, 'I am starting all over new – Have put everything I have ever done away and don't expect to get any of it out ever again – or for a long time anyway.' "

Drawing XIII (1915) is similar to other drawings of this 6
period by American modernists – such as *Sentimental Music* 7
(1917) by Arthur Dove (1880-1946) – in its evocation of nature
through purely abstract forms and its subjective interpretation
of personal experiences. Like Dove, O'Keeffe also found equiva-
lents between art and music, and as early as 1915 she wrote to
Anita Pollitzer: "It's a wonderful night – I've been hanging out
the window waiting to tell some one about it – wondering how I
could – ...I'm going to try to tell you about the music of it – with
charcoal." Although she claimed that these images were derived
solely from her imagination, they reproduce basic forms found in
nature that were familiar to the artist from her keen observations
of the landscape. In later pictures she used similar shapes and
patterns to describe apples, trees, leaves, shells, and bones. What
is so unexpected in this particular drawing of such early date is
the strength of its compositional structure and its assured
draftsmanship. The image consists of three distinctly separate
parallel sections, united in their thrust upward. Each evokes a
different aspect of nature. On the right, meandering lines recall
the flow of a river or the rise of a flame. In the center, four ellipti-
cal bulbs suggest a rolling hillside or densely foliated trees. To
the left, a severely jagged black line, accentuated by erasure,
alludes to a rocky mountain range or a bolt of lightning.
Interestingly, the contour of the total shape as formed by these
three elements is very close to that of the tree in Vincent van
Gogh's painting *Cypresses* (1889). Although unexpected, the con- 8
nection to van Gogh's work is not as improbable as it might at
first seem. As an avid reader of Stieglitz's periodical *Camera Work*
(published 1903-17), O'Keeffe most likely saw this painting
reproduced there, in black and white, in the June 1913 issue;
although she received her first issue of *Camera Work* and
Stieglitz's other periodical *291* only in fall 1915, she often
ordered back issues on subjects of particular interest. Both van
Gogh's and O'Keeffe's pictures convey a sense of movement and
growth, but while van Gogh's image is agitated and chaotic,
O'Keeffe's is ordered and controlled, a quality that continued to
define her art even sixty years later. The comparison illustrates
her ability to absorb the examples of other artists and transform
them into original expressions.

Since the summer of 1915 she had been sending samples
of her work to Anita Pollitzer (1894-1975), a classmate from
Teachers College. In late December of that year she once again
shared her most recent charcoal drawings with Pollitzer, including

6. *Drawing XIII*, 1915. Emboldened to throw off
the yoke of tradition, O'Keeffe made a series of
exquisitely beautiful charcoal abstractions while
she was teaching in South Carolina. Drawings
such as this first drew her to Stieglitz's attention,
and prompted him to give her a gallery show.

7. **Arthur Dove**, *Sentimental Music*, 1917. Other members of Stieglitz's circle, such as Arthur Dove, one of America's first modernists, were already producing lyrical abstractions based on nature by 1910.

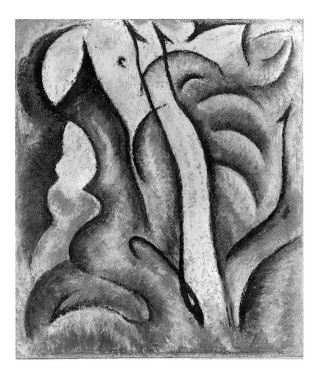

8. **Vincent van Gogh**, *Cypresses*, 1889. O'Keeffe probably saw Van Gogh's painting of cypress trees illustrated in the magazine *Camera Work*. The abstract imagery in her drawing, *Drawing XIII*, shows a strong similarity to shape of the tree in this painting.

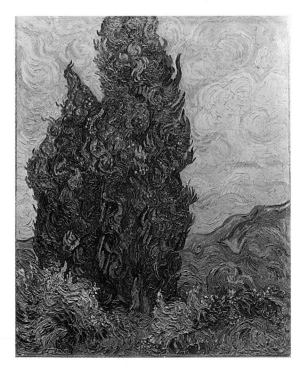

Drawing XIII, as well as *Specials No. 1-5, 7-9*. Disregarding O'Keeffe's instructions not to show them to anyone, Pollitzer took them directly to Stieglitz at 291 on January 1, 1916. He reacted immediately and positively, reportedly calling them the "purest, finest, sincerest things that have entered 291 in a long while," and he suggested that they might be shown in the gallery at some later, unspecified time. As Barbara Buhler Lynes has noted: "It is unlikely…that O'Keeffe's drawings could have been received more sympathetically anywhere else in the country in 1916. Stieglitz was committed to modernism, and by the mid-teens, he had begun to devote himself almost exclusively to the promotion of American art. Furthermore, he thrived on the unexpected and did not hesitate to give his attention to the work of an unknown artist. One aspect of his progressivism was…[also that] he did not believe the production of art to be an exclusively male endeavor."

Encouraged by Stieglitz's appreciation of her art, O'Keeffe worked prolifically in charcoal during the first six months of 1916. Among the drawings she produced is the beautiful *Abstraction IX* – a serenely elegant depiction of a young woman asleep, her head, shoulders, and lips clearly delineated by the rich, flowing lines of charcoal. The image was inspired during a camping trip in the mountains: "One morning before daylight, as I was combing my hair, I turned and saw her lying there – one arm thrown back, hair a dark mass against the white, the face half turned, the red mouth. It all looked warm with sleep." After drawing a small quick pencil sketch on the spot, O'Keeffe later produced another large charcoal drawing (similar to this one) and several sheets painted in red, before achieving this final version. Although based on an actual event, the non-descriptive title of the work indicates that the artist's true interests lay not with the figure *per se*, but with its formal elements of line and shape. She may have been inspired to experiment in this direction after seeing Abraham Walkowitz's (1878-1965) drawing *From Life to Life I* (1912), that was reproduced in the March 1914 issue of *Camera Work*. Although the figurative source of Walkowitz's drawing is evident, his work is far more drastically abstracted than any of O'Keeffe's studies.

With the limited tools of charcoal and paper O'Keeffe produced a composition that is both tonally and graphically complex. The subtle gradations of gray, black, and white are as rich in nuance as any that could be achieved with color. Equally varied is her modulation of line, which ranges from harsh, broad, dark

9. *Abstraction IX*, 1916. The flowing ribbons of black charcoal and subtle gray shading in this drawing produce a visual parallel between the outlines of the woman's head, neck and shoulder, and a beautiful rolling landscape or meandering river.

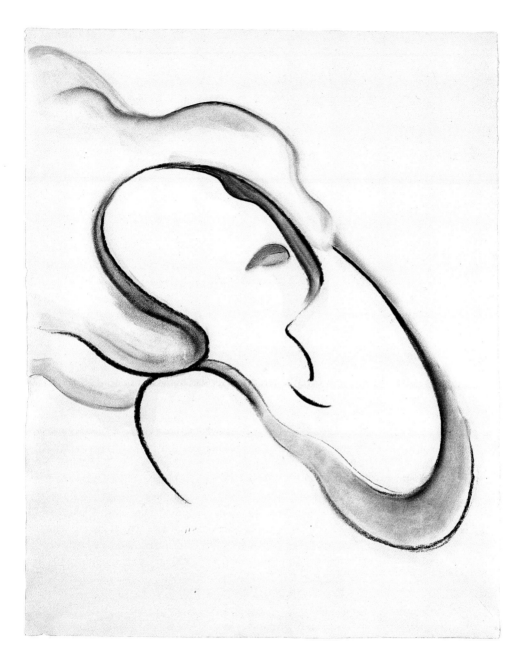

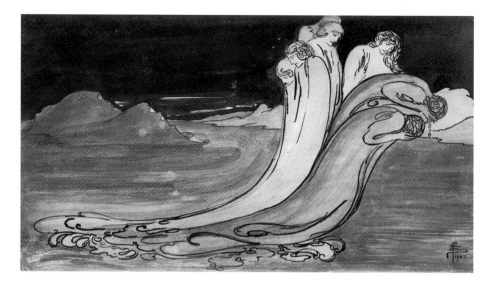

10. **Pamela Colman Smith**,
The Wave, 1903. The symbolist
rendering of figures in Pamela
Colman Smith's 1903 watercolor
may have influenced O'Keeffe's
figurative sculpture of 1916 and
her subsequent series of
watercolor figures where flowing
lines are also used to delineate
the shape of the body.

strokes to ethereal veils of shading and pencil-thin notations. The diagonal meanderings of line make the image appear to float within the pictorial space, and the woman's sensuality is translated into graphic calligraphy. A simple sweep of charcoal denotes the roundness of her shoulders and the outline of her neck. The shaded areas above and below the uplifted head suggest flowing hair and clothing. It is the mouth, full and sensuous, that unequivocally indicates this drawing's figurative origins. Years later, however, in such paintings from the 1960s as *It Was Blue and Green* (1960), *Winter Road* (1963), and *Road to the Ranch* (1964), O'Keeffe used an almost identical curvilinear pattern to depict landscape subjects. 107 108

In May 1916 Stieglitz fulfilled his promise to exhibit her drawings by mounting a group show at 291 that featured her work and the work of two other new artists, Charles Duncan and René Lafferty. O'Keeffe had the largest representation with the ten charcoal drawings that Pollitzer had brought to Stieglitz in January. Although she was initially upset to find her work on public display without her permission, the drawings remained on view at 291 until July. They elicited attention from the art critics, who saw in them explicit sexual imagery, an interpretation that was also fostered by Stieglitz. Ever the romantic, Stieglitz responded to the intense feelings expressed by O'Keeffe in these drawings. After the close of the show, he wrote to her asking that he be allowed to keep one of the drawings for himself, probably *Drawing XIII*: "The one I want most is…the one I considered by 6

far the finest – the most expressive. It's very wonderful – all of it –There are others running it a close second – but none gives me what that one does."

O'Keeffe's 1916 exhibition was the first of numerous group and solo shows of her work organized by Stieglitz over a thirty-year period. Later that year she was included in another group show at 291 with the gallery's more established regulars – Arthur Dove, Marsden Hartley, John Marin, Abraham Walkowitz, and Stanton MacDonald Wright. Eventually Stieglitz devoted all his energies to promoting the work of just three artists: Marin, Dove, and O'Keeffe, the only woman fully accepted into his inner coterie.

While in New York for her May 1916 show, O'Keeffe created at least one small abstract standing figure in plasticene (a non-hardening clay) that measured 10 inches tall. The original plaster cast made from it in 1916 still exists and in 1979-80 ten white lacquered bronze sculptures were cast from four maquettes made after the 1916 design. Although the gender of the figure is hidden by a floor-length shroud that seems to drape not only the body but also the bent head, correspondence between O'Keeffe and Pollitzer indicates that it was intended to represent a woman. Some have suggested that the sculpture may have been a memorial homage to her mother who had recently died.

The overall shape of this sculpture seems to evolve from the imagery in some of her abstract charcoal drawings from around 1915 (e.g., *No. 3* and *4 Specials*), and bears a striking resemblance to Steichen's series of photographs of Rodin's sculpture, *Balzac*. It may also derive from the symbolist work of Pamela Colman Smith, an artist who was associated with both Dow and Stieglitz. In particular, O'Keeffe's sculpture shows strong affinities to Smith's 1903 watercolor, *The Wave*, where similarly posed and draped figures rise from the water. Prior to O'Keeffe's studies with Dow, Smith too had been one of his students, and from 1907 to 1909 Stieglitz had exhibited her works on paper annually at 291. Her 1907 installation had the distinction of being both the first non-photographic show held at 291 and the first to feature the works of a woman painter. It is conceivable that while studying at the Art Students League O'Keeffe saw Smith's (February-March) 1908 exhibition at 291. It is also quite possible that Stieglitz – ever the promoter and educator – brought Smith's work to O'Keeffe's attention when she came to 291 in 1916. Several of Smith's drawings from these early shows remained in Stieglitz's possession throughout his life.

When O'Keeffe's sculpture was exhibited at 291 the following year, it was paired with her charcoal drawing, *No. 12 Special* (1916), a tall flume-like swirl, about which she wrote simply (in 1974): "Maybe a kiss…" Stieglitz's photograph of this section of the installation (framing the sculpture with the drawing together), coupled with O'Keeffe's remark, seems to suggest a romantic implication that was reinforced by Stieglitz's subsequent photography. Despite the specific figurative references mentioned above, the shape of this sculpture is decidedly phallic, and it was this interpretation that Stieglitz chose to emphasize in his photographs. In a 1919 photograph (*Georgia O'Keeffe: A Portrait – Painting and Sculpture*) Stieglitz provocatively places the sculpture in front of the gaping hole that is O'Keeffe's painting *Music, Pink and Blue I* (1918). The photograph clearly indicates his sexual reading of both these images. A year later, in a 1920 photograph, O'Keeffe is suggestively shown grasping the shaft of the upright sculpture.

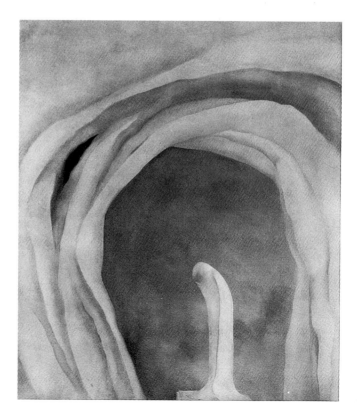

11. **Alfred Stieglitz**, *Georgia O'Keeffe: A Portrait – Painting and Sculpture,* 1919. Stieglitz's 1919 photograph, pairing O'Keeffe's sculpture and a painting from her music series, reflects the sexual interpretation he often placed on her work. O'Keeffe's own writings, however, suggest that she intended the sculpture to be a shrouded woman.

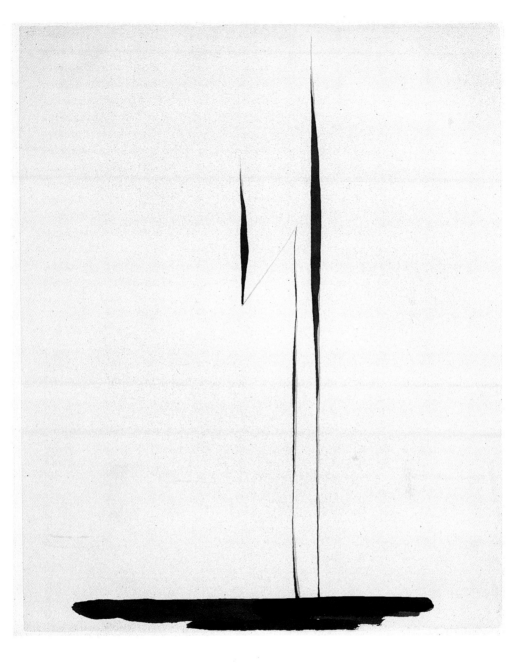

12. *Blue Lines X*, 1916. The meaning of this simple, elegant watercolor drawing remains a mystery, but the essential configuration of two lines connected by a diagonal recurred in many of her later compositions as well, where it took on a more three-dimensional shape.

While she always discouraged sexual interpretations of her work, they persisted throughout her life, in part because her art, particularly her paintings – with their velvety texture, sumptuous color, and organic forms – exuded such intimacy and sexuality. Late in life she acknowledged that these feelings might have entered unconsciously into her work, and that Stieglitz, through his words and photographs, had fostered such readings: "Eroticism! That's something people themselves put into the paintings. They've found things that never entered my mind. That doesn't mean they weren't there, but the things they said astonished me. It wouldn't occur to me. But Alfred talked that way and people took it from him." Indeed, several writers associated with the Stieglitz circle described her art in similar terms, much to her dismay.

Having mastered the concepts of abstraction in black and white works like *Drawing XIII* and *Abstraction IX*, O'Keeffe gradually reintroduced color into her compositions around June 1916. As she later explained, she returned to color because "I found that I could say things with color and shapes that I couldn't say in any other way – things that I had no words for." She worked almost exclusively in watercolor for the next three years and then moved on to oil paint, which remained her primary medium thereafter. 6, 9

Blue Lines X was among her first attempts in watercolor, and followed after an earlier black-and-white composition drawn in charcoal and five or six versions in black watercolor drawn with a delicate Japanese brush. Its elegantly simple arrangement of two parallel vertical lines (one angled at the top) anchored on a broad horizontal base recalls Dow's assertion that "great art could come from the harmony of two lines." Indeed, the configuration of the jagged line and the sense of upward movement are reminiscent of *Drawing XIII*. When the proportions of the linear elements and the spatial relationships between them were adjusted to her satisfaction in the black-and-white works, O'Keeffe produced the final statement in blue watercolor. The resulting composition presents a lyrical motif, stripped bare of all extraneous detail. 12

Her choice of the color blue – which Kandinsky likened to a "typical heavenly color…a call to the infinite, a desire for purity and transcendence" – may reflect her desire to imbue this work with symbolic significance. At least that was the intent Stieglitz ascribed to it. During O'Keeffe's absence from New York (when she taught at West Texas State Normal College in Canyon from

June 1917 to June 1918), *Blue Lines X* hung in his gallery office. To him this piece symbolized the potential relationship between man and woman, and he saw the two lines as representing their different sensibilities. His sentiments about this watercolor were closely echoed in a newspaper review of her 1917 exhibition, written by Henry Tyrrell, who referred to *Blue Lines X* by his own title (*Two Lives*): "'Two Lives,' a man's and a woman's, distinct yet invisibly joined together by mutual attraction, grow out of the earth like two graceful saplings, side by side..."

The flat, linear configuration of *Blue Lines X* became a basic motif in her oeuvre. It assumed a third dimension in her 1920s paintings of naturalistic trees (e. g., *Grey Tree, Lake George*, 1925); 39 decades later the motif reappeared as a simplified, flat shape that described the meanderings of rivers seen from aerial perspective, as in *Drawing X*, 1959. This sequence of transformations, which 106 changed the motif from line to three-dimensional form to shape, is typical of the visual metamorphoses that often took place in her work.

O'Keeffe's first solo show, which opened at 291 in April 1917 while she was living in Texas, included both *Abstraction IX* and *Blue Lines X*. With this show Stieglitz in effect gave O'Keeffe his full support, which continued even after 291 closed a few months later. Thereafter she was considered part of his inner circle of artists. Although the country was preoccupied with war, her show (which lasted until mid-May) received considerable attention from the art critics, who still remembered the stir provoked by her debut the previous year.

More characteristic of the watercolors she produced between 1916 and 1918 were the numerous small landscapes, such as *Blue Hill No. 1* (1916), *Morning Sky with Houses* (1916), and *Canyon with Crows* (1917), which were painted primarily on 9-by-12-inch 13 sheets of paper. These luminous compositions masterfully exploited the clarity and fluidity of the watercolor medium, taking full advantage of the visual effects derived from leaving strategic areas of white paper unpainted. The colors in these works were expressionistically bold – bright magentas, blues, greens – and imitated the palette, and sometimes the dappled brushwork, of the French Fauve artists of the early 1900s.

O'Keeffe's watercolors were also closely related in color and composition to the small woodcuts produced by her teacher Dow about a decade earlier. Among his many followers, O'Keeffe in her early work most closely emulated his style. *August Moon* (*c.* 1905) 14 and *Marsh Creek* (*c.* 1905) are two examples of Dow's work that

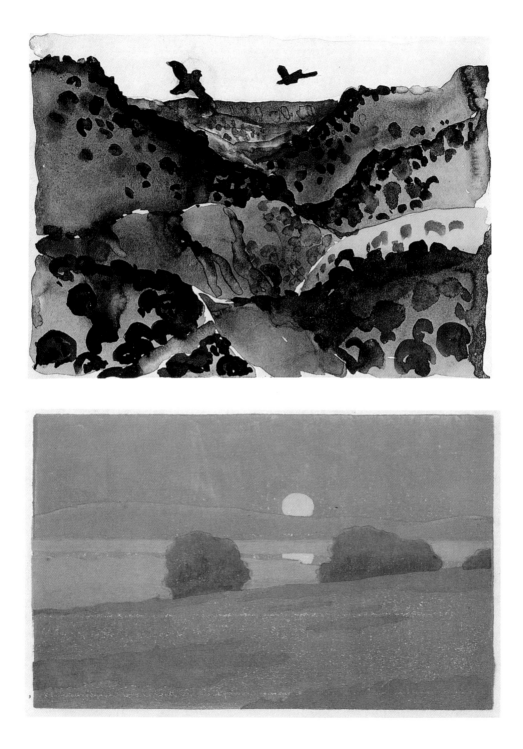

13. *Canyon with Crows*, 1917. When O'Keeffe resumed work in color in 1916 she initiated an extensive series of small watercolor landscapes that celebrated a palette of bright expressionist colors. Almost thirty years after completing this lively composition she reprised the motif of black crows flying over a V-shaped canyon in her more somber oil painting of 1946, *A Black Bird with Snow-Covered Red Hills* (cf. ill. 99).

14. **Arthur Wesley Dow**, *August Moon*, c. 1905. Arthur Wesley Dow's design theories about dividing space in a beautiful way informed O'Keeffe's work throughout her life. His own artworks, most notably the small, simply designed, color-intense woodcuts he produced in the early 1900s, were a direct influence on the subject and style of her early watercolors.

illustrate the similarities. Like him, she experimented with dividing the space of the picture into large interesting shapes of unequal size and proportion. These bold designs, coupled with unusual color schemes, conveyed the diversity and wonder of the natural landscape, but were fairly static compositions in comparison to those that followed.

By 1917 she had found an avenue for even greater personal expression by exploiting the flowing quality of watercolor paint and by increasing the intensity of her palette. Such vibrantly explosive pictures as the eight works in the *Evening Star* series show her at the height of her watercolor powers. In this glorious series, loose, wide brushstrokes saturate the space with light and movement, and allow the colors to blend seamlessly into one another. The bright saturated tones – featuring hot reds and yellows, and deep blues – accentuate the emotional intensity of the scene. In *Evening Star No. IV* and *Evening Star No. V*, for example, one or more bands of dark blue ground anchor the red explosion happening in the sky and flow out along the horizon line. The source of this immense energy seems to emanate from the pale yellow evening star in the upper left corner of the composition. 15,16

Like other landscapes of this period, the *Evening Star* series was inspired by the open plains around Canyon, where she had gone to teach. She described the terrain as being wide open like the ocean, without paved roads, fences, or trees. In a letter to Stieglitz she wrote:

The plains – the wonderful great big sky – makes me want to breathe so deep that I'll break – There is so much of it.... It seems so funny that a week ago it was the mountains I thought the most wonderful – and today it's the plains – I guess it's the feeling of bigness in both that just carries me away....

In closing she says, "you are more the size of the plains than most folks." It was in such an expansive environment that O'Keeffe herself felt the freedom to be emotionally and artistically expansive.

In late 1917, and continuing into 1918, she resumed the figurative subject matter that had occupied her in *Abstraction IX*. This group of primarily seated figures marks her most extensive, and last, exploration of the human figure in her oeuvre (with the exception of a few portrait drawings done in the 1940s). The twenty-nine watercolors produced in 1917 form two distinct series: six highly abstracted figures in profile and thirteen seated female 9 18, 19

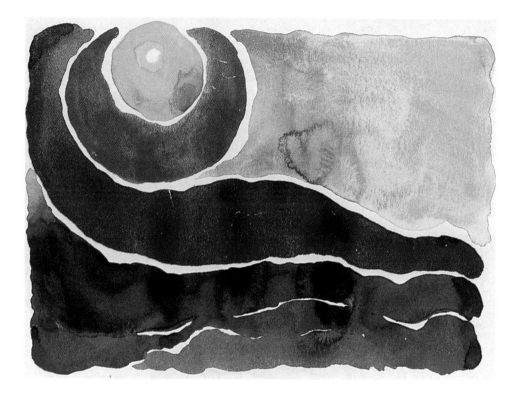

15. *Evening Star No. IV*, 1917.
16. *Evening Star No. V*, 1917.
Inspired by the evening sunsets
that spread over the open plains
around Canyon, Texas, O'Keeffe
painted a series of eight vibrant
watercolors that fill almost the
entire composition with intense
color. Executed without benefit of
preliminary under-drawing, the
colored bands are separated by
white strips of unpainted paper.

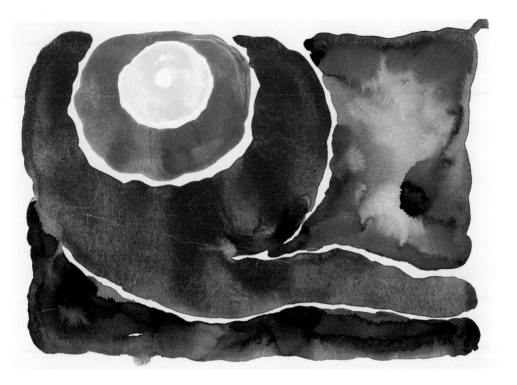

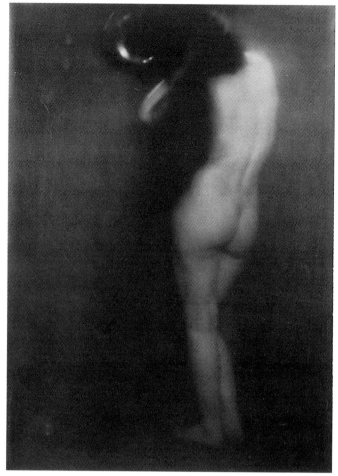

17. **Edward Steichen**, *The Little Round Mirror*, 1902. O'Keeffe was eminently familiar with the photography of Edward Steichen, who was Stieglitz's collaborator and art advisor in the early days of "291." Works like this (which were in Stieglitz's personal collection) were often featured in the magazine *Camera Work* and seem to bear a striking similarity to O'Keeffe's more abstract watercolor figures.

nudes. The first set of profiles, painted with highly watered-down pigment on small sheets of paper (approximately 12-by-9 inches), are dark and mysterious, suggesting only in the most abstract terms the amorphous shape of the figure. Three of these pictures were gifts from the artist to Paul Strand, and have been identified as abstract portraits of the photographer. Three others, titled *Portrait – W – I-III* have thus far been identified as portraits of Kindred M. Watkins, a mechanic friend from Texas (although they present a decidedly feminine form). The artist wrote about these figures: "I have painted portraits that to me are almost photographic. I remember hesitating to show the paintings, they looked so real to me. But they have passed into the world as abstractions – no one seeing what they are." These pictures do seem to evoke a strong physical presence but it is difficult

to see the portrait likenesses O'Keeffe speaks about. Perhaps it is the emotional identity of her sitters that her works project. The willowy, somewhat mysterious figures she created in watercolor recalled the soft-focused photographs Steichen took of women at the turn of the century, such as *The Little Round Mirror* (1902). It is possible that she saw this particular work, or works just like it, in Stieglitz's collection, or illustrated in *Camera Work*.

In O'Keeffe's second group of figures from 1917 – women seated alone, possibly based on the artist herself – she focuses more specifically on the anatomical structure and pose of the body. These works are generally brighter in color than the "portraits," with reds, blues, browns (and once magenta) predominating. Her watercolor technique is considerably more spontaneous, but nonetheless controlled as she bleeds colors, blurs edges, and creates sharp contours at will, with little or no pencil underdrawings. *Nude Series* (1917) and *Seated Nude XI* (1917) illustrate the two variations in pose that occur within the group: a three-quarter view and a frontal pose. The colors are different in each work (red and brown in the three-quarter views; red and blue in the frontal ones), as is the effect they produce. In the former, O'Keeffe tends to silhouette the figure against a blank background, while in the latter she incorporates the figure into a richly painted background. As in many of her landscape watercolors of the period, the composition is reduced to a few large colored shapes and areas of unpainted paper that form their own independent shapes.

The nudes invite comparison with the watercolor figures done a decade earlier by Rodin that O'Keeffe had seen at 291 in 1908 (which were reproduced in *Camera Work*, nos. 34–35, April-July 1911) and those of O'Keeffe's contemporary Charles Demuth. However, unlike O'Keeffe, both Rodin and Demuth relied on preliminary underdrawings to define the structure and composition and then added watercolor. O'Keeffe's direct application of watercolor to blank paper produced far more abstracted and modern-looking compositions.

Overleaf:
18. *Untitled ("Portrait of Paul Strand"),* 1917
19. *Seated Nude XI,* 1917.
Between 1917 and 1918 O'Keeffe freely applied watercolor to paper to create a colorful series of posed figures – some abstract, others more representational – that were modeled after friends, and perhaps her own reflection.

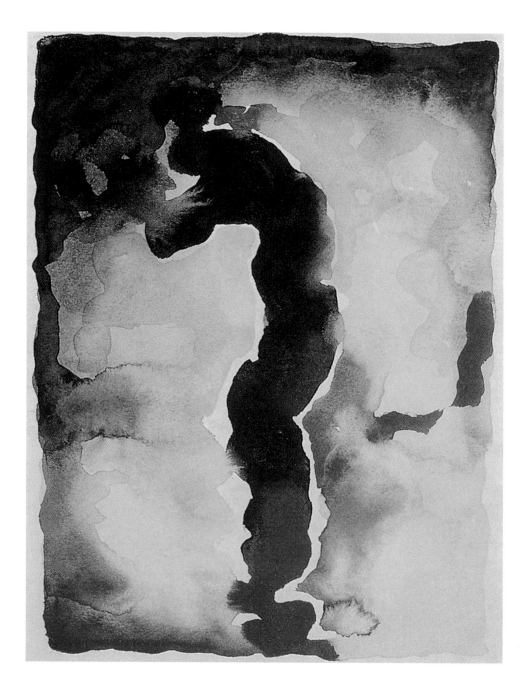

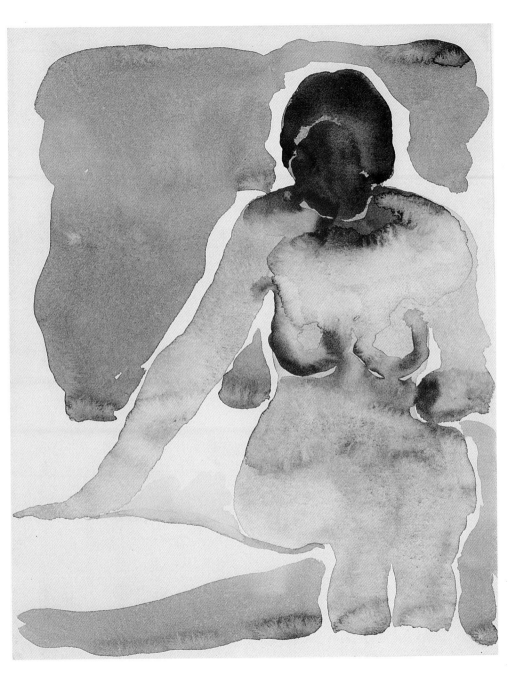

Chapter 2: In New York:
First Oil Paintings

O'Keeffe's early years in New York (from 1918 through the 1920s) were crucial to her final maturity as an artist. During this period she associated closely with the avant-garde American artists and photographers around Stieglitz, who shared her commitment to abstraction based on an observed reality. An inevitable exchange of ideas took place between them and O'Keeffe, who was fully aware of developments in contemporary art and photography. It was not uncommon for her to adapt to her own artistic purposes specific images, themes, or compositions from other people's work, although her ideas more often paralleled, and sometimes even preceded, those of the other artists.

O'Keeffe's artistic and spiritual kinship with Arthur Dove, one of America's first abstractionists, particularly illustrates this exchange of influences. She felt an affinity with Dove even before she made his acquaintance through Stieglitz, and she continued a friendship with him through letters and sporadic visits until his death in 1946. As a young art student she had been very impressed by one of his pastels (*Based on Leaf Forms and Shapes*, ca. 1911-12), reproduced in Arthur Jerome Eddy's book *Cubists and Post-Impressionism* (1914), and subsequently she actively sought out his work in exhibitions. What she most admired in Dove was his ability to create seemingly abstract compositions that were actually based on an observation of nature. In his work line, color, and shape were visual interests in their own right, exclusive of subject. His example provided an important model for her early work. Many motifs found in Dove's early abstractions find remarkably close counterparts in her work of slightly later date. The direction of influence seems to have occasionally reversed itself, with O'Keeffe's paintings providing the inspiration for Dove's work, especially in later years.

O'Keeffe may have been aware of Dove's charcoal drawing *Thunderstorm* (1917-20) when she herself recorded a similar theme in 1922. In *A Storm*, one of two pastels drawn at Lake George, she seems to capture her initial response to the awesome sight of a raging electrical storm over water. In the other pastel, erroneously titled *Lightning at Sea*, O'Keeffe's interpretation is

20

far more stylized and consciously composed, suggesting that it was produced later. As was usually the case, the artist moved from a naturalistic treatment to an abstract one. In this instance, *A Storm* is the more faithful rendering of the incident, even to the inclusion of the full moon reflected in the dark water. It achieves a sense of the particular moment and reproduces the dramatic display of sudden light in an otherwise blue-black sky.

This piece exemplified O'Keeffe's mastery of expressive color and her expert handling of pastel, a medium she favored in the 1920s and to which she returned for brief interludes over the next sixty years. In *A Storm* she contrasts the smudged, velvety quality of the deep blue sky and water with the sharp angularity of the red lightning bolt, accented by a pale line of yellow. After seeing the two storm pastels in her 1934 exhibition at An American Place, a critic was moved to write about her "thrilling imprisonment of the sky's wild splendor."

The visual drama of these images may have made a lasting impression on John Marin (1870-1953), who in 1930 rendered his own watercolor version of a lightning storm. Combining specific elements from O'Keeffe's two compositions, Marin quotes the trapezoidal shape from *Lightning at Sea* and the jagged bolt from *A Storm.* Confronted by this display of natural power while visiting New Mexico, O'Keeffe's adopted locale, he might well have recalled her earlier interpretations of the subject and paid homage to her memorable vision.

Although O'Keeffe's affinity with the painters of the Stieglitz circle must be recognized, her work seems most closely related to that of photographers of the period (including those not directly associated with Stieglitz), such as Paul Strand, Imogen Cunningham, Johan Hagemeyer, Paul Haviland, and Edward Weston. Understandably, the painters around Stieglitz shared his appreciation of photography as an art form. O'Keeffe in particular, as intimate and protégée of Stieglitz, was kept current on developments in this field and often (unconsciously) adapted them to her own work.

Particularly influential was Paul Strand (1890-1976), a young and innovative photographer whose association with Stieglitz lasted from 1907 to 1933. O'Keeffe had seen Strand's photographs in *Camera Work* in October 1916, seven months before she actually met him in New York. In his photographic vision and choice of locales he seemed to confirm what she was already beginning to attempt in her own work, and often set precedents that she later followed. When they did meet in May 1917 there

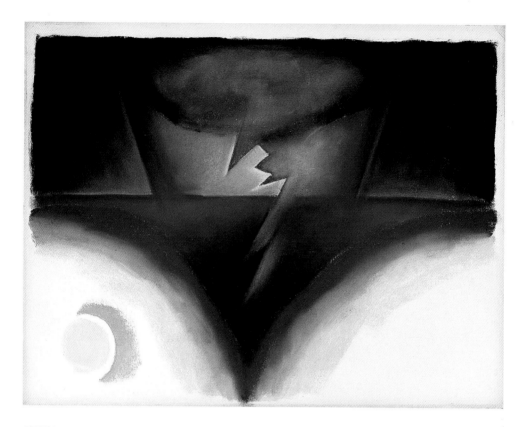

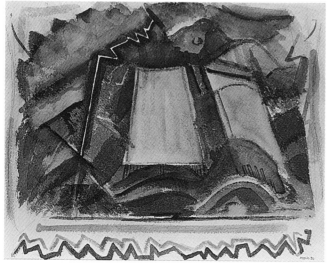

20. *A Storm*, 1922.

21. **John Marin**, *Storm, Taos Mountain, New Mexico, 1930*. John Marin, another member of the Stieglitz circle, may have recalled O'Keeffe's earlier pastel rendering of a dramatic lightning storm when he produced his later version in New Mexico.

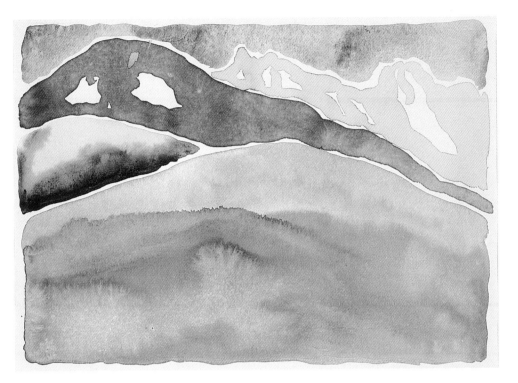

22. *Pink and Green Mountains, IV*, 1917. The registers of large colored shapes that structure O'Keeffe's early watercolor landscapes may have derived from the flattened spaces in Paul Strand's landscape photographs of just slightly earlier date.

23. **Paul Strand**, *Bay Shore, Long Island, New York*, 1914.

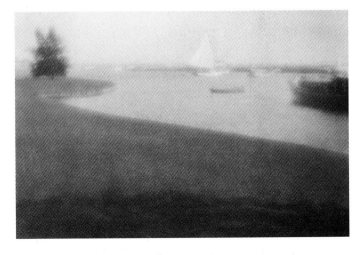

was an immediate personal attraction that was matched by their complementary artistic outlooks. As O'Keeffe admitted in a letter sent to him from Texas: "…I've been wanting to tell you again and again how much I liked your work – I believe Ive been looking at things and seeing them as I thought you might photograph them – …making Strand photographs for myself in my head." In response, Strand sent her some of his photographs including *Snow, Backyard, New York*, 1915, *Porch Shadow*, 1916, and *Abstraction – Bowls*, 1916. No doubt O'Keeffe would also have read the final issue of *Camera Work* (June 1917) devoted to Strand. Perversely, it was the smitten Strand whom Stieglitz sent as his emissary in May 1918 to convince O'Keeffe to return to New York (and to Stieglitz). Mission accomplished, O'Keeffe and Strand arrived in New York on June 10, 1918. She moved into a studio apartment (at 114 East 59th Street) vacated by Stieglitz's niece, and a month later, Stieglitz joined her.

Strand's influence on O'Keeffe's artistic vision continued for many years, and helped her to develop strategies for her later work. Of particular importance were his 1915-16 photographs that magnified the details of everyday objects and transformed them into images of pure abstraction, studies of pattern, shape, and line, without pictorial reference. His landscape subjects made around those years, for example, compressed space into flat, horizontal registers stacked one on top of the other, a device that O'Keeffe began to explore in 1916, and more fully developed in her 1917 watercolor series *Pink and Green Mountains*. In 1922 she wrote: 22

Paul Strand has added to photography in that he has bewildered the observer into considering shapes, in an obvious manner, for their own inherent value. Surely bolts and belts and ball bearings and pieces of all sorts of things that one does not recognize readily because of their unfamiliarity, or because of distortion, when organized and put together as Strand has put them together arrest one's attention. He makes more obvious the fact that subject matter, as subject matter, has nothing to do with the aesthetic significance of a photograph any more than with a painting.

In this way his early photographs were related to her similarly geometric abstractions, painted a few years later (*c.* 1919-23). In addition, they contributed to her conception of the greatly enlarged flower and plant paintings of the mid-1920s, which were also influenced by the photographic work of Stieglitz's former associate, Edward Steichen. Strand's travels to the Gaspé Peninsula in Quebec, where he photographed weathered barns

and houses, and his sojourns in New Mexico in the late 1920s also prompted O'Keeffe to visit these places.

The connection between O'Keeffe and Strand is easily found in their work. More difficult to assess is the extent to which O'Keeffe and Stieglitz influenced each other's work. Their subjects are often similar, but their approaches seem vastly different. The intense emotional fervor expressed in some of Stieglitz's photographs, such as the *Equivalents*, a cloud series, is rarely evident in O'Keeffe's more coolly rendered, though no less personal, images. His essentially romantic viewpoint is also at odds with her emphasis on analytic observation and calculated permutations. Where they coincide, to a certain degree, is in their use of abstraction, which occurred initially in her non-objective images of 1915-16. Stieglitz was the first of the two, however, to create abstract compositions with recognizable images by focusing on one section, thereby negating a subject's natural context. His 1918 photograph of O'Keeffe showing just her hand and coat is an example of this (*Georgia O'Keeffe*, 1918).

In a general sense their creative processes were also similar. Both explored the multiple possibilities of a subject in thematic series, reworking compositions in order to discover the ultimate solution. More than any specific aspect of their technique, however, it was their equal dedication to perfection that made them compatible as creative partners and receptive to each other's influence. Years after Stieglitz's death, she astutely noted:

For me he was much more wonderful in his work than as a human being…I believe it was the work that kept me with him…though I loved him as a human being…I put up with what seemed to me a good deal of contradictory nonsense because of what seemed clear and bright and wonderful.

Although informed by contemporary photography, O'Keeffe's paintings were never merely painted photographs. What distinguished her work from photography was her use of options afforded by the painting medium and process. Photographers like Strand and Stieglitz could not completely escape the documentary nature of the camera in recording the texture and detail of a subject. O'Keeffe could be, and was, selective in the amount of detail she included in her paintings. As a painter she was able to adjust the subject to fit her artistic concept by eliminating, reworking, or adding any element she deemed necessary. As she is reported to have said in 1922: "Nothing is less real than realism. It is only by selection, by elimination, by emphasis that we get at the real meaning of things."

Overleaf:
24. *Music – Pink and Blue No. 2,* 1918.
25. *Grey Lines with Black, Blue and Yellow, c.* 1923. Among the most abstract paintings ever made by O'Keeffe were those that she did while listening to music and the sequence of related paintings that followed in the early 1920s. Although devoid of recognizable subject matter, the imagery conjures up flower petals and human sexual anatomy.

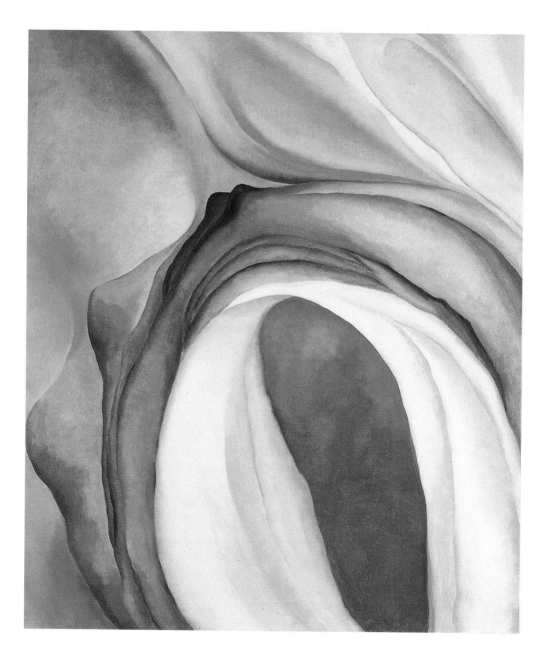

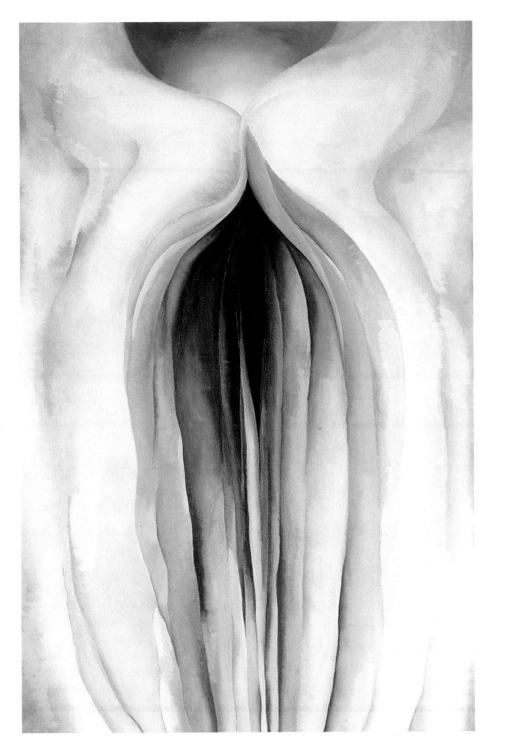

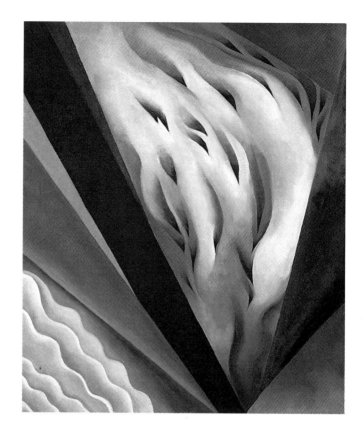

26. *Blue and Green Music*, 1921. The strong geometric structure of this early music-inspired painting became a recurring motif in O'Keeffe's oeuvre. This picture is particularly unusual for its combination of both geometric and organic forms.

27. *Flower Abstraction*, 1924. *Flower Abstraction* is among the first enlarged close-ups of floral subjects attempted by O'Keeffe in 1924 to make people "surprised into taking time to look at it."

Even when her paintings were so accurately representational and sharply focused that some critics associated them with the Precisionist movement of the 1920s, they were nevertheless based on abstraction. These differences often make her paintings of the 1920s and '30s seem more abstract and modern than the work of even her most avant-garde contemporaries in photography.

Some of the most abstract paintings O'Keeffe ever produced were done immediately after her arrival in New York. During those years, she concluded her previous series of black-and-white drawings, and began to use color in her first group of abstract oil paintings; previously she had reintroduced it only into her watercolors. In a series of highly evocative oil abstractions, executed in a range of tones – from intense yellows, reds, magentas, and greens, to softer shades of pink and blue – she elaborated on motifs from her earlier charcoal drawings, but depicted these forms with greater sculptural definition.

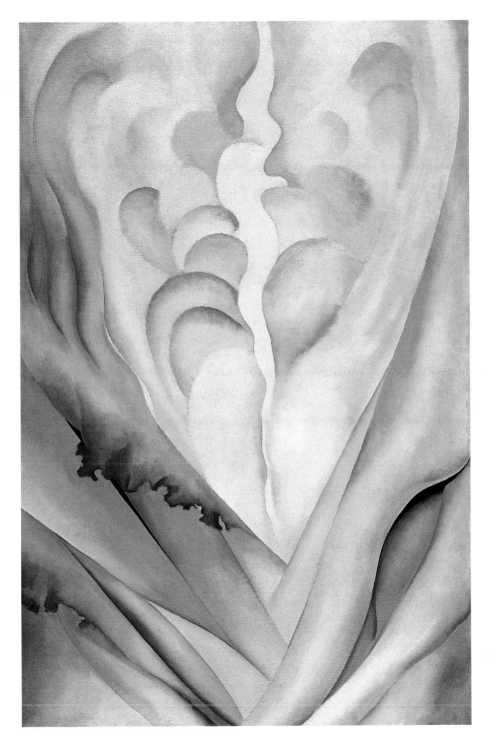

Some of them were inspired by listening to music. O'Keeffe had first been introduced to the idea of synesthesia, the ability of one art form to stimulate the subjective experience of another sense, through Dow's teachings. And among the artists in Stieglitz's sphere, she was not alone in making this connection between art and music. Dove in particular had produced a number of amorphously flowing early pastels that derived their sensuous imagery from listening to music. O'Keeffe's paintings were no less sensual, but they more concretely illustrated her expressed desire for "Music that makes holes in the sky." *Music – Pink and Blue No. 1* (1918) and *Music – Pink and Blue No. 2* (1918), are two important examples showing her translation of that idea. Each of them emphasizes the hole through which a blue sky can be seen – a motif that would be reprised later in her *Pelvis* paintings of the 1940s. And in each, the entire space around the hole is filled with some sort of unidentified membrane whose sinuous folds ripple gently with movement. These music pictures are also notable for being the first, and one of the few, large-size oil paintings O'Keeffe produced at this time (each canvas measures 35 x 29 inches). *Blue and Green Music* (1921) is another painting inspired by music. Smaller in size, but equally powerful in its evocation of sound and movement, this tightly organized composition is structured around a central "V" formation that would recur with frequency in O'Keeffe's later work.

24

26

Other paintings from 1918-21 used a similar vocabulary of colors and shapes, but gave no clue as to their visual sources – e.g., the three versions of *Black Spot* (1919) and *Series I, No. 8* (1919) – while others made specific references to flowers, landscapes and the human body in their titles and imagery. Among the latter category are *Blue Flower* (1918), *Series I, No. 10* (1919), *Inside Red Canna* (1919).

In 1923-24 O'Keeffe returned to the sexually charged imagery and compositional formats of her 1918-19 musical abstractions. *Grey Lines with Black, Blue and Yellow* (c. 1923), its mate *Grey Line with Lavender and Yellow* (1923), and *Flower Abstraction* (1924) are large, complex abstractions that came from her "desire to make the unknown – known," to clarify an experience that is felt, but not clearly understood. As in much of O'Keeffe's work, their compositions are highly controlled and symmetrically arranged, although fraught with visual intrigue. The tall shape of the canvases (each painting measures 48 x 30 inches) accentuates the elongated arcs or V and the central dividing line that form the basis of their structure. Like the music

25

27

series, these pictures deal with the general theme of openings and the ambiguity between solid and void. Whether shapes and lines are perceived as rounded forms or as voids is determined by their coloration, light, and shading. O'Keeffe's palette could be subtle or dramatic, and gradations of colors flow into one another with little visible brushwork. These works point up her ability to achieve vastly different effects with a limited formal vocabulary. The sources for her imagery in these three paintings are clearly various aspects of nature, with references to landscape in the rising mounds of gray and crescent "sky," to flower petals with their delicate layering, as well as to female sexual anatomy.

That O'Keeffe's work could evoke such diverse associations was in fact at the heart of her working process, and the result of her paring down images to their essential, universal forms. Often, as she reworked compositions within a series or moved from one series to another, she unconsciously applied the same forms and arrangements to unrelated subjects. It is not unusual, therefore, to find that her seascapes look like her floral compositions, or that her studies of seashells resemble mountain ranges, or for that matter, that abstractions could relate to paintings with identifiable subjects. Her 1923 *Grey Line* paintings, for example, anticipate her representational depictions of opened and closed clamshells in 1926 and the jack-in-the-pulpit flower paintings of 1930. One senses that, at least sometimes, the visual correlations that she produced between unrelated subject matter were subconscious. Years later, writing about two other paintings (from her *Shell and Old Shingle* series, 1926) – one a vertical still-life, one 58, 59 a horizontal landscape – that were remarkably similar, she acknowledged this phenomenon, saying, "I did not notice that they were alike for a long time after they were painted."

Chapter 3: Lake George

Throughout the 1920s O'Keeffe produced an enormous number of landscapes and botanical studies that were generated by her annual trips to the Stieglitz family country estate in Lake George, New York. Beginning in August 1918, she and Stieglitz spent several months of each year there, from spring to fall, working in their respective studios, and in the company of his large extended family. Hedwig Stieglitz, beloved matriarch of the family, oversaw a bustling household inhabited at various times by different combinations of Stieglitz's many siblings, their spouses, and children. From the early to mid-1920s O'Keeffe's feelings of exhilaration at being with Stieglitz and her discovery of new subject matter at Lake George were reflected in her paintings. She wrote enthusiastically to the author Sherwood Anderson in 1923: "I wish you could see the place here –there is something so perfect about the mountains and the lake and the trees –Sometimes I want to tear it all to pieces – it seems so perfect – but it is really lovely – And when the household is in good running order – and I feel free to work it is very nice."

Although O'Keeffe's paintings at Lake George were mainly based on nature, she did on occasion depict the houses, barns, and studios on the property. One example is the small, narrow canvas *Flagpole* (1925), one of five versions of this site; the others date from 1921-22, 1923-24, 1924, and 1959. Its whimsical merger of reality and fantasy conveys as much about the setting as it does about O'Keeffe's liberated state of mind. Nestled beneath gently rolling blue mountains is the small square wooden house that Stieglitz used as a darkroom when he was at Lake George, and sometimes pictured in his photographs. O'Keeffe's composition reduces the scene to its fewest essential shapes and architectural features – a triangular roof, a rectangular black door, an arrow from the rooftop weather-vane, and two narrow electrical wires. In contrast to these fairly representational details, the exaggerated proportions of the soaring flagpole and the enormous blue ball of light add a magical touch to this ordinary scene.

Such indications of humor and contentment were short-lived in her Lake George pictures, as marital conflicts with Stieglitz arose in the late 1920s, as a result of his infidelities and constant

28. *Flagpole*, 1925. Mixing fantasy and reality, O'Keeffe's picture conveys her joy at being in Lake George with Stieglitz in the early-mid 1920s. The little house in the picture contained Stieglitz's photography darkroom.

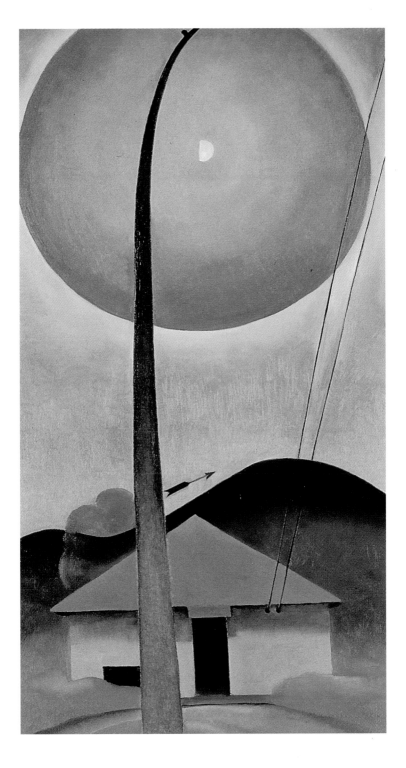

29. **Alfred Stieglitz**, *Little House, Lake George, c.* 1934. Stieglitz's photograph of his Lake George studio shows the arrow weather vane and the flagpole that also appear in O'Keeffe's painting of the same site.

familial obligations. In her large canvas, *Farmhouse Window and Door* (1929), painted just four years later, for example, she rendered an exterior portion of the main house with cold austerity; in 1934 Stieglitz photographed his own version. Flat and starkly geometric (save for the decorative pediment above the window frame), O'Keeffe's house neither invites entry, nor reveals its contents, much like Sheeler's 1917 photograph in Stieglitz's collection. Even through its uncurtained window we are met with a visual obstruction — an inner wall or door that floats mysteriously in a white space. While the message of this 1929 painting is ominous, twenty years later in New Mexico O'Keeffe reinvented the motif of the floating rectangle into the more hopeful patio door series. As these architectural paintings of Lake George suggest, O'Keeffe employed both realistic and abstract idioms – two very different styles that recurred throughout her life, as she studied different aspects of a subject. By switching between these

32

opposing approaches she found adequate means to express the different facets of an experience.

At Lake George she produced evocative color studies, reductive designs, and panoramic views based on the mountains and lake, as well as close-up studies of particular objects on the property. Paintings of leaves, focusing on their irregular shapes and contours and their color, and small, jewel-like arrangements of fruit picked from the trees on the property, e.g., *Apple Family – 2* (1920) and *Red Pear with Fig* (1923), formed a significant number of still-life studies created during the 1920s.

Close-up views of leaves alone, silhouetted against a blank background or densely overlapped in bunches, appear with great frequency in about 28 large and small oil paintings between 1922 and 1929. As expected, these images are variously presented as either realistic observations of her surroundings or as expressively exuberant color abstractions. Also as expected,

30. **Charles Sheeler**, *Bucks County House, Interior Detail*, 1917. In Charles Sheeler's paintings, photographs, and drawings he often depicted architectural subjects. The stark frontality of his darkened window (in Stieglitz's photography collection) relates to O'Keeffe's painted interpretation of a window from the Lake George house twelve years later.

31. **Alfred Stieglitz**, *House and Grape Leaves*, 1934. Five years after O'Keeffe's highly stylized close-up of the Lake George window, Stieglitz photographed the same setting showing all of the decorative details of the surrounding wall, porch, and nearby plants.

32. *Farmhouse Window and Door*, 1929. Painted in a year of marital discord, the Lake George window is ominously devoid of human life or emotion. Similar architectural elements appear in her Canadian barn series of 1932 and the patio door pictures painted in New Mexico after 1946.

33. *Apple Family – 2*, 1920. This is one of a number of small, jewel-like canvases filled with ripe apples from the Lake George property. Compressed into a shallow space, their voluptuous forms and vibrant colors seem to burst with life.

they suggest visual associations with the other images she was producing at the time, such as flowers and landscape settings. For example, there are comparable rust red and black color schemes, jagged contours, and irregular forms in O'Keeffe's series of *Four Dark Red Leaves*, 1923 and in her landscape *Storm Cloud, Lake George*, 1923. Although the leaves seem to evolve out of O'Keeffe's interest in nature, Marjorie P. Balge-Crozier has pointed out that the subject matter is unusual in Western art: "by themselves [leaves] do not turn up in the history of still-life painting until O'Keeffe elevates them to that privileged position." They were, however, familiar subjects to O'Keeffe from her years of study and teaching using Dow's methods. As she recalled, Dow asked his students to "take a maple leaf and fit it into a seven-inch square in various ways," and she did likewise with her students. A page from Dow's book illustrates a "Japanese Botanical Work" containing many different types of leaves which are closely related to the leafy images O'Keeffe painted in the 1920s. Leaves make their last appearance in her work in a 1936 painting *Ram's*

34. **Alfred Stieglitz**, *Lake George*, 1922. Apples were the subject of some of Stieglitz's Lake George photographs. Shown within the context of their surroundings and at a specific moment in time, they assume a narrative, and sometimes symbolic, role.

Skull with Brown Leaves, where they echo the negative spaces around the skull and horns.

Between 1920 and 1923, when the apple harvest at Lake George was especially plentiful, Stieglitz and O'Keeffe each produced a large number of compositions that prominently feature this fruit. Stieglitz took some sixteen photographs, frequently including her in the picture as well; she produced some twenty

small paintings and pastels that seem to give individual "person-alities" to the pieces of fruit. Among the differences in their work, Stieglitz's photographs were black-and-white (as were Strand's earlier photographs of apples *c.* 1916), while O'Keeffe's paintings mimicked the vibrant reds, yellows, and greens of the apples themselves. She reveled in what Paul Rosenfeld wrote were "tart harmonies" which gave her compositions their "curious, biting, pungent savor." Together, these photographs and paintings form a fascinating group of works that reveal how two different artists could see the same subject and make very different associations.

Many of O'Keeffe's paintings of apples have a decidedly per-sonal and familial component to them that suggests they were not meant to be viewed as simple still-life arrangements, but rather had some deeper connection to the artist and her circum-stances. Her repeated use of the title *Apple Family,* and her often crowded compositions in which numerous apples are bunched into the same small space, may refer to her living situation at Lake George, where the large and boisterous Stieglitz family often overwhelmed her and thwarted her concentration on work. Perhaps as an antidote to these emotional images, O'Keeffe also painted some deceptively simple still-life arrangements with just one or two apples on a plate, that are really analytical studies of flatness, design, and shifting perspectives. In such works as *Apple on Tray* (1921) and *The Green Apple* (1922) the apple (seen head on) looks like a planetary orb levitating in front of (rather than sitting on) a flat black disk that is the plate viewed from an unusual angle.

Stieglitz's photographed apples, on the other hand, may contain a subliminal nationalistic meaning, as Sarah Greenough has suggested in *From the American Earth,* by equating O'Keeffe and her artistic roots to the American soil. They also have more overt erotic connotations – recalling the story of Adam and Eve, as well as the shape of firm round breasts. In this regard, it is interesting to note that O'Keeffe painted a large number of alligator pears (avocados) around this time, whose pendulous shapes are distinctly breastlike. In all, she painted 14 small pictures of this fruit between 1920 and 1925, half of which showed two alligator pears together. Curiously, on the back of one of these pairs she painted a more explicit close-up of breasts and a female torso in a pose that resembles one of Stieglitz's nude photographs of O'Keeffe, further reinforcing this association.

In 1924 Stieglitz wrote that O'Keeffe was "self portrayed through flowers and fruits," an idea that her friend Demuth had

33

35, 36

35. Untitled (Self-Portrait – Torso), c. 1919.
36. Alfred Stieglitz, *Georgia O'Keeffe: A Portrait – Breasts*, 1919. The connection between Stieglitz's photographs and O'Keeffe's paintings is often less apparent than in this pair of nudes. O'Keeffe's painting is hidden on the reverse side of an alligator pear picture, a subject that has its own sexual associations.

previously exploited when he created an abstract poster portrait of her in 1923-24. As he did for his other poster portraits, including those of Dove, Hartley and Marin, Demuth selected objects that symbolized the life, personality, and physical traits of the person being represented. In O'Keeffe's case, he included two Kieffer pears (as well as a yellow gourd and a green apple). The name of the pears not only played on the spelling of the artist's name, but also alluded to her alligator pear paintings of the same years, and to Stieglitz's photographs of her breasts.

Trees – maples, cedars, pines, poplars, chestnuts, and birches – were also abundant at Lake George, and became favorite subjects. Exuberantly painted either singly, in groves, or as one part of a panoramic landscape, they usually conveyed a sense of vitality and growth. Like her depictions of fruit, O'Keeffe's trees have distinctive personalities, and were again, perhaps, surrogates for people that she knew or personality types that she encountered. Although her arboreal paintings reflected the changing seasons through color and foliation differences, this

was not their main purpose. Rather, they conveyed something more permanent that was characterized by the strong, upward rising tree trunks that anchored an elegant, sometimes chaotic, symphony of bending branches and limbs. Similar imagery is captured in Stieglitz's Lake George photographs of trees from the same period.

Autumn Trees – The Maple (1924) is a fine Lake George 38 painting in which thickly brushed veils of vibrant autumnal color fill the background around a central gray tree. Judging by the distinctive configuration of branches, the tree is the same one depicted in two of O'Keeffe's subsequent canvases: *Grey Tree*, 39 *Lake George* (1925) painted in thin washes of tone, and *Red Maple* (or *Fall Leaves*) (1927), displaying her agitated, feathery brushwork. All three are executed on the same size canvas (36 x 30 inches), and have similar compositions. They were probably painted in the fall just before she would have returned to New York for the winter season. What most distinguishes these paintings is their coloring – one a deep autumnal red and gray; the second a somber gray, green, and purple; and the last a garishly bright tomato red, yellow, and blue.

Demuth, too, depicted trees with some frequency in the late 1910s and early '20s, emphasizing the line of their elegantly sweeping trunks and branches. Both artists often gravitated to the same subject matter – trees, flowers, and still-life arrangements with fruits – although the size of their work, choice of mediums, and painting styles were very different. One of his 1917 watercolors, *Trees*, bears an uncanny resemblance to *Grey Tree*, 40 *Lake George*, in terms of composition, and particularly in its use of purple and green, as well as its style of painting. A similar comparison might be drawn between O'Keeffe's oil painting *Pink Daisy with Iris* (1927) and Demuth's equally watery flower paintings. In both examples Demuth's medium is watercolor, O'Keeffe's is oil, but the same translucency and washiness of pigment is achieved in both, an effect uncharacteristic of O'Keeffe's oil paintings. She was quite familiar with Demuth's work by 1924 when she started the maple tree series, and had begun to make regular visits to his home in Lancaster, PA, in early 1923. They apparently exchanged artwork, because she owned one of his 1916-17 tree watercolors (now in the J.R. Hyde III collection), while he had one of her alligator pear paintings.

Demuth had been a frequent visitor to 291 since 1914. Although Stieglitz, unlike O'Keeffe, did not develop an especially close personal relationship with Demuth, he did take several

37. **Charles Demuth**, *Poster Portrait: Georgia O'Keeffe*, 1923–24. From 1923 to 1929 Charles Demuth painted a series of poster portraits of his famous friends (O'Keeffe, Dove, Marin, Hartley, etc) that used words and emblems to characterize the subject's personality and activities.

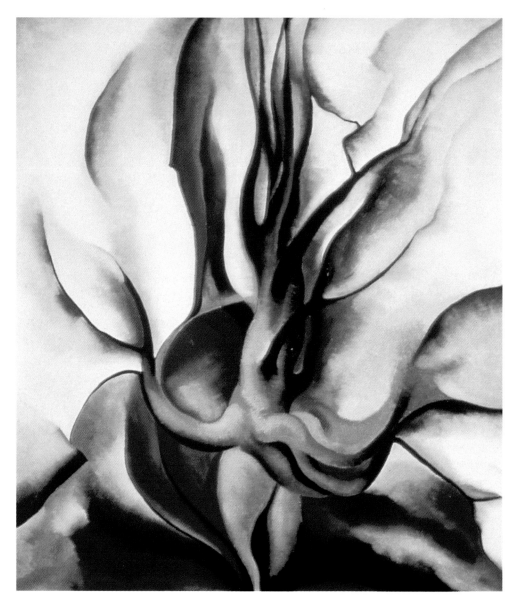

38. *Autumn Trees – The Maple*,
1924.
39. Grey Tree, Lake George,
1925. These two maple tree
paintings – one autumn red, the
other winter gray – describe
primarily through color the
seasonal changes that O'Keeffe
witnessed at Lake George, where
she often worked into late fall.

40. **Charles Demuth**, *Trees*, 1917. O'Keeffe and Demuth were friends and often exchanged artwork. Although they shared a penchant for certain subjects – fruits, flowers, and trees – their painting styles and media were vastly different. In one instance, however, Demuth's thinly washed gray and green watercolor of a tree, may have been the direct inspiration for O'Keeffe's 1925 painting, *Grey Tree, Lake George* (*cf.*.ill. 39)

photographs of him over the years, beginning in the spring of 1915. Demuth's friendships with several members of the Stieglitz circle, including Marsden Hartley and Marius de Zayas (whom Demuth had known since the 1910s), also brought him into the Stieglitz orbit. Stieglitz, who was afraid that Demuth's water-colors might compete with Marin's, however, did not show any of his work until a 1922 auction at the Anderson Galleries. Three years later (the year O'Keeffe painted *Grey Tree, Lake George*), Stieglitz included Demuth in the 1925 "Seven Americans" exhi-bition at the Anderson Galleries (along with O'Keeffe, Marin, Hartley, Dove, Strand, and Stieglitz), where Demuth showed his poster portrait of O'Keeffe. Later that year, Stieglitz opened the Intimate Gallery in Room 303 of the Anderson Galleries building.

Among the richest and most powerful images to emerge in O'Keeffe's early work as a result of her extended time in Lake George were her studies of flowers and plants. In the summer of

1924, she painted three rather abstracted compositions with an unusual green-and-magenta color scheme that actually depicted the leaves of a corn plant in her Lake George garden. "The growing corn was one of my special interests – the light-colored veins of the dark green leaves reaching out in opposite directions. And every morning a little drop of dew would have run down the veins into the center of this plant like a little lake – all fine and fresh." The decorative patterns she described could only be seen when you looked down into the plant from directly above. In order for the viewer to share her unusual perspective, O'Keeffe magnified the plant in her painting and pushed it to the immediate foreground; then, by tipping the picture plane upright, the viewer seems to look at the leaves head-on. The solution was simple and elegant, yet somehow unsettling. In this way, O'Keeffe's compositions often appear deceptively simple, when in fact they deal with complex issues of perception, perspective, and spatial orientation. By creating a series of variations on a single theme – in this case the corn plant – she could focus on different factors in each and find multiple solutions for a composition – a method that recalled Dow's design theories.

In *Corn, Dark I* (1924) the most monumental of the three versions, O'Keeffe explored the ambiguities of positive-negative space, the challenge of creating a composition whose focus is below center, and the emotive power of color. There is no sense of movement in this painting beyond the pale white vein's piercing verticality, which is echoed in the elongated shape of this fairly small canvas. The painting, however, exudes a great visual power that was described by Edmund Wilson in his 1925 essay for the "Seven Americans" exhibition: "…the dark green stalks of one of her 'Corn' pictures have become so charged by her personal current and fused by her personal heat that they have the aspect of some sort of dynamo of feeling constructed not to represent but to generate, down the centre of which the fierce white line strikes like an electric spark. This…picture, in its solidity and life, seem to me one of her most successful." By comparison, O'Keeffe's second and third versions of this subject writhe with movement as an overload of curves and scallops and diagonal lines capture the plant's vitality and growth.

During the summer of the *Corn, Dark* series, O'Keeffe expanded the size and internal scale of her paintings. At first, she had portrayed floral specimens in simple, traditional still-life arrangements on small to moderate size canvases. *Calla Lily – Tall Glass – No. 1* (1923) and *Petunia and Glass Bottle* (c. 1924-25)

Overleaf:
41. *Corn, Dark I*, 1924. This magnified and elongated rendering of leaves is on a fairly small canvas, but the unexpected perspective gives the viewer the exhilarating sensation of watching a corn plant grow.

42. *Black and Purple Petunias*, 1925. O'Keeffe's finesse with contour lines and unusual color schemes is evident in this floral painting where the leaves and negative space around the blossoms are as important to the composition as the subject itself.

43. *Petunia and Glass Bottle*, c. 1924–25. Prior to her first magnified flowers of 1924, O'Keeffe painted simple floral arrangements like this petunia in a vase. For a short while after that date she also initiated her extended series with one small, traditional composition, before venturing forth into larger, more radically cropped compositions.

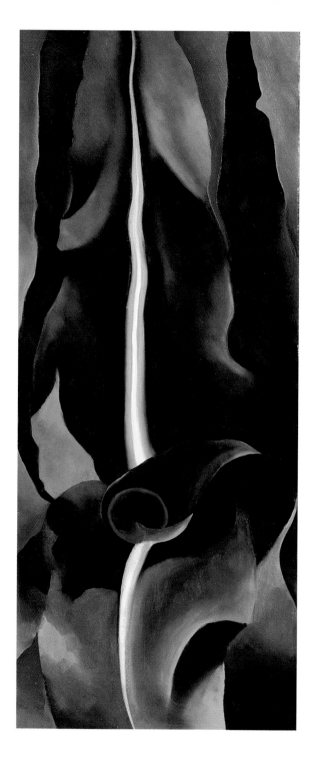

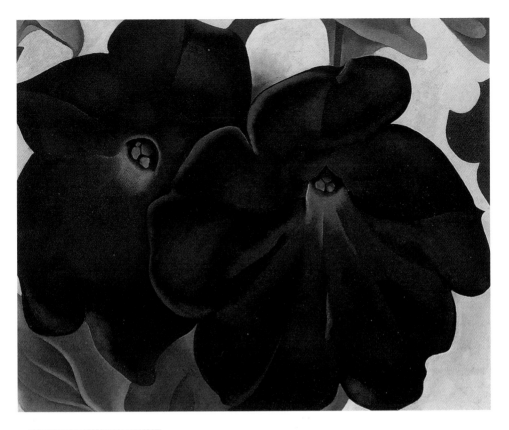

exemplify this genre in which a single flower stalk in a vase is set in a nondescript interior. By the summer of 1924, however, the *Corn, Dark* series heralded her new approach to botanical subjects, especially flowers, painted from closer range, in much greater detail, and subsequently, on larger canvases. In such works as *Flower Abstraction* (1924), *Black and Purple Petunias* (1925), and *Red Canna* (c. 1925), she focused her attention on small sections of the plant and enlarged them to encompass the entire canvas, which measured upwards to 48 x 30 inches. In these paintings the flower heads alone filled the canvas from edge to edge, with little or no room for leaves or background. In many of them the delicate petals of the flower unfurl from the stem in a V-shape configuration that suggests the growth of these plants and recalls the compositions of her earlier nature-inspired abstractions. By thrusting the image to the fore of the picture plane, she also brought the viewer right into the work. Although the results often appeared abstract, they were in fact close transcriptions of what she saw in nature.

O'Keeffe reasoned that although "everyone has many associations with a flower.... Still – in a way – nobody sees a flower – really – it is so small – we haven't time.... So I said to myself – I'll paint what I see – what the flower is to me but I'll paint it big and they will be surprised into taking time to look at it." When Stieglitz first saw these adventurously large flowers, he is reported to have said, "Well Georgia, I don't know how you're going to get away with anything like that – you aren't planning to show it, are you?" The comment reflects her contention that "Alfred was always a little timid about my changes in my work – I always had to be willing to stand alone." He did, however, include the large flowers in the 1925 "Seven Americans" exhibition at The Anderson Galleries, where they received rave reviews from the critics.

Precedents for such magnified images can be found in Strand's and Steichen's photographs of botanical subjects, which O'Keeffe knew well through Stieglitz. But unlike Strand and Steichen, who did not alter their images, O'Keeffe applied judicious editing to her paintings – simplifying compositions, flattening forms and space, and eliminating extraneous details (including cast shadows) when they distracted from the overall focus and power of the composition. Other photographers such as Edward Weston (1886-1958) and Imogen Cunningham (1883-1976) seem to have adopted this style only *after* O'Keeffe's painted interpretations were executed. Not surprisingly then,

44. **Edward Weston,** *Artichoke Halved,* 1930.
45. **Imogen Cunningham,** *Leaf Pattern,* 1920s. The enlarged close-ups of plants and flowers captured by photographers Edward Weston and Imogen Cunningham share O'Keeffe's attention to detail and contours. Although her paintings were often indebted to the photographic vision of older photographers like Paul Strand and Edward Steichen, Weston and Cunningham seem to have adopted this style only after O'Keeffe created her painted versions.

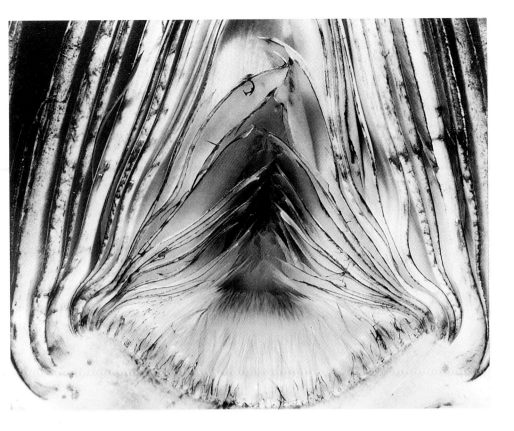

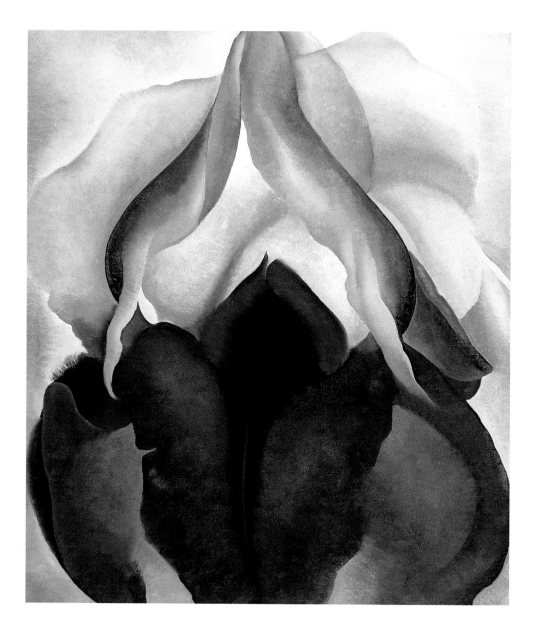

46. *Black Iris III*, 1926. One of
the artist's most masterful flower
paintings is this exquisitely
brushed and subtly tinted black
iris, whose full bloom can not be
contained within the confines of
the canvas edge.

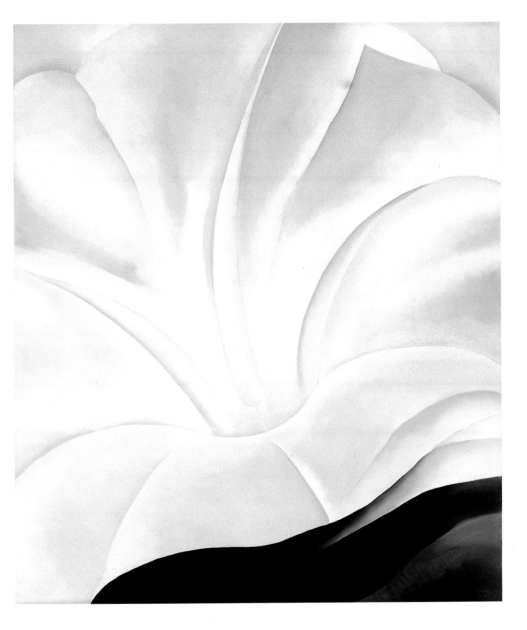

47. *Black Petunias and White Morning Glory*, 1926. The magnification of this flower head is so dramatic that the viewer sees the subject as an abstract arrangement of tone and line.

their greatly magnified, cut-off images are very similar to those of O'Keeffe's artistic vision.

One of her floral masterpieces, *Black Iris III* (1926), is representative of her large, early compositions that depict a single flower. As the largest of six variations on the subject produced between 1926 and 1927, this is also the most detailed and frontal of the compositions, and the most monumental. By translating the delicate ephemerality of this exotic flower, which blooms for only a few weeks each spring, into the artist's language of color, form, and brushwork, O'Keeffe gave it a strength and monumentality that was not inherent in the flower itself.

46

The colors of the painting are subtle and dense, ranging from a dark impenetrable black purple and deep maroon at the iris's center to the soft veils of pinks, grays, and whites in the upper petals. Although O'Keeffe separates the darks and lights into upper and lower halves of the composition, the multiple variations in tone seem to blend smoothly into one another. Similar purples and whites were contrasted more sharply in her concurrent series of *Black Petunias and White Morning Glory* of 1926, where fewer intermediary shades exist. In *Black Iris III*, O'Keeffe's feathery brushstrokes capture the velvety quality of the flower's center. In two other paintings in the series – the very small *Black Iris* (1926) and the considerably larger *Dark Iris No. 2* of the following year – she pays particular attention to the intriguing shapes and textures at the flower's center. O'Keeffe draws the viewer into the ruffled petals, which are softly tinted and exceedingly sensual. It was just such paintings that led some reviewers to see sexual implications in her floral images, though the artist always flatly denied this.

47

The composition of *Black Iris III* offers an interesting modification on the V-shaped arrangement of her first large-scale flower paintings (e.g., *Flower Abstraction*, 1924 and *Red Canna*, 1925). With the V inverted, the resulting triangular image is decidedly weighted toward the bottom. Anchored by the strong horizontal edge of the canvas and the dark coloration of the lower petals, *Black Iris III* is vastly different from the earlier paintings in its emotional tenor. No longer an image of spontaneous growth and uplifting movement, the flower is now an image of monumentality, conveying a sense of frozen time and somber dignity. It is perhaps not surprising, given the autobiographical nature of O'Keeffe's work, that this solemn pictorial mood paralleled changes that were occurring at this time in her relationship with Stieglitz. Squabbles over time spent with the Stieglitz family at

27

Lake George, his aversion to other travel, and a string of recurring maladies (both real and exaggerated) in Stieglitz and O'Keeffe, caused tensions between the couple that led them to spend less time alone with one another than they had done in years past.

Of particular concern was Stieglitz's growing friendship with a wealthy young woman, Dorothy Norman (1905-97), who since November 1927 had visited him almost daily at The Intimate Gallery. Increasingly, as she became more involved with Stieglitz and the operations of his galleries, O'Keeffe diminished her own role there. Eventually, Norman became one of the financial backers for Stieglitz's new gallery, An American Place, in 1929, and in 1932 he put the gallery's renewed lease in her name. She also became the model for Stieglitz's photographic portraits, which emulated the poses and intimacy he had previously displayed in his photographs of O'Keeffe. In 1932 some of his portraits of Norman were included in a large Stieglitz exhibition at An American Place, although he refrained from showing the ones of her in the nude. With his guidance, Norman developed her own career as a photographer.

Chapter 4: New York City: Architectural Subjects

In O'Keeffe's predominantly nature-oriented work, architectural subjects appeared infrequently, yet when they did they were often significant indicators of her reactions to new places encountered through travel or change of residence. For instance, a variety of barns charted her visits to Lake George, Wisconsin, and Canada; and a large group of churches recorded her first extended trips to New Mexico in 1929 and 1930. Her adobe house in Abiquiu, New Mexico, in which she lived after 1948, inspired one of her largest and most interpretive series of architectural paintings – the patio pictures of the 1950s, which were also some of her most abstract, minimalist works. Observing the physical details of her immediate environment and then committing them to paint seems to have been the natural process through which she assimilated new surroundings. As her familiarity with a particular place increased, she produced less representational and more interpretive works, exploring different aspects of the environment and her emotional reaction to them. As she explained, "You paint *from* your subject, not what you see….I rarely paint anything I don't know very well."

During the 1920s, O'Keeffe created one of her largest architectural cycles, using New York City as its subject. Executed over a period of four years, the series consisted of some twenty-one paintings and finished drawings, and many preliminary sketches. Like so many other artists and photographers of the first quarter of the century, O'Keeffe was captivated by the radical changes to the skyline that had taken place in just a few short years. The first skyscrapers erected in the 1910s were soon followed by many more even taller buildings in the 1920s and 1930s.

New York, of course, was also an important subject for Stieglitz, who photographed it many times, before, during, and after, her brief foray into the field. Although they were often drawn to the same types of scenes – tall buildings and panoramic views – their finished works were very different. While she tended to look up or down at single skyscrapers, he shot them head-on or bunched them into groups. Her palette, though rather somber, was generally stronger and more emotive than what

48. **Alfred Stieglitz**, *Old and New New York*, 1910. The dramatic growth of New York City during the first quarter of the twentieth century was a favorite subject for many of the modernist photographers, including Stieglitz, who recorded its changing skyline over several decades.

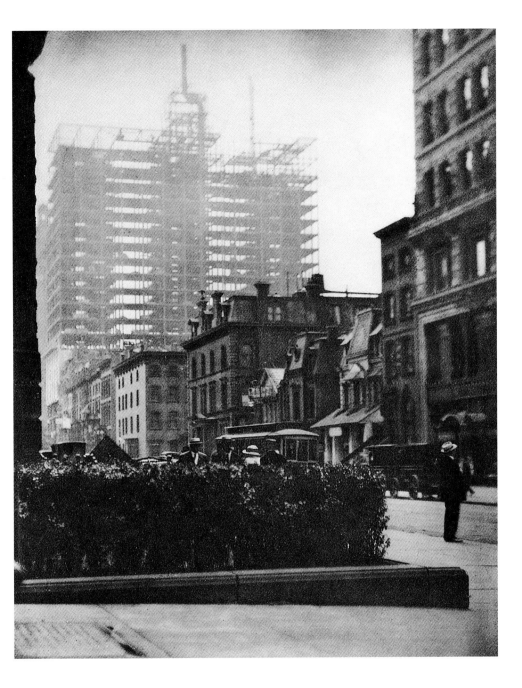

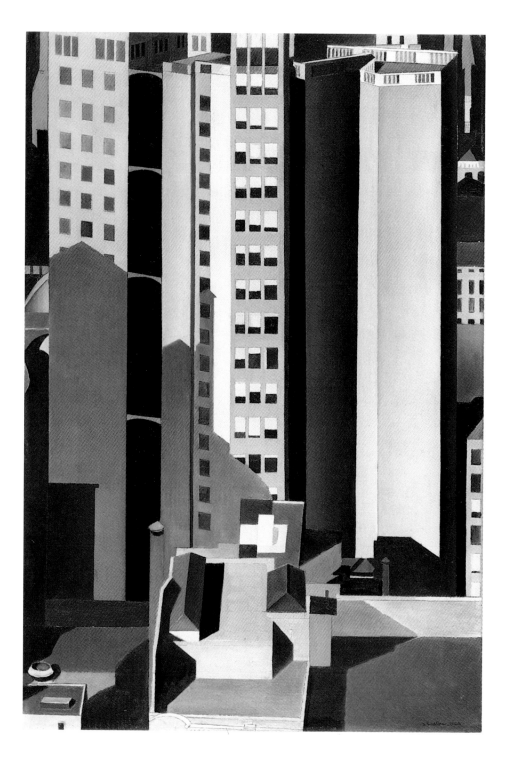

could be achieved with black and white photography. And the big discrepancy in size between his small prints (some smaller than postcards) and her paintings gave the latter a dramatic advantage.

Living in New York as a student in 1907-08 and 1914-16, and later, as an all-year or part-time resident from 1918 to 1949, O'Keeffe witnessed for herself the birth of the modern metropolis, with all its advancements and drawbacks. By the time she decided to paint its towering buildings and panoramic skyline, New York City was very familiar territory. The urban images she created, although an anomaly in her oeuvre, proved to be some of the most memorable of her career. Strongly geometric, and often stylized in an Art Deco manner, the paintings reflected the modern design sensibility of the time and suggested stylistic parallels to the Precisionist paintings and drawings by Charles Demuth and Charles Sheeler. Some of her other views of the city, however, offer a softer, more romanticized interpretation of the same subject.

For thirty-one years (1918-49), O'Keeffe lived part- or full-time in various apartments that were located in the most bustling section of the city, midtown Manhattan: 114 East 59th Street (June 1918-December 1920); 60 East 65th Street (December 1920 November 1924); 35 East 58th Street (November 1924-November 1925); the Shelton Hotel, Lexington Avenue between 48th and 49th Streets (November 1925-April 1936); 405 East 54th Street (April 1936-December 1942); and 59 East 54th Street (December 1942-June 1949). The busy streets, soaring architecture, and congested skyline had been a principal source for Stieglitz's photographs since the early part of the century. But surprisingly, considering the length of her residence in the city – and its importance in her life as the place where she had established her artistic reputation – she focused on the city as a sustained theme in her art only between 1925 and 1929 (with a few exceptions). As her early roots were in rural America, O'Keeffe found New York an exciting but draining, and ultimately stifling, environment. Her ambivalent feelings about the city are evident in her paintings and drawings of the time, which range in feeling from dynamic to claustrophobic. Prior to those years just two isolated New York City pictures exist – *59th Street Studio* (1919) and *Backyard at 65th Street* (c. 1920-23) – one an interior room, the other a behind-the-scenes view of the city. Following her epic New York City pictures of the 1920s, she returned to this subject again only three more times (despite living there another twenty years) – in 1932 with a small group of buildings, in a 1949 series

49. **Charles Sheeler**, *Skyscrapers*, 1922. Sheeler's paintings and photographs of Manhattan emphasized its congested airspace and soaring verticality. The stylized manner in which this work was painted related to O'Keeffe's own interpretations of similar scenes.

of Brooklyn Bridges, and lastly, in the 1970s when she produced a copy after her 1926 painting *City Night*.

Although she had lived in New York since 1918, she was inspired to paint the city only after she and Stieglitz moved into an apartment in the Shelton Hotel in November 1925 ; they lived at this address for eleven years, their longest residency anywhere together.

The Shelton Hotel was a recent addition to the skyline and stood 34 stories high on the southeast corner of Lexington Avenue between 48th and 49th Streets; at the time it was one of the tallest skyscrapers in the city. It offered its tenants a wide range of amenities, including housekeeping services, a cafeteria, gym, swimming pool, lounges, observation terrace on the 16th floor, and rooftop solarium. But most importantly for O'Keeffe and Stieglitz, their apartment, and the public outdoor spaces, offered views far into the distance, unobstructed by any other tall buildings. O'Keeffe left the apartment windows uncurtained and used one of the light-filled rooms as her studio. It was the first time either of them had ever lived so high above the city. The exhilaration they both felt was immediately reflected in their work and in their words. Just a few weeks after moving into an apartment on the 12th floor, Stieglitz wrote in a letter to Sherwood Anderson: "We live high up in the Shelton Hotel….The wind howls & shakes the huge steel frame – We feel as if we were out at midocean – All is so quiet except the wind – & the trembling shaking hulk of steel in which we live –…" The following year they moved even higher to the 28th floor, and by early 1928 they had relocated to the 30th floor. The elevated perspective allowed O'Keeffe to contemplate the city from a distance and at her leisure.

For the first time since moving there seven years earlier, she felt confident that she could "paint New York" even though she was "told that it was an impossible idea – even the men hadn't done too well with it…I was accustomed to disagreement and went on with my idea of painting New York." She reasoned:

I know it's unusual for an artist to want to work way up near the roof of a big hotel, in the heart of a roaring city, but I think that's just what the artist of today needs for stimulus. He has to have a place where he can behold the city as a unit before his eyes but at the same time have enough space left to work… Today the city is something bigger, grander, more complex than ever before in history. There is a meaning in its strong warm grip we are all trying to grasp. And nothing can be gained by running away. I wouldn't if I could.

50. *The Shelton with Sunspots, NY*, 1926. After O'Keeffe and Stieglitz moved into an apartment on a high floor of the newly built Shelton Hotel in 1925, the painter commenced a series of cityscapes that continued until 1929.

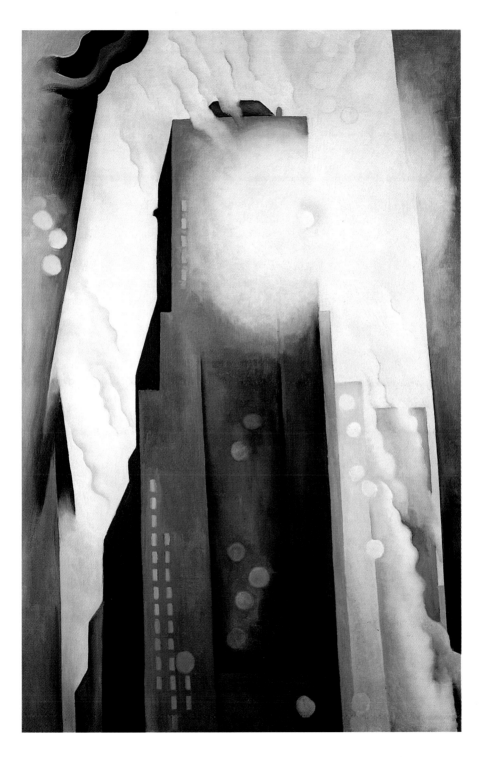

51. **Marius de Zayas**, *Alfred Stieglitz*, c. 1912-13. This abstract portrait of Stieglitz by Marius de Zayas, his close advisor at "291," uses circular motifs for a symbolic purpose. Although the orbs of light and color in O'Keeffe's city paintings relate to sunspots and street lamps, they may also contain a more private message.

Overleaf, p. 84-85:
52. *Radiator Building – Night, New York*, 1927. The drama and excitement of the modern metropolis are embodied in this theatrical vision of the Radiator Building at night. Floodlights illuminate the sky at right, and at left, a red marquee lights up the name "Stieglitz."

53. *New York Street with Moon*, 1925. As in her floral paintings, O'Keeffe sometimes created interesting background shapes that added dramatic accent. Here, the darkened silhouette of the central building and the encroaching towers on either side leave only enough room for an oddly cut piece of sky.

Like so many artists of the early twentieth century, O'Keeffe at first attempted to capture the enormous size, scale, and energy of the city. In order to process this information, she made numerous small pencil sketches, some of which were turned into finished drawings and paintings. Specific buildings (e.g., the Shelton Hotel, the Radiator Building, and the Ritz Tower) were presented in close-up, usually from street-level looking upward. Her first New York skyscraper painting was *New York Street with Moon*, 1925, a geometric arrangement of tall glowing buildings set on a diagonal that cut menacingly into the bright blue sky. Often, as she does here, she emphasized the space around and between the buildings as a separate visual element in her compositions. The relationship between the hulking building mass and the open sky is comparable to that of her later Southwestern mountain-and-sky landscapes.

This visual connection between her cityscapes and her landscapes (from Lake George and New Mexico) is also strengthened by the recurring circular motifs and orbs of light, both natural (sun, moon, and stars) and man-made (street lamps and traffic lights) that appear in both genres with some frequency. In the city pictures, these elements provide a design counterpoint to the straight-edged linear aspects of the architecture, and help to move the observer's eye around the composition. While such circles in O'Keeffe's work are usually based on something in the real world, they may also have had a more private meaning for the artist. Certainly, for some members of the Stieglitz circle – Dove, Hartley, and de Zayas, in particular – orbs and semicircles were recurrent elements that held spiritual and symbolic import. Sometimes they were references to the camera lens through which Stieglitz and his photography associates captured many of the same scenes. In other instances, as in de Zayas's caricatures of notable artists, photographers, and society personalities, the precise placement of the orb (left, right, or top center) seemed to be an indication of the subject's status within the Stieglitz group.

Between 1926 and 1929 O'Keeffe produced at least nine paintings (including *New York Street with Moon*) and a few drawings of the skyscrapers in the city. All of them dramatized the largeness of these structures as compared to the smaller buildings around them and emphasized their elongated perpendicularity as experienced from both street-level looking up and from a high floor looking down. Some pictures presented generic buildings on generic streets with no identifiable landmarks,

while others depicted an actual building whose distinctive silhouette or decorative roofline helped identify the specific site.

As with her paintings of other subjects, O'Keeffe's New York pictures projected a range of emotions. *A Street* (1926) and *City Night* (1926), for example, used the anonymous skyscraper and street to convey negative feelings. Rather than being a celebration of lights and movement, or admiration of architectural engineering, O'Keeffe created two grim and desolate scenes.

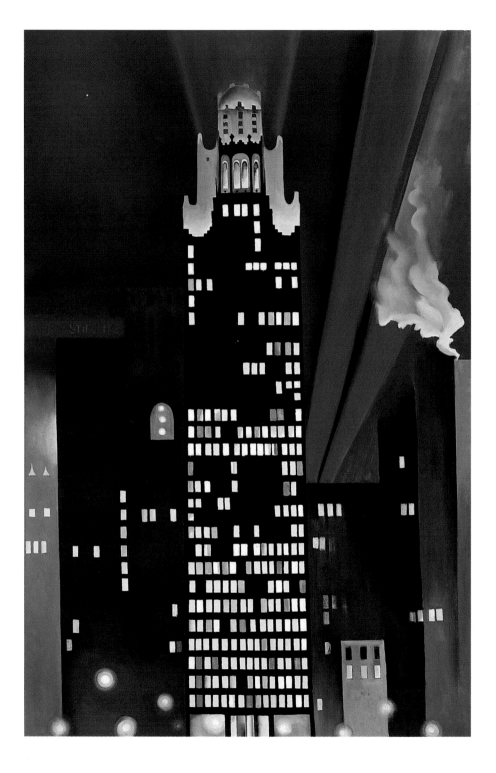

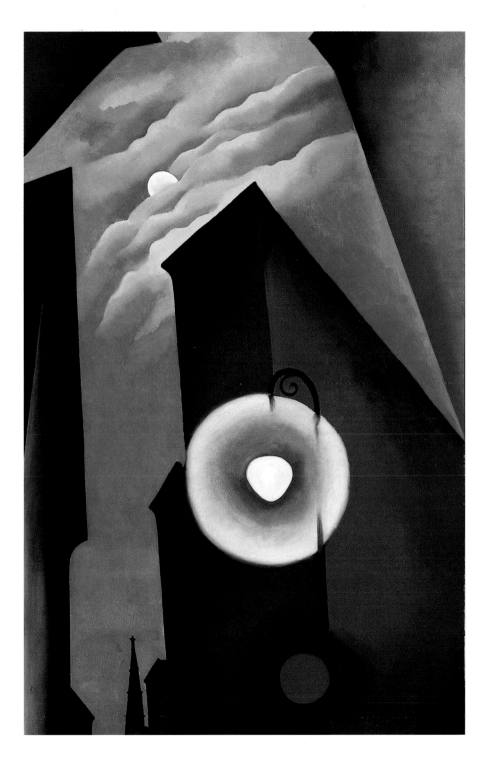

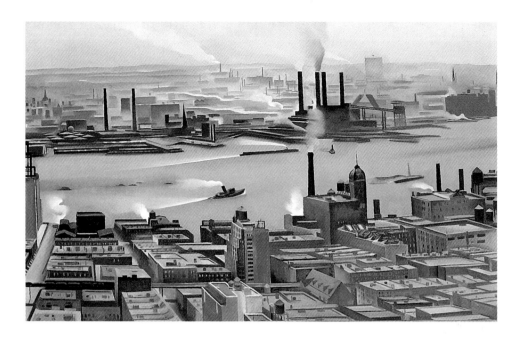

54. *East River from the 30th Story of the Shelton Hotel*, 1928. Both the vastness and the claustrophobia of the smoggy city are suggested by this panoramic view over New York's East River

In both works, two immense walls, without windows, lights, or signs of life, crowd out what little gray sky is left. The city is equated with an uninhabitable ghost town, perhaps mirroring the artist's own feelings of isolation and unhappiness. Yet, during the same time period, she also created paintings that explode onto the canvas with positive energy. *The Shelton with Sunspots, NY* (1926), which the artist claimed to paint without revision in one continuous movement from upper left to lower right, and *Radiator Building – Night, New York* (1927), which lights up the building, sky, and Alfred Stieglitz's name as if at a Hollywood premiere, exemplify the best of the skyscraper series. About *The Shelton with Sunspots* O'Keeffe noted: " I went out one morning to look at it [the hotel] before I started to work and there was the optical illusion of a bite out of one side of the tower made by the sun, with sunspots against the building and against the sky." In these works realism and imagination merge with emotion and technical skill to produce a complex picture that can be enjoyed on many levels.

Concurrently, between 1926 and 1928, O'Keeffe worked on a series of some eight panoramic paintings and pastels that depict New York's East River, the rooftops in the foreground, and the borough of Queens and the sky beyond. A ninth work from 1929 (*Pink Dish and Green Leaves*) uses a smaller portion of the same

East River scene as a backdrop for a still-life arrangement set on a windowsill. Through subtle changes in color scheme, hard- and soft-focus styling, and the spacing and alignment of images, O'Keeffe was able to alter the mood of each *East River* picture and our perceptions of the scene. Such elusive effects as the time of day, weather and lighting conditions, and the seasons are all accurately conveyed. Unlike the skyscraper paintings that featured close-up views of several different buildings in the interior heart of Manhattan, the *East River* pictures look out panoramically beyond Manhattan's borders, and repeat the same section of New York City waterfront that could be seen looking east from her Shelton apartment windows or from the hotel's roof terrace.

All the East River compositions are divided into three horizontal registers. In the bottom third are the darkened water towers and irregular rooflines of the buildings along the east side of Manhattan. In the middle section, the calm waters of the East River separate Manhattan from the boroughs of Queens and Brooklyn. In the upper portion are the jagged piers and smoggy

55. **Charles Sheeler**, *American Landscape*, 1930. The hard-edged, industrial look of O'Keeffe's East River panoramas finds visual parallels in Sheeler's contemporaneous factory paintings where belching smokestacks also punctuate the sky.

cloud-covered spires and factory smokestacks of Long Island City, an industrial section of Queens. Noticeably absent are the bright colors and the sense of organic growth that enlivened her nature-inspired work. As always, O'Keeffe's vision was selective and judiciously edited when necessary. Photographs taken by Stieglitz in the 1920s from the Shelton Hotel show that the view from the apartment extended further north past the Queensboro Bridge and west over midtown Manhattan (the view that Stieglitz preferred to photograph).

Of the eight *East River* pictures, six are relatively small and narrow (about 12 x 32 inches). Although each can stand alone as a complete composition, they are also preliminary studies for the two considerably larger and more finished canvases O'Keeffe painted between 1927 and 1928. Both *East River No. 1* (1927-28) and *East River from the 30th Story of the Shelton Hotel* (1928) greatly expand the subject into squarer formats – the former orientated vertically to encompass a great deal of sky, the latter horizontally to include a greater number of buildings in detail.

As final statements of this theme, they both conveyed negative feelings about the city, but in very different ways. *East River No. 1* is a dreamlike vision of surrealistic apocalypse with smoldering sun, choking smog and blood red water. It is wrought with emotional turmoil and ominous premonitions that recall the feelings engendered by Stieglitz's earlier photographs of the river and city, titled *City of Ambition* and *The City across the River* (both 1910). *East River from the 30th Story of the Shelton Hotel*, on the other hand, depicts the lifeless details of the sprawling metropolis with emotional coldness. Executed in a hard-edged Precisionist style (even the industrial nature of this view is akin to Sheeler's factory subjects), the particulars of the setting are brought into sharp focus by the clarity of light and O'Keeffe's straightforward reporting. In both paintings it is as if the artist had finally come to terms with being in New York and decided that she did not like it.

As the relationship between O'Keeffe and Stieglitz became troubled and the strains of living and working in a big city took their toll on her physical and emotional health, she came to feel oppressed by the city views that had once excited her. Her last New York picture, for the moment, was a rather uninteresting skyscraper painting of the Beverly Hotel, *New York, Night* (1928-29), which was completed in 1929, the year she began to make extended trips away from New York City, the sameness of Lake George, and Stieglitz.

Chapter 5: Abstractions and Transitions

56. *Wave, Night*, 1928. Although based on a nocturnal marinescape that the artist saw in Maine – wave, shore, and distant beacon – the pared down composition is one of the most abstract in O'Keeffe's oeuvre.

The mid-1920s to early 1930s was a period of emotional turmoil for O'Keeffe, and also a time of artistic experimentation. During these years she began to extricate herself from Stieglitz's daily schedule and to travel on her own in search of new visual stimulation, and to recuperate from a variety of mental and physical maladies. She made several short trips without Stieglitz to places such as Maine, Canada, and Wisconsin. Even before her trips West began in 1929, O'Keeffe had found temporary refuge at the home of her friends Bennet and Marnie Schauffler in York Beach, Maine, a popular summer community that boasted an amusement park. Since 1920, whenever physical illness or the stresses of annual exhibitions and her daily life in New York became too

much to handle, she stayed there for a few days or several weeks. Occasionally, Stieglitz joined her, but most often she went for solitude and rest, and the ocean view. Like many other American artists of the 19th and 20th centuries who vacationed in Maine, including her good friend John Marin who had a home there, O'Keeffe found the water inspiring. Having always lived in landlocked rural areas, or in big cities, however, she must have been as overwhelmed by the enormous power and vastness of the Atlantic Ocean as she was exhilarated. Perhaps this was the reason she did not attempt her first ocean views until 1922, and then in pastel.

By the spring of 1928, however, her familiarity with the area, coupled with a renewed interest in abstraction, resulted in one of her most starkly simple, yet evocative canvases, *Wave, Night*. In it she captured the enormity of her experience with solemn reverence, allowing the endless blackness of the ocean to shroud the entire composition in mystery. Only the bright white spot of light in the distance and the foamy spray of water at the shoreline indicate any sense of spatial recession. Many years after painting this

56

picture, O'Keeffe still vividly recalled the awe she felt: "I loved running down the board walk to the ocean – watching the waves come in, spreading over the hard wet beach – the lighthouse steadily bright far over the waves in the evening when it was almost dark. This was one of the great events of the day." Unlike Marin's pictures of Maine (executed mainly in watercolor), which depicted specific places and moments in time (e.g., *Deer Isle*, 1926, Whitney Museum of American Art; and *Small Point, Maine*, 1928, Metropolitan Museum of Art), O'Keeffe's paintings of Maine, particularly *Wave, Night*, are timeless and iconic.

Besides several seascapes, she also created a number of still-life arrangements with the shells, seaweed, and driftwood that she collected during long walks on the beach. These made interesting subjects for her oil paintings and pastel drawings, executed in Maine or when she returned to New York with her souvenirs. Her seven *Shell and Old Shingle* compositions, for example, were painted at Lake George in 1926, with objects from both places. In this series of variously sized canvases (ranging from 9 x7 inches to 21 x 32 inches) she studied the possibilities offered by pairing a weathered plank of wood (from one of the Lake George barns) with a white clamshell, and sometimes a green leaf. The objects are depicted in extreme close-up and from far away, realistically and abstractly, in sharp focus and soft, and in varied tones of color from cool, bluish grays and whites to deep blacks and pale pinks and purples. The emotions evoked by these works differed as much as their compositional arrangements. The last of the *Shell and Old Shingle* paintings, and also the largest, began as a horizontal Lake George landscape. But when the artist realized that she had made "a misty landscape of the mountain across the lake, and the mountain became the shape of the shingle – the mountain I saw out my window, the shingle on the table in my room," she made this work part of the series, too.

In eleven other compositions created between 1926 and 1930 O'Keeffe focused on single shells mainly in small, realistic studies that represented the individual shapes and colors of different types of shells. Two of these works, however, are large canvases that magnify the interior of a clamshell, precisely detailing every indentation, undulation, ridge, and color modulation. Although the actual subject of these 1930 paintings is in no way obscured, her careful rendering of the clam shell topography enables us to read this image as a landscape as well. Such multiple associations, as happened with the *Last of Shell & Shingle Series*, find parallels in Weston's series of close-up photographs of stones, e. g. *Eroded Rock, Point Lobos*, 1930.

Overleaf:
58.. *Shell and Old Shingle II*, 1926.
59. *Shell and Old Shingle VII*, 1926.
60. *Clam Shell*, 1930.
As an avid collector of rocks, shells, and other natural debris, O'Keeffe often displayed these materials in her homes and they became the subjects of her paintings. Viewed in extreme close-up their lines and forms often wound up looking like landscapes, although that was not her intention. Only after she completed her last shell and old shingle painting (cf. ill. 59) did she realize that it resembled a Lake George scene.

59

Among the other subjects she recorded from her travels were the austere barns and crucifixes that she saw in Canada. From a trip to the Gaspé Peninsula in August 1932, suggested by Strand's own travels there, she painted a large series of barns (seven or eight in all), and simple wooden crucifixes that symbolized the hard lives of the region's farmers and fishermen. Unlike her Lake George barns, these Canadian structures were stark in color and design, and precisely delineated with an iconic presence that implied significance far beyond their utilitarian purpose. Such buildings resembled the barns in Bucks County, PA, that Sheeler had drawn, painted, and photographed fifteen years earlier, and exhibited at de Zayas's Modern Gallery in 1920 (e.g., *Barn Abstraction*, 1917). Like Sheeler, she distilled the essential geometric shape from each architectural element in such works as *White Canadian Barn II*, although she also eliminated the textured patterns of the barns' surfaces that were part of his imagery. For Henry McBride, who wrote about this series when it was exhibited in 1933, there was "exquisite precision with which these barns are placed upon the canvas….the artist seems to stand aside and let the barn [apply power] all by itself. That is why I say the best O'Keeffe's seem wished upon the canvas – the mechanics have been so successfully concealed."

The narrow, horizontal format of *White Canadian Barn II* typifies her larger Canadian pictures – the largest is 16 x 40 inches (two others are much smaller, measuring about 9 x 12 inches each). As in other paintings of the period – e.g., the *Corn, Dark* series, which used an extremely narrow, vertical canvas – she allowed the subject matter to determine the appropriate proportions of the composition. Here, in the barn series, the elongated canvases echo the flat rectangular forms of the barn roof and walls. The picture space is divided into three distinct areas denoting sky, building, and ground. Similarly, in one of Stieglitz's earlier 1923 photographs from Lake George, he also simplified and flattened the roof, wall, and foundation of a barn into three horizontal strips of unequal width.

In O'Keeffe's Canadian barns three-dimensional form and depth are almost completely negated by the strictly frontal presentation of the buildings. The somber coloring and massive size of the barns, however, indicate a tangible and weighty presence. Impenetrable vertical doorways, painted black, gray, or red anchor the horizontal movement of the composition. Similarly, Strand had immortalized a series of black rectangular recesses on the side of a city building (albeit set on a steep diagonal) in his

famous photograph, *Wall Street*, of 1915. The emotional detachment associated with such imagery speaks to issues of societal and personal alienation. Interestingly, twenty years later, when O'Keeffe was in a better frame of mind, she reprised the motif of the darkened doors, now set free from their architectural surrounds, in her highly celebrated patio paintings of the 1950s.

During the same period (1926-30) when she was painting numerous landscapes, floral studies, and cityscapes, she also created several highly reductive abstractions that often have an architectural quality about them. Her ability to switch easily between seemingly contradictory approaches was explained by the artist later in life:

It was surprising to me to see how many people separate the objective from the abstract. Objective painting is not good painting unless it is good in the abstract sense. A hill or tree cannot make a good painting just because it is a hill or a tree. It is lines and colors put together so that they say something. For me that is the very basis of painting. The abstraction is often the most definite form for the intangible thing in myself that I can only clarify in paint.

Previously, her 1919 abstractions and her 1925 designs (used to illustrate advertising posters for Cheney Silks) were perceived as sculpturally modeled forms. Here however, in her abstract paintings and drawings of 1926-30, the picture space was flat and two-dimensional, divided in half either vertically or horizontally, and prominently featuring the elements of point-and-line. Descriptive titles, when there were any, provided the only clue about possible subject matter. In O'Keeffe's severely reductive composition *New York – Night* (1926), for example, point-and-line represented the converging city streets, while in her more recognizable seascape *Wave, Night* (1928), the same two elements had described a distant lighthouse beacon and a wave against the shoreline. 56

In *Black Abstraction* (1927), one of O'Keeffe's most abstract statements, point, line, and shading are the only elements in this mysterious composition. As before in her early charcoal drawings, a black-and-white color scheme allowed her to concentrate on the graphic structure of the composition as a means for expressing emotions. This time, however, the imagery was based more on the artist's visualization of an experience than on observed reality. The picture was inspired by the first of two surgeries the artist underwent in 1927 to remove benign cysts from her breasts. She recalled that while trying to forestall the inevitable effects of anesthesia, she reached up to a bright light overhead that seemed 64

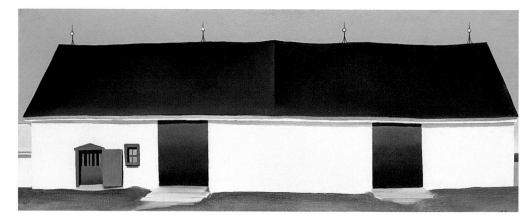

61. *White Canadian Barn II*,
1932. The austere Canadian
barn series was inspired by a
summer trip to the rugged Gaspé
Peninsula in 1932. With their
dark, impenetrable doors they
predate O'Keeffe's patio door
series by some 15 years.

to whirl and become increasingly smaller. The painting conveys the nebulous sense of floating in space as she moved from alertness to unconsciousness. Three dark, concentric rings swell to the edges of the canvas, and in front of these a graceful white V suggests her extended arms. At its vertex, a small white spot represents the disappearing light. With its severely limited palette of black, white, and gray, *Black Abstraction* projects a tense and ominous mood that echoed the artist's own trepidation.

That same year, O'Keeffe used a similar black, white, and gray palette in a pair of *White Rose* floral paintings. Unlike the cold austerity of *Black Abstraction*, however, these nature-inspired reveries are luxuriously sensual visions that draw the viewer into their swirling, light-filled spaces, although there remains in them a similar sense of loss and longing. The imagery of *Black Abstraction*, and the experience that inspired it, remained with her for a number of years and manifested itself in several later variations on the theme.

Her 1930 versions – *Black and White* (1930) and its only slightly more colorful companion, *Black White, and Blue* (1930) – were painted after her many city scenes, and as a result were decidedly

62. **Charles Sheeler**, *Barn Abstraction*, 1917. Sheeler's reductive drawings of barns from c. 1917 are one precedent for O'Keeffe's later Canadian structures.

63

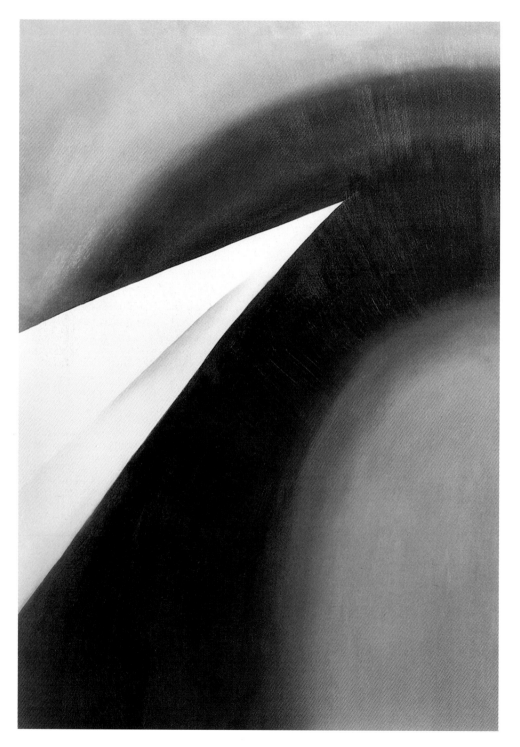

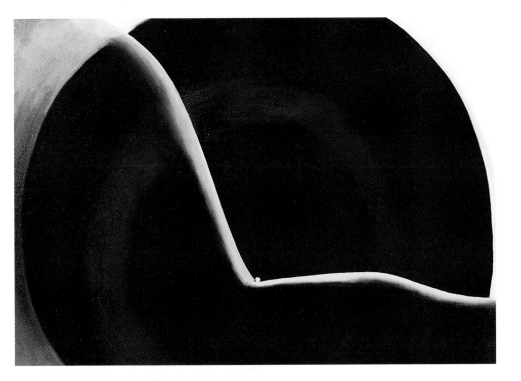

63. *Black and White*, 1930.
64. *Black Abstraction*, 1927.
Between 1927 and 1930
O'Keeffe produced a series of
highly abstract, black-and-white
paintings that conveyed the
sensation of moving off into deep
space. For the 1930 versions, she
inserted a white diagonal triangle
that was appropriated from a
photograph by Edward Weston.

65. **Edward Weston**: *The Ascent
of Attic Angles*, c. 1921.

more architectonic than the earlier ones. Their clinical precision, disconnected from nature and devoid of human feeling, may again relate to her own emotional disconnection at this time and her recent resolve to move on with her own life in New Mexico. Together with *Black Abstraction* these works illustrate the fascinating process through which the artist developed forms and themes within series. The sweeping black arc in the background of these two 1930 works comes directly from the concentric rings in *Black Abstraction*, now reduced to a small detail. Over this arc a new element has been added – a sharply pointed white triangle tipped on a diagonal – that seems to quote directly from Weston's black-and-white photograph, *The Ascent of the Attic Angles* (1921). O'Keeffe knew Weston's work through his meetings and correspondence with Stieglitz. And although she never acknowledged this particular source for her black pictures, the shape and axis of her painted white triangle so closely matches the ceiling angle in Weston's photograph that it is inconceivable that his photograph was not the basis for her paintings.

65

About *Black and White*, however, she said only that it was "a message for a friend – if he saw it he didn't know it was for him and wouldn't know what it said. And neither did I." Quite possibly that friend was Weston, who in October 1930 (the same year as O'Keeffe's last two black paintings) had an exhibition in New York at Alma Reed's gallery, Delphic Studios. Seeing his work again may have triggered a connection in O'Keeffe's mind between his work and life, and her own. Like O'Keeffe, Weston had recently resolved to change his circumstances when he left his wife and children to live with another woman (the photographer, Tina Modotti).

That year O'Keeffe also created one of her most extraordinary series of flower paintings. In early March 1930 she completed six *Jack-in-the-Pulpit* pictures that marked the culmination of her early obsession with floral subjects, and bridged her transition to a new phase of life and work. Even as she successfully explored other subjects during the first part of her career, flowers, more than any other subject, remained dominant in her imagination and were the *raison d'être* for her enduring reputation. Throughout her life she saw visual metaphors in flowers that continued to intrigue her, and even after she was no longer able to paint, she often requested her nurse to read a particular passage from Kakuzo Okakura's book, *The Book of Tea*, saying "turn to the pages about flowers.... You know, he says that a butterfly is a flower with wings."

According to O'Keeffe, the first flower she ever scrutinized carefully was a jack-in-the-pulpit. Her high school art teacher had pointed out

...the strange shapes and variations in color – from the deep, almost black earthy violet through all the greens, from the pale whitish green in the flower through the heavy green of the leaves. She held up the purplish hood and showed us the Jack inside. I had seen many Jacks before, but this was the first time I remember examining a flower...she started me looking at things – looking very carefully at details. It was certainly the first time my attention was called to the outline and color of any growing thing with the idea of drawing or painting it.

Years after this inspirational lesson, O'Keeffe immortalized the jack-in-the-pulpit blossom in a series of striking paintings from 1930. They employed the range of her virtuosity to represent the hidden and obvious aspects of that flower. Boldly majestic in their presentations, her painting styles varied from detailed realism to near abstraction. Looking back to early drawings and paintings, they recycled motifs and color schemes developed in the 1910s and '20s. The bulbous shapes and sweeping lines of *Jack-in-the-Pulpit, No. 4*, for example, recalled similar elements in her 1915 charcoal *Drawing XIII*, while the green and purple color scheme of *Nos. 1, 2, 3, and 5* related to the unusual palette of her *Corn, Dark* series. While these works looked back, two others in the series, *Nos. 4* and *6*, summarized her recent explorations into reductive abstraction (as exemplified by the black series). Paring down the small trumpet-shaped blossom to its most essential forms, the artist isolates the jack's dark center and its white striations from the rest of the flower and shows it alone in a startling distillation.

6

41

Overleaf:
66. *Jack-in-the-Pulpit, No. 3,*
67. *Jack-in-the-Pulpit, No. 4,*
1930. These two extraordinary paintings from the six-canvas *Jack-in-the-Pulpit* series mark the culmination of the floral subjects that dominated the first part of her career.

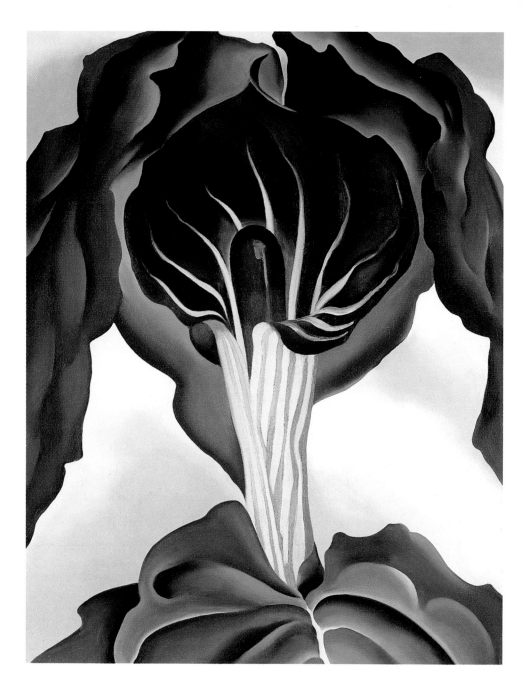

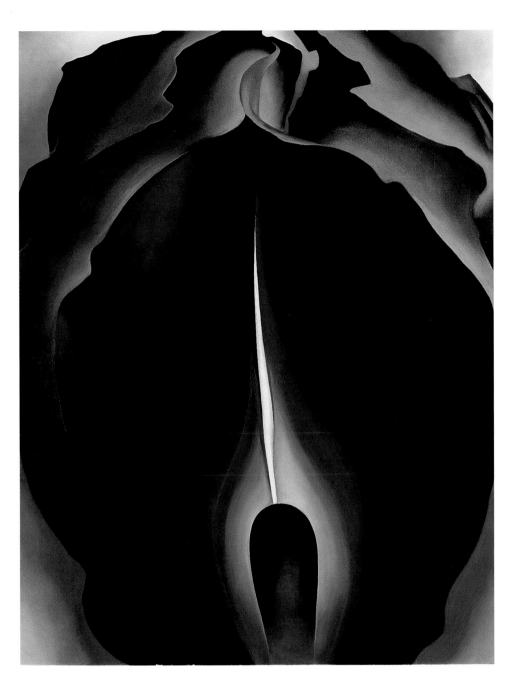

Chapter 6: From New York to New Mexico

Georgia O'Keeffe

68. **Miguel Covarrubias**, *O'Keeffe as a Calla Lily*. The Mexican artist was a guest at Mabel Dodge Luhan's Taos home in 1929 when O'Keeffe was also in residence. His caricature of the artist as a calla lily appeared in *The New Yorker* magazine that summer.

69. *Georgia O'Keeffe near "The Pink House," Taos, NM*, 1929. From her first visit in 1929 O'Keeffe felt at home in New Mexico. Her pleasure is evident in this photograph taken on the Luhans' Taos ranch, which was a center for many modern artists, writers, and photographers of the day.

While the Canadian barns, like her New York City skyscrapers and Maine ocean views before them, were some of her most memorable images, they represented only a brief experimental interlude that ultimately proved to be of limited consequence. Of more profound and lasting effect was her extended stay from April to August 1929 in New Mexico. When she made this first trip (by train, in the company of artist-friend Rebecca Strand, wife of Paul Strand), she was 41 years old and well established as an artist. Over the next twenty years, she traveled almost every year to New Mexico, working there for up to six months at a time in relative solitude (although she continued to have visitors from her wide circle of acquaintances). She stayed in various locales – Taos, Alcalde, Ghost Ranch, and Abiquiu (in the last two she owned houses) – then returned to New York each winter, ready to exhibit her paintings at Stieglitz's gallery. This pattern continued until 1949, three years after Stieglitz's death, when she moved permanently to New Mexico.

Prior to 1929 her trips away from Stieglitz had been of short duration. This, however, was their first lengthy separation, and one that made a decisive statement not only about their failing relationship, but also about the priority she was placing on her artistic pursuits. Her decision to go was motivated by her growing feeling of confinement in New York and Lake George, and was probably prompted by Paul Strand's enthusiasm for the region. After her annual exhibition at The Intimate Gallery (February-March 1929) received cool reviews and generated few sales, she resolved to visit socialite-author-art patron Mabel Dodge Luhan (1879-1962) at her Taos home, despite Stieglitz's objections.

Mabel Dodge had been hostess to a wide circle of modern artists, writers, and political thinkers, first in Europe (where she knew Gertrude and Leo Stein), and then in her New York home in Greenwich Village (1912-17). She was part of the counterculture, and encouraged radical thinking, creative pursuits of all types, and sexual experimentation. When she moved to New Mexico in 1917 and married her fourth husband Tony Luhan, a Native American, she created another salon where visiting

American and European modernists mixed with local artists and artisans. In an old renovated house high in the hills, they had rooms for more than a dozen guests. In 1929, when O'Keeffe was staying at the Luhans' she was in the company of art historian Daniel Catton Rich (who, as director of the Art Institute of Chicago organized her first museum retrospective there in 1943), photographer Ansel Adams, and artists John Marin and Miguel Covarrubias, a Mexican who drew a caricature of her as a calla lily (published in *The New Yorker*, July 6, 1929, in an article by Robert M. Coates, "Profiles: Abstractions – Flowers").

At first, she reveled in the new environment. She stayed in a separate building on the Luhans' Taos property known as the Pink House: "…the most beautiful adobe studio…Out the very large window to a rich green alfalfa field – then the sage brush and beyond – a most perfect mountain – it makes me feel like flying…" She noted that she never felt "…at home in the East like I do out here – and finally feeling in the right place again – I feel like myself – and I like it…" She learned to drive and purchased a Ford automobile, which allowed her to explore the area with greater freedom. In June, for example, she camped on the Taos Reservation (at Bear Lake) and took a 10-day trip to Mesa Verde. A letter written at the end of her 1929 sojourn confirmed her initial instincts to go to New Mexico: "When I saw my exhibition last year I knew I must get back to some of my own ways or quit – it was mostly all dead for me – Maybe painting will not come out of this – I don't know – but at any rate I feel alive – and that is something I enjoy." Yet, as one might suspect, the constant socializing at the Luhans' ultimately did not afford her the solitude and privacy she needed in order to paint. She spent only two seasons there before venturing away from Taos, a thriving artist colony since the 1880s, and moved on to more undeveloped parts of the state.

The move West provided many benefits to O'Keeffe's art and general well being, but it did not happen without conflict. In 1932, after several years of moving between New York and New Mexico for extended periods, she wrote to a friend: "I am divided between my man and a life with him – and something of the outdoors… – that is in my blood – and that I know I will never get rid of – I have to get along with my divided self the best way I can –." It was a situation she was willing to endure for twenty years so that her art could flourish.

The time she spent painting alone in the unspoiled New Mexico wilderness during the 1930s and 1940s proved to be

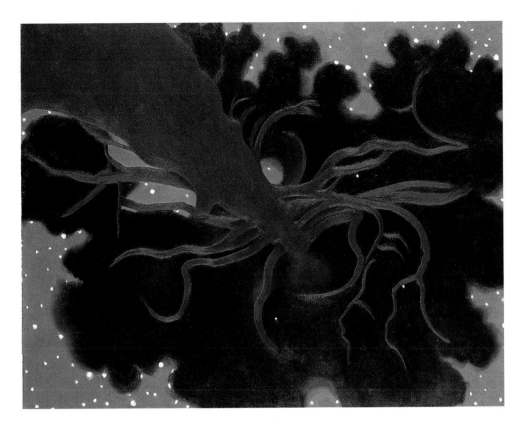

70. *D.H. Lawrence Pine Tree*,
1929. The unexpected angle
simulates the view when looking
up at a tree from a prone position.
The intense color harmonies and
inventive composition speak
volumes about the artist's sense
of artistic and personal freedoms
during her extended stays in
New Mexico.

O'Keeffe's most fertile period. Other artists from the Stieglitz group were also attracted to New Mexico: Marsden Hartley, in 1918 and 1919; John Marin, in 1929 and 1930; and Paul Strand, in 1926 and 1930-32. None stayed as long as O'Keeffe, however, nor did any of them capture the understated magnificence of the area as she did. While the abundance of visual stimuli prompted her to focus selectively on particular aspects of the scenery, it seemed to overwhelm the other artists, who tried to incorporate too much in each picture. Their paintings ended up chaotic and unfocused, at once aloofly panoramic and overly detailed. Hartley, in particular, could only approach O'Keeffe's clear vision and sense of immediacy when he recreated some scenes from memory five years after his New Mexico trip (e. g. *Cemetery, New Mexico*, 1924).

One of the first paintings she made in New Mexico expressed the wonder she felt at being in this part of the world. It is a fanciful composition based on a ponderosa pine tree that was in the front yard of D. H. Lawrence's home in Taos; during his fifteen-month residency there, Lawrence wrote under this tree. Mabel Dodge Luhan, Lawrence's patron gave him the 160-acre ranch, located near her own property, and in return he gave her the original manuscript of *Sons and Lovers*. O'Keeffe's rendering of the Lawrence tree is observed from an unexpectedly imaginative perspective (which has led to debate about the canvas's proper orientation on the wall). According to the artist's own words, the tree is intended to appear as it would at night if "you lie under it on the table – with stars – it looks as tho it is standing on its head." Sensuous and mysterious, it floats untethered to the ground, spilling its heavily laden branches across the speckled sky – a metaphor for her feelings of artistic rebirth. Seen as if in a dream, the unusual color scheme (deep purplish maroon, velvety black, and vibrant blue and white) enhances the surreal quality of the painting. Although she periodically returned to the theme of trees after 1929, and continued to do so with regularity in the 1940s and 1950s when she moved to New Mexico permanently, none of these subsequent pictures had the intensity or magic of her *D. H. Lawrence Pine Tree*. 70

On successive visits to Taos in 1929 and 1930, O'Keeffe documented more of her immediate reactions to the area in two groups of paintings based on the impressive façade of the Saint Francis of Assisi Mission. In a total of six paintings (plus several small preliminary pencil sketches), she reproduced the shape and texture of this eighteenth-century adobe church on the village square of Ranchos de Taos. Located just a few miles south of Taos

and the Luhan home, Ranchos Church, as it was known, was an obvious target for her interest. With the exception of one painting depicting the front of the church with its gate, bell towers and white crosses, the five other canvases address the large and imposing back view of the structure, where the massive form of the church is sculpted by unusual buttresses. It was, in fact, this view that was visible from the main road leading from Taos to Santa Fe, just as it is today.

O'Keeffe's first interpretations – exemplified by *Ranchos Church, Taos* (1929) – emphasized the church's bulging, sculptural masses and its undulating, irregular walls. Deep shadows enhanced the three-dimensional quality of the image. The building's placement in the space, vis-à-vis the sky, made a correlation between this man-made wonder and the natural mountains of the region. The juxtaposition of church and sky was specifically addressed in a relatively small painting of 1929, *Ranchos Church, No. 3*, that zooms in on that juncture between solid wall and vaporous sky, demarcated by the sharp edges of the roof line.

The following year, in her painting *Ranchos Church* of 1930, the building is no longer distinct from the setting, but rather united with its surroundings by similarities in color, tone, and texture, and by the elimination of harsh outlines. Church and earth meld into one form that appears more geological than architectural. Correspondences are drawn between the irregular shapes of the building and the radiating cloud formations. The sense of harmony conveyed in this work may indicate O'Keeffe's own growing sense of belonging to this new environment during her second trip to New Mexico.

In 1931, two years after she initiated the *Ranchos Church* series, Paul Strand photographed the site from an almost identical perspective (*Church, Ranchos de Taos, New Mexico, 1931*). His black-and-white image reveals the accuracy of O'Keeffe's representation of the architectural structure, as well as some instances of her selective vision. In her paintings the actual proportions of the building were altered slightly to emphasize its horizontal mass. Small architectural details and textural elements (cracks and irregularities in the surface) were also completely deleted, save for the suggestion of the adobe surface in the rough, grainy texture of the paint.

Related to the Ranchos Church paintings in terms of their religious imagery were the four canvases and one drawing she produced in 1929 depicting the Penitente crosses that dot the New Mexico landscape, a subject that also appeared in Rebecca

71

72

73

74

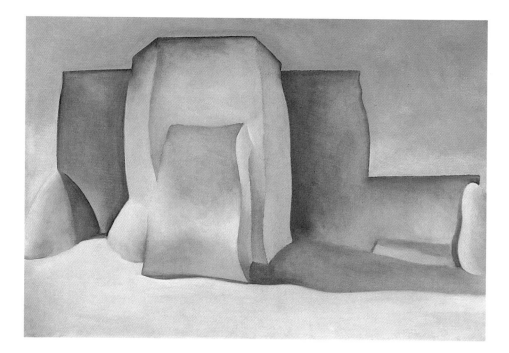

71. *Ranchos Church, Taos*, 1929
72. *Ranchos Church*, 1930.
Among the earliest New Mexico-
derived subjects to attract
O'Keeffe's attention was the
buttressed adobe church in the
small town of Ranchos de Taos.
Her interpretation of it changed
over a short time from strictly
recording its unusual shape to
making it seem like part of the
natural landscape

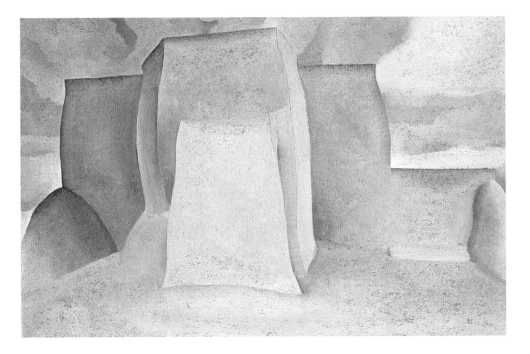

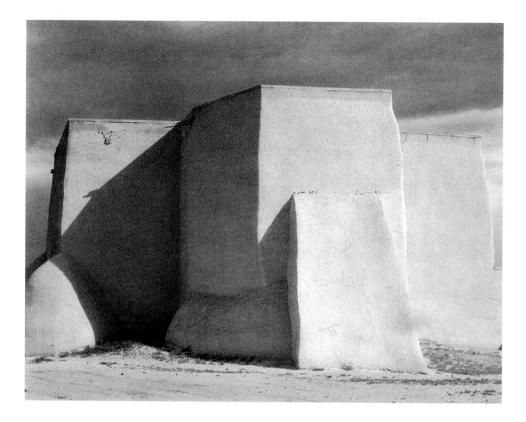

73. **Paul Strand**, *Church, Ranchos de Taos, New Mexico*, 1931. Two years after O'Keeffe began to paint the Ranchos Church series, Paul Strand photographed the same site. His picture reveals the accuracy of her vision, as well as the instances where she took artistic liberty to eliminate small architectural details or distracting cracks.

Strand's work from the same trip. These were among the first Southwestern motifs to be incorporated into her standard repertoire of images. *Black Cross, New Mexico* is the best of this genre, and one of the artist's most dramatic masterworks – combining exquisite painting techniques with exceptional structure and intense color. Here, the massive, dark form of the cross is pushed to the very foreground of the painting, making it seem particularly large and imposing. Within its dense blackness, four maroon-colored circles – either wooden plugs or sunspots – are almost invisible. Behind it, an endless succession of rolling hills recedes into the fiery red and yellow horizon that underlines the horizontal beam of the cross. And at top, a small strip of sky with a single yellow star in it glows brightly, providing dramatic backlighting for the Penitente cross. It is a somber and monumental sight, yet incredibly beautiful and awe-inspiring. The Penitentes, a lay religious society (originally developed in northern New Mexico and southern Colorado in the late 18th century) practiced flagellation and mock crucifixions. To O'Keeffe, their

crosses symbolized "a thin dark veil of the Catholic Church" that blanketed the Southwest, both literally and figuratively, but it was also, she said, "a way of painting the country."

More literally, she painted the country again and again in the many landscapes she completed over the next fifty years. The mountains of New Mexico, viewed both in detail and in full breadth, remained the inspiration for much of her subsequent work. The majestic terrain, with its varied geological formations, wide range of exotic colors, intense clarity of light, and unusual vegetation, provided O'Keeffe with a rich source from which she expanded her already extensive visual vocabulary. Color, which had always been a potent form of expression in her work, became even more intense as she amplified the natural colors found in the Southwestern environment.

Mountains were a new and powerful subject that readily adapted to her style of combined representation and abstraction. The sculptural qualities inherent in these formations led her in a new direction, toward more three-dimensional space and form. Their contours were a realization in nature of the purely abstract forms that she had previously only imagined in some of her earliest abstractions (e. g., *Drawing XIII*, 1915). The breathtaking simplicity of enormous mountain ranges silhouetted against an expansive sky and the sculpted quality of rolling hills creased and furrowed by centuries of erosion caused her to return to these forms again and again in her art.

O'Keeffe painted a few landscapes during her first trip to Taos in 1929, and their numbers increased significantly during and after her 1930 visit. The extraordinary light in New Mexico enabled her to see sharply over great distances as if endowed with telescopic vision. Clarity and brightness also emphasized the sculptural qualities of the natural formations and often silhouetted their distinctive contours against large backdrops of blue sky. Initially, however, it must have been daunting to capture the magnificence of the landscape in paint, and her first trials were relatively small compositions depicting the low gray sand hills around Alcalde, rather than the huge mountain ranges. In these works, a single hill fills almost the entire space of the picture, without making reference to the surrounding environment. The viewer is thereby given an impression of enormous size, when in fact the reality is just the opposite, a device similar to the one she used in her magnified flower paintings.

Making the small seem large was easy for O'Keeffe. What proved more challenging was finding a way to convey the

Overleaf:
74. *Black Cross, New Mexico*, 1929. The imposing presence of the black cross in the landscape was analogous to the controlling power of the Catholic Church in the southwestern part of the United States.

75. *Black Mesa Landscape, New Mexico/Out Back of Marie's II*, 1930.
76. *The Mountain, New Mexico*, 1930-31.
To capture the enormity of the New Mexico landscape O'Keeffe took two different tacks. One was to compress the receding space into a series of stacked layers; the other was to magnify a small section of the landscape to fill up the entire composition.

6

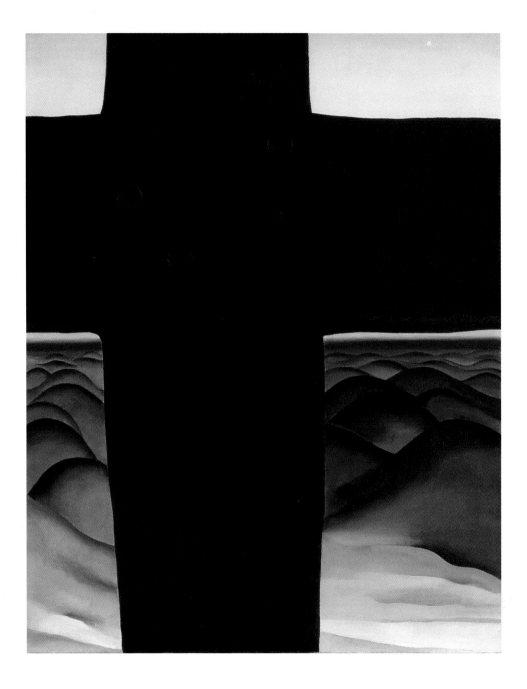

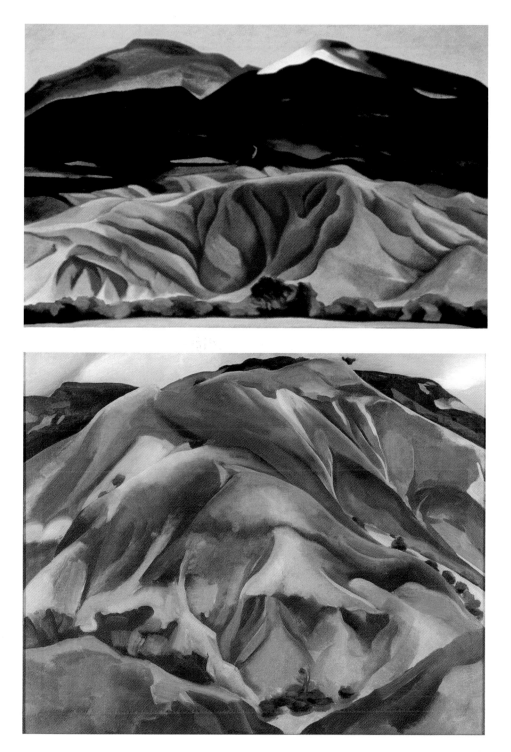

expansiveness of the Western sky and the enormity of the mountain ranges in an easel-size canvas. These were issues that she had not had to address in her paintings of Lake George, where the terrain was quite different. Not until her second visit to New Mexico in 1930 did she attempt to render the geography more panoramically. Again, her first attempts were small in actual size, but progressively, as she became more familiar with the subject, her canvas sizes increased, and she devised new methods for recording such vast spaces.

Black Mesa Landscape, New Mexico/Out Back of Marie's II ⁷⁵(1930), for example, is a fairly large painting for the period, that depicted a vista extending far and wide into the distance. Rather than using traditional perspective to render the distance, however, she compressed and flattened the landscape into a succession of horizontal bands that move the viewer's eye through the composition by virtue of their color changes from light to dark. Instead of receding into deep space, the layers appear stacked on top of one another. O'Keeffe's detailed modeling of the red hills in the foreground, versus the flat color planes that denote the mountains in the midground and background areas, also made the red hills appear to advance. Such emphasis on the red hills was not just a compositional device to bring our attention to the foreground, but also conveyed the artist's first-hand experiences of being in that setting. As she noted: "It was the shapes of the hills there that fascinated me. The reddish sand hills with the dark mesas behind them. It seemed as though no matter how far you walked you could never get into those dark hills, although I walked great distances." In this painting the artist's amazement at not being able to traverse further into this vast terrain is given visual form.

In 1930-31, O'Keeffe produced a pair of large paintings (30 x 36 inches) that dramatically magnify one section of the red hills in extreme close-up (*Red Hills Beyond Abiquiu* and *The Mountain, New Mexico*). Here, the artist's position has shifted from ⁷⁶being a distant observer to actually standing within the hills. She seems to look up, and even these relatively small hills fill her entire view. The ground has dropped away, and only a sliver of sky is visible above the rock. By concentrating on a small section of the landscape, O'Keeffe has better conveyed the scale of the entire place. Paired with *Black Mesa Landscape, New Mexico/Out Back of Marie's II*, these paintings illustrate the two very different approaches she used to convey size and scale in her New Mexico works. In both instances her approach challenged artistic conventions for landscape painting and the viewer's own perception of reality.

Magnifying a subject and painting it in extreme close-up was the method she had devised earlier for her flower paintings back East, and it continued to serve as her approach to flower painting in New Mexico. Floral subjects remained a relatively frequent theme in O'Keeffe's oeuvre through the 1930s (totaling more than sixty finished paintings and pastels), but appeared only sporadically in her subsequent work of the 1940s and 1950s (when she completed just twenty-five floral pictures in total). What she added to her repertoire were the native plants of the region – Indian paintbrush, jimson weed, and evening primrose.

Among the first flower paintings produced in Taos were a striking pair titled *Black Hollyhock with Blue Larkspur* (1929 and 1930). In them she captured the delicate textures and dramatic coloring of the flowers that lined the path outside the Luhan guesthouse. What set them apart from her previous floral series were their differing orientations: one vertical, the other horizontal. Although the relationship between the floral elements was identical in each painting – a large red-black hollyhock dominates a group of smaller-petaled blue larkspur – the overall effect differed according to the direction of the canvas. In the vertical composition, for example, the hollyhock swelled into the upper two-thirds of the canvas, encroaching on the delicate blue larkspur below. In the other one, the space was divided almost evenly, although the hollyhock remained dominant by virtue of its massive size and dark coloring. In both, she skillfully balanced the contrasts of light and dark, small and large, and delicate and dense masses.

O'Keeffe's later florals more frequently featured local specimens. In 1932 she produced a handsome series of three works that explored three different views of the jimson weed, a beautiful but poisonous flower *(Datura stramonium)* that proliferated in the Southwest. It was an unusual subject for a painting since the plant was an unattractive weed with prickly seedpods that bloomed at night. Only a persistent artist like O'Keeffe had the patience to await its hidden beauty. Years later, she wrote vividly about her attraction to the strange exoticism of this night-bloomer, which grew in her own garden in Abiquiu:

It is a beautiful white trumpet flower with strong veins that hold the flower open and grow longer than the round part of the flower – twisting as they grow off beyond it.... Now when I think of the delicate fragrance of the flowers, I almost feel the coolness and sweetness of the evening.

Overleaf:
77. *Black Hollyhock with Blue Larkspur*, 1929. Even after she began traveling to New Mexico, O'Keeffe continued to paint the flower subjects that had propelled her career in New York. This starkly frontal, centered composition was frequently repeated in her work.

78. *Jimson Weed*, 1932. This is an exquisitely stylized rendering of a Southwestern night-bloomer, the jimson weed, which grew in O'Keeffe's garden.

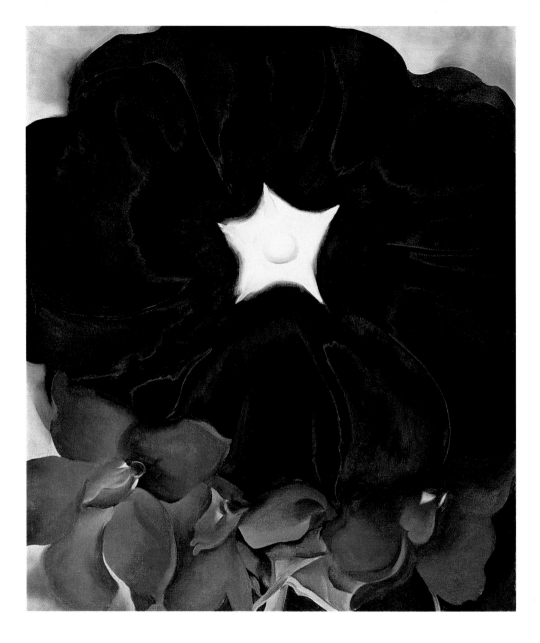

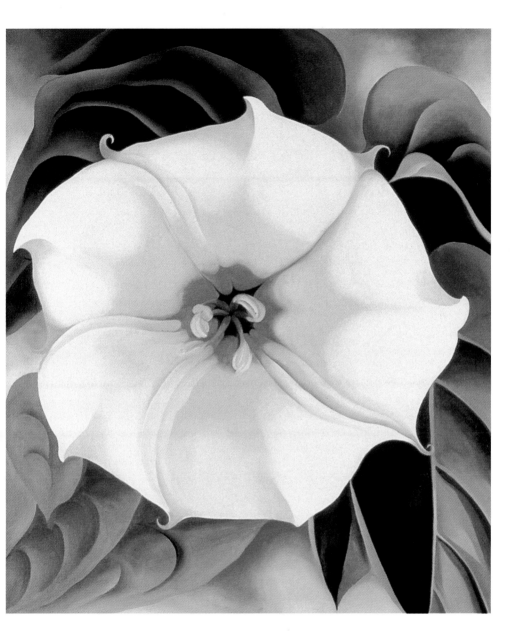

79. *Pineapple Bud*, 1939.
In this year O'Keeffe accepted
a commission from the Dole
Pineapple Company to paint
Hawaiian images for their print
ads. Under pressure from
the company this one and only
pineapple bud was painted after
she returned to New York.

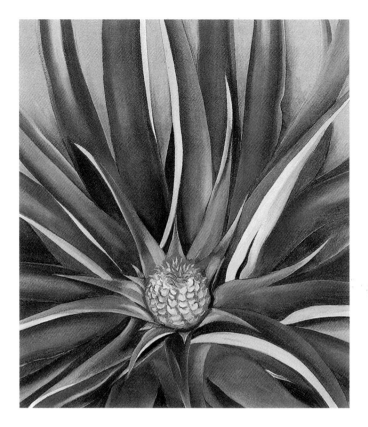

Her painted versions were highly stylized, and relied on the same basic color scheme of translucent white and bluish-greens, with accents of a soft glowing yellow. In each, the edges of the petals were crisply silhouetted against the darker leaves to emphasize their delicate curves and curls.

In 1936 O'Keeffe combined these three separate views of the jimson weed into a single composition, commissioned for the Elizabeth Arden spa in New York, for which she received $10,000. Painted as a moveable mural on canvas, it measured almost 6 feet tall and 7 feet wide, and was up to that point the largest work she had ever completed. Although this composition was by no means a new invention, since it appropriated imagery directly from her previous paintings, it did fulfill her "desire to paint something for a particular place – and paint it *Big*...." The success of the project was especially significant for the artist who had failed to complete a commission from the Radio City Music Hall four years before. Later, in 1939, she again returned to the striking image of the jimson weed (minus the leaves)

for another commissioned work – an etched glass plate design for Steuben Glass.

Also commissioned in 1939 were a number of paintings for the Dole Pineapple Company in Hawaii to be used in magazine advertisements promoting their products. The company had intended her to spend her entire time at their pineapple farm on the big island of Hawaii (from early February to mid-April), but instead O'Keeffe, who did not appreciate being told where or what to paint, traveled to the other islands as well. She turned in nineteen landscapes and floral pictures, but no pineapple subjects. Only at the insistence of the Dole Company did she concede to paint one small pineapple bud, and only after she returned to New York. In general, her paintings during this interlude broke no new ground and were of secondary importance. She did, however, execute several very beautiful flower paintings in Hawaii that followed her already established formula. Especially notable is the large, diaphanous composition titled *Bella Donna* that was created during a two-week stay on Maui. Although it closely echoed the imagery and arrangement of her earlier jimson weed compositions, it displayed none of their stylized rendering or detailing. Instead, she was able to express the tropical sensuality of these lush white blossoms *(Datura candida,* known as angel's trumpets) with amorphous shapes and lines and with softly shaded veils of pale color. While such pictures were exceedingly accomplished, they added nothing new to O'Keeffe's oeuvre.

Chapter 7: Bones:
Skulls and Pelvises

Of immense importance in her New Mexico work are the recurring images of animal bones, which first emerged in the 1930s as potent symbols of the rugged American Southwest. For her, these bones symbolized the eternal beauty of the desert:

To me they are as beautiful as anything I know. To me they are strangely more living than the animals walking around.... The bones seem to cut sharply to the center of something that is keenly alive on the desert even tho' it is vast and empty and untouchable – and knows no kindness with all its beauty.

Over the years she painted from the skulls of horses, cows, steers, elks, and rams that she collected and often displayed on the ledges, roof beams and walls of her homes. After she shipped a barrel full to New York in 1930, she began to portray their sun-bleached surfaces, jagged edges, and irregular openings in numerous guises, either alone or within a landscape setting. In these objects she found a tangible way to develop the theme of solid-and-void that had inspired many of her early abstractions. As so often in her work, this theme evolved even further in the decades that followed.

Some of her first bone compositions in 1930-31 featured a single, isolated skull, floating supernaturally against a solid backdrop. O'Keeffe's small canvas, *Horse's Skull with White Rose* (1931), with a black background, and its same-size companion piece, *Horse's Skull on Blue* (1931), were two of these earliest studies, probably painted at Lake George in the fall of 1931. Tipped forward so that the head stands upright on its teeth, each skull is viewed straight-on, without any indication of its roundness. The position accentuates the skull's elongated shape, which is reiterated by the long narrow canvas. In this unnatural pose, the empty eye sockets seem to hold the viewer with a hollow gaze. Another painting of the same year, *Horse's Skull with Pink Rose*, combined the blue, black, and white palette of the other two, but scrutinized the horse's skull in three-quarter profile. Lying on its blue-white cloth, the head appeared much less commanding despite the painting's significantly larger size, perhaps because its eyes are averted from the viewer.

80. Page from *Life* magazine, February 14, 1938, p. 28, "Georgia O'Keeffe Turns Dead Bones to Live Art," showing the artist collecting and handling animal bones and skulls.

122

GEORGIA O'KEEFFE TURNS DEAD BONES TO LIVE ART

The horse's skull and pink rose pictured in color on the opposite page may strike some people as strangely curious art. Yet because it was painted by Georgia O'Keeffe, whom they consider a master of design and color, American experts, collectors and connoisseurs will vehemently assure the doubters that it is a thing of real beauty and rare worth.

O'Keeffe's magnificent sense of composition and subtle gradations of color on such ordinarily simple subjects as leaves and bones have made her the best-known woman painter in America today. As such she commands her price. At an art sale O'Keeffe's *Horse's Head with Pink Rose* would bring approximately $5,000. A collector once paid $25,000 for a series of five small O'Keeffe lilies. Elizabeth Arden, the beautician, commissioned O'Keeffe to paint a flower piece for $10,000 last year. Art Critic Lewis Mumford has called her "the most original painter in America today." The Whitney Museum, The Museum of Modern Art, the Brooklyn Museum, the Detroit Institute of Arts, the Cleveland Museum of Art, and the Phillips Memorial Gallery in Washington, D. C. are proud to hang her paintings in their permanent collections. The color reproductions on the following pages include several from a portfolio of twelve O'Keeffes which Knight Publishers issued in November at $50 per copy.

Georgia O'Keeffe was born in 1887 in Sun Prairie, Wis. Her father was Irish, her mother Hungarian. She grew up in Virginia, attended art school in Chicago and New York, gave up painting in 1906 to spend the next ten years working for advertising agencies and teaching art. Her first show occurred in New York in 1916. Since then her talent for painting flowers with great sexy involutions and her flair for collecting ordinary objects and turning them into extraordinary compositions have made her famous.

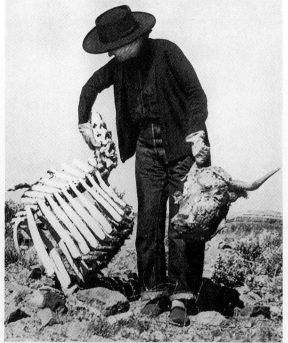

IN NEW MEXICO O'KEEFFE GETS MATERIAL FOR A STILL LIFE BY LUGGING HOME A COW'S SKELETON

As long as there is light, O'Keeffe paints steadily all day. Here she pastes back a piece of the fragile skull which has broken off. Her best friends call her O'Keeffe, not Georgia.

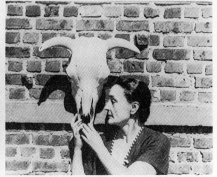

On her penthouse roof in New York O'Keeffe keeps this steer's skull bleached in the sun. She looks upon skulls not in terms of death but in terms of their fine composition.

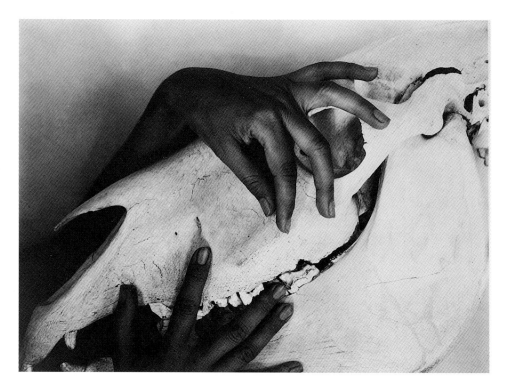

81. **Alfred Stieglitz**, *Georgia
O'Keeffe* (hands and horse skull),
1930. Stieglitz's extensive
photographic portrait of O'Keeffe
included this memorable image
of the artist's hands probing
the cavities of a horse's skull.
Although beautifully composed
and printed, Stieglitz seems to be
commenting on the hardness of
the artist's personality, like the
skull she holds.

Sometimes these ghostly visions were adorned with the fabric flowers that she also collected while in New Mexico. Previously, Rebecca Strand (who often made reverse paintings on glass) did some paintings of calico roses when she was with O'Keeffe in New Mexico in 1929. In 1931 O'Keeffe painted her own striking version, *The White Calico Flower*, in various shades of gray. In composition and coloring it is related to Imogen Cunningham's earlier floral photographs such as *Magnolia Blossom* (1925), although Cunningham's live flower is decidedly more delicate and luminous than O'Keeffe's fake one.

During the period when she was painting the cows' skulls, Stieglitz photographed her with the bones as part of his extended photographic portrait, as if they said something significant about her personality. His exquisite photograph of her hands probing the cavities of a horse's skull makes such a strong visual connection between the artist and the bone that it suggests a reading of the picture that is more symbolic than a simple study of an artist and her subject matter. In general, Stieglitz's portraits of O'Keeffe, taken over the course of twenty years, recorded not only the physical and emotional changes in his model, but also his own altered perception of her and their relationship. This particular photograph seemed to echo O'Keeffe's interpretation of the bones as symbols for the dual nature of the desert, at once magnificent and harsh. Created during a year of marital discord, Stieglitz may have also intended to draw an analogy between O'Keeffe and the bone she touches – both beautiful and unapproachable.

Like Stieglitz, O'Keeffe was able to create compositions of extraordinary simplicity that could be appreciated on many different levels. Among her most famous images from any decade were a pair of monumental skull paintings from 1931 – *Cow's Skull: Red, White and Blue* and *Cow's Skull with Calico Roses*. In both, similar objects are enlarged and elaborated, but with vastly different color schemes, and to very different effects.

The larger *Cow's Skull: Red, White, and Blue*, is an eloquent abstraction of form and line, and a richly symbolic image that raises issues of nationalism and religion. Its compositional arrangement is starkly simple. The skull, isolated from its natural environment, is set off against a creased blue field that could be the sky or a hanging cloth backdrop. In *The Great American Thing* (1999), Wanda Corn has suggested that the background might be the Navajo blanket that wrapped O'Keeffe in four of Stieglitz's photographs from 1930. The skull's strictly frontal placement and precise modeling cause it to become an image of great mystical power, like a sacred relic.

Overleaf:
82. *Cow's Skull: Red, White and Blue*, 1931.
83. *Cow's Skull with Calico Roses*, 1931. Two of O'Keeffe's most famous images are the cow skull paintings she created in 1931 using two very different palettes – one patriotically red, white and blue, the other a symphony of whites. Both celebrated the eternal beauty of the desert.

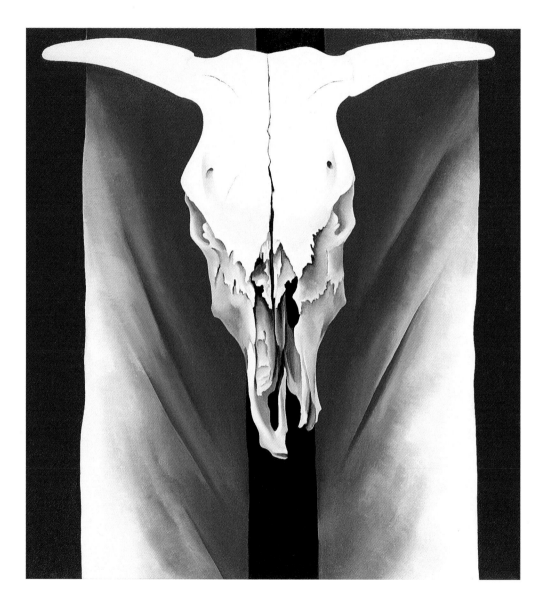

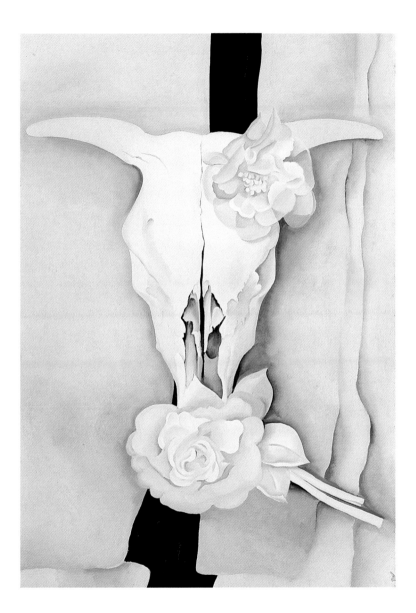

The religious connotation was reinforced by the cross configuration formed by the extended horns and the vertical support (probably the tree or easel upon which the skull was hung). An even more direct association between skull and crucifix was made in O'Keeffe's more minimal painting, *Cow's Skull on Red* (*c.* 1931-36), which used the same head. Only a few years before, O'Keeffe had produced a number of paintings of the actual wooden crosses found in the New Mexico landscape.

Cow's Skull: Red, White, and Blue prominently displays the three colors of the American flag, and its title reinforced this association. In the 1920s and '30s artists, musicians, and writers were all interested in developing an indigenous American art form. For William Carlos Williams (a friend of Demuth's and Sheeler's) in his influential book *In the American Grain* (1925), "there was a source in *America* for everything we think or do." It was up to the artist "to recognize his 'new locality' in order to create an expression based on native form and structure; this he called a sense of place." It was an idea strongly supported by Stieglitz and the artists around him. When Stieglitz opened An American Place, in fact, he wrote to Williams that he had changed the name of the gallery in honor of Williams's book. The Stieglitz circle, however, interpreted their mission somewhat differently from the one Williams had suggested, and sought to create an American *style* rather than just an American subject. Other artists, particularly the Regionalists and Social Realists, pursued the American spirit through more tangible representations of the American scene that often bordered on sentimental illustration. Their subjects were the American agricultural landscape and the urban narrative. To O'Keeffe these artists portrayed an inaccurate view of America:

82

There was a lot of talk in New York then – during the late twenties and early thirties – about the Great American Painting. It was like the Great American Novel. People wanted to "do" the American scene. I had gone back and forth across the country several times by then, and some of the current ideas about the American scene struck me as pretty ridiculous. To them, the American scene was a dilapidated house with a broken-down buckboard out front and a horse that looked like a skeleton. I knew America was very rich, very lush....
For goodness' sake, I thought, the people who talk about the American scene don't know anything about it. So, in a way, that cow's skull was my joke on the American scene, and it gave me pleasure to make it in red, white and blue.

128

As early as 1923, one writer had called her work "entirely and locally American," and in 1945, she claimed for herself: "I am one of the few who gives our country any voice of its own."

Despite her satirical intentions, *Cow's Skull: Red, White, and Blue* is symbolic of America as O'Keeffe saw it represented by the New Mexico desert and its relics. She explained in 1932 that painting bones was "a new way of trying to define my feelings about that country." Her attitude, however, was not very far from that of the Regionalists whom she chastised, although she did not moralize about the demise of Native American culture, or sentimentalize about life in the Wild West, as they might have done. In general, the American landscape was a subject that was revered by modern artists, just as it had been by an earlier generation of American artists in the nineteenth century. O'Keeffe reinforced the sacredness of the land by infusing her painting with subliminal religious undertones.

None of the many other works in the skull series attained quite the same degree of starkness or monumentality as *Cow's Skull: Red, White, and Blue*. In fact, *Cow's Skull with Calico Roses*, painted the same year and with an almost identical composition but dramatically different color scheme, achieved an opposite, and somewhat bizarre, effect of jaunty lightheartedness. Rather than using bright primary colors, O'Keeffe relied on an exquisite ensemble of whites that range from the soft grays of the dry bone to the slightly greener whites of the two calico flowers and the creamier tones of the background. The hidden recesses of the cow's nasal area are painted a mellow butterscotch-yellow that draws the viewer's attention for further inspection. The seriousness of the image was mitigated by the frilly flowers that look foppish on such an ethereal creature. By playfully joining these unlikely elements in a single composition, simply because it pleased the artist to do so, O'Keeffe invited the viewer to seek some logical connection, even if there was none, beyond their similar coloring and inanimate status.

The following year (1932), in another odd juxtaposition, O'Keeffe superimposed three calico flowers (colored red, pinkish-white and blue) over a geometric rendering of New York City skyscrapers that she designed for The Museum of Modern Art's exhibition "Murals by American Painters and Photographers"; the full-size mural was never executed (see *Manhattan*, 1932).

Adding to the visual dilemma of *Cow's Skull with Calico Roses* is the artist's distortion of the black-brown beam behind the skull, which, like the one in *Cow's Skull: Red, White, and Blue*, at

first guides the eye downward in a straight line, but then bends unexpectedly to the left. O'Keeffe's skill as a painter and her ability to manipulate her compositions for specific effect are evident in this pair of paintings, which marked the culmination of her intensive examination of animal skulls painted in isolation.

As we have seen in O'Keeffe's work, the fruition of one theme often contained the seeds of another. Four years after she introduced floral elements almost offhandedly in *Cow's Skull with Calico Roses*, she developed the skull-and-flower theme more fully in *Ram's Head, White Hollyhock – Hills* (1935). That she sustained this idea for four years indicates its strong hold on her imagination, and thereafter she experimented freely with juxtaposing disassociated images in the same picture.

83

The gap in time between these works was caused by a series of professional and personal difficulties that included a three-year separation from New Mexico and an eighteen-months period during which the artist did little or no painting. In April 1932, over Stieglitz's objections, she accepted $1,500 to paint a mural for the ladies' powder room in New York's Radio City Music Hall, scheduled to open later that year. Under pressure to validate her decision and to work within time constraints and overcome technical difficulties, O'Keeffe's confidence wavered, and she retreated to Canada (where she painted the *White Canadian Barn* series); by October 1932 she abandoned the commission altogether. That same year, in another personal blow, Stieglitz had the lease for An American Place put in Dorothy Norman's name. A few months later, in February 1933, O'Keeffe was admitted to the hospital diagnosed with psychoneurosis. By March, however, she was well enough to see her exhibition at An American Place (which had opened in January), but immediately left to recuperate in Bermuda (March-April) with her friend, the photographer, Marjorie Content. It was not until October 1933 that she was inclined to draw again, and not until January 1934 that she tentatively resumed painting. A second trip to Bermuda (March-April 1934) produced some overworked charcoal drawings of banana flowers and lackluster banyan trees. Even her return to New Mexico with Marjorie Content, from June through September 1934, yielded few important paintings during a stay at the H & M Ranch near Alcalde. That winter (December 1934), *America & Alfred Stieglitz: A Collective Portrait* was published in honor of Stieglitz's seventieth birthday, a selection of photographs and written tributes by his colleagues, coordinated by Dorothy Norman. When asked, O'Keeffe had declined to participate, and

61

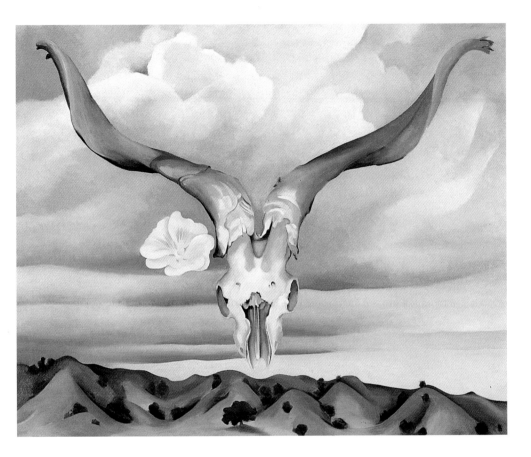

84. *Ram's Head, White
Hollyhock – Hills*, 1935.
The straightforwardness with
which each element of the
composition is painted does not
belie the fantasy of the scene .
A proportionately over-size ram's
skull and white flower hover in the
sky above a thin strip of rolling red
hills, distorting our sense of
accurate spatial relations.

Stieglitz's personal inscription in her advance copy of the book, seemed to be an effort to mitigate her feelings about being replaced: "For Georgia / without whose being I / would not be what I am – / Alfred Nov. 31/34 – / Nor would the Place exist / nor very many of my best / photographs –." In the light of all these upsets and disappointments, an appendectomy in April 1935 was just another setback.

Following this period of stagnation, during which she had to overcome a litany of obstacles, the strength of her 1935 paintings come as a revelation. *Ram's Head, White Hollyhock – Hills* (1935) and related pictures done in the following years marked her triumphant return to the skull theme. They were also the first works in O'Keeffe's oeuvre to combine skeletal and landscape imagery in the same composition; several added a third floral element. Previously, she had examined each motif separately – bones, landscape, and flowers – in extended series. When she combined these images in a single work it was without regard to their relative size, scale, or perspective. In other words, although the skulls were depicted head-on in scrupulous detail, the landscapes might be shown as aerial panoramas. Unexpectedly, each element was rendered in equally sharp focus, blurring the distinctions between what was near and what was far. Also unnaturally, the skulls now floated mysteriously without visible means of support. Although the individual images were realistically described, the scene had no verisimilitude. The visual effects of such manipulations were at once startling and exhilarating. To Lewis Mumford her combinations seemed "inevitable and natural, grave and beautiful."

In *Ram's Head, White Hollyhock – Hills*, the gently rolling sand hills of the Rio Grande Valley (west of Taos) formed an undulating mass at the bottom of the canvas. They were depicted without much specificity, however, as if seen from a great distance and from a high vantage point. The skull and flower, on the other hand, were shown in scrupulous detail at close range. The slightly upward tilt of the hollyhock revealed its shallow depth, while the strictly frontal view of the ram's head with its long graceful horns emphasized its exotic contours, a feature that made it a favorite in O'Keeffe's paintings of the period. In *Ram's Skull with Brown Leaves* (1936) she floated the skull against a blank background that further accentuated its attenuated lines. Rather than pairing it with the red sand hills, she found a visual equivalent in the undulations of two brown autumn leaves. Two years later, in *Ram's Head, Blue Morning Glory* (1938), the same skull was presented next to a blue flower.

In these pictures, the surprising juxtapositions of unrelated elements seemed to suggest some underlying symbolic connection between the disparate elements. However, while the imagery was often provocative or unsettling, leading some people to call it surrealistic, the connections O'Keeffe made were primarily formal – related colors, shapes, textures, and patterns that tied the elements together. Such associations may echo Fenollosa's beliefs that "relationships are more real and more important than the things which they relate." In a way, these paintings synthesized her New Mexico experience through their collaging of representative images, rather than broke new ground.

From the Faraway Nearby (1937) demonstrates a later and more 85 ambitious development in the landscape-skull theme. It was painted in 1937, when O'Keeffe was living for the first time in what was to become her house on the Ghost Ranch property, near Abiquiu. The composition departs somewhat from the standard landscape-and-bone format outlined above, although it maintains the overall effect of the related works. Here the animal skull is not suspended in mid-air, but rests tentatively on the narrow strip of landscape at the bottom, emphasizing the strong similarities between the color and shape of the enormous antlers and the hilltop peaks. These horns though, as one writer pointed out, "are not real; no deer or elk ever carried such a rack. This is instead a mythic beast, a poetic evocation of all the animals that have lived on that land…. It is a statement about what endures, what transcends, what is eternal." Like her later interpretations of Ranchos Church where the building grew out of the ground, the skull here too becomes an extension of the landscape, its hollowed cavities and irregular surfaces echoed in the forms of the crevassed hills. The painting's muted tones of rose, gray, blue, and brown helped to unify the diverse elements and produced an unusual serenity of mood. While the other skull-in-landscape paintings of this period showed the animals' heads in flattened frontality, here it is presented from a three-quarter angle that emphasizes its three-dimensionality. Yet, overall there is little spatial plausibility to the scene. Without a discernible middle ground, the skull looms large toward the front of the picture plane, while the small strip of landscape, painted as if at a long distance, recedes quickly. Despite its hyper-realistic style, the picture is a thoroughly modernist construct, rooted in abstraction and challenging artistic conventions about landscape painting.

For O'Keeffe, this painting also held a more personal significance related to her changing feelings about being out West.

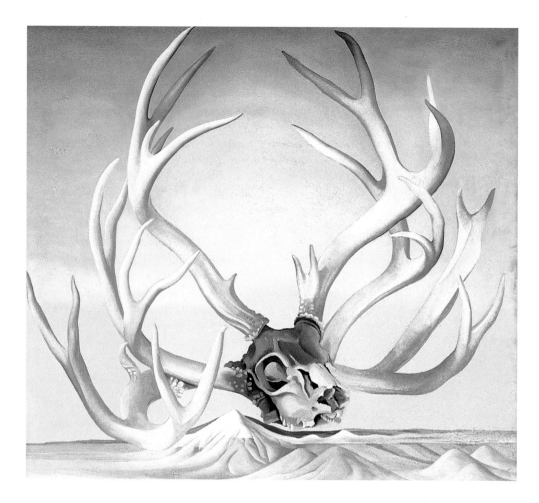

85. *From the Faraway Nearby*,
1937. The title of this painting
refers to the "Faraway," a location
that the artist once said was "a
beautiful, untouched lonely-
feeling place."

Originally, it was titled *Deer's Horns, Near Cameron,* linking it to her camping experiences in Arizona in the early fall of 1937 with photographer Ansel Adams and others. Later, however, she renamed it *From the Faraway Nearby.* At first, she used "the Faraway" when referring to the Southwest in general, then she applied the term more narrowly to the area around Abiquiu. By changing to the more poetic title, O'Keeffe loosened the painting's original connection to a specific place and allowed the strange image to resonate with a broader, more elusive meaning. In 1976, when she wrote about "a beautiful, untouched lonely-feeling place – part of what I call the Far Away," she used it to identify both a physical and an emotional reality.

In her extended series of *Pelvis* pictures, painted between 1943 and 1945, she further developed the dual themes of collected animal bones and the desert landscape in which they were preserved. This cycle consisted of fourteen canvases (and one known drawing), and progressed from analyses of the pelvis bone as a whole shape to tighter, fragmentary close-ups. In these pieces, and in a related abstract sculpture of 1946 (based more specifically on the configuration of a goat's horn (*Goat's Horn with Blue,* 1943), O'Keeffe contrasted convex-and-concave surfaces and solid-and-open spaces. Similar issues had engaged her at the beginning of her career when she painted the ambiguous orifices of the 1918 *Music* series and the 1923 *Grey Line* series, and when she emphasized the elliptical openings and curvilinear forms of her leaf and flower subjects in the mid-1920s. In the 1950s she produced two final pelvis images, although neither is identified as such by title: *Pedernal – From the Ranch I* (1956) and *Pedernal – From the Ranch II* (1958). Later, in her rock paintings of the 1970s, O'Keeffe again addressed the ovoid shape, not as an opening, but as a solid, three-dimensional object.

The earliest pelvis pictures of 1943, such as *Pelvis with the Moon – New Mexico* and *Pelvis with Shadows and the Moon,* describe the elegantly convoluted shape of the bone in its entirety, standing upright in the landscape. Placed in the forefront of the picture plane, the pelvis occupies the canvas from edge to edge. Although in different pictures it is explored from various angles – front, back, or side – its placement on the canvas is always centered and the painter's perspective is always head-on. Attention is drawn first to the bone, which monopolizes our vision, and then, almost incidentally, to the landscape elements that appear behind it like a theatrical backdrop. In both of these works the immediately recognizable form of Cerro Pedernal, a flat-topped mesa in the Jemez mountain range, appears like a blue mirage in the distance.

135

86. Photograph by Ben Blackwell of O'Keeffe standing on large black version of *Abstraction*, 1982. Noted as a prolific painter and draftsman, O'Keeffe's sculptural output is limited to just two designs. This one from 1946 relates to her pelvis paintings and was produced in several different sizes and in black and white finishes.

In subsequent works of the *Pelvis* cycle O'Keeffe excluded all extraneous landscape details so that the viewer's attention rested solely upon the essential elements of the composition — the empty sockets within the bones, through which the sky, and sometimes the moon, could be seen. This seemed to coincide with her readings on Asian art theory at the time, including Laurence Binyon's *The Flight of the Dragon* (1943) which stated that empty space was "no longer something not filled and left over, but something exerting an attractive power to the eye…" In a letter from the novelist Jean Toomer, he noted that she painted "the universe through the portal of a bone." It was a way of seeing that she first learned as an art student in William Merritt Chase's classes at the Art Students League. Chase instructed his students to "hold up a card with a square hole in it and put what you see through the opening on your canvas." Such a devise – with a narrow rectangular cut-out, similar to the format of many of her New Mexico landscapes – was later found tucked inside one of the books in O'Keeffe's library. In 1959 the artist allowed herself to be humor-

ously photographed by Tony Vaccaro, looking through a piece of Swiss cheese held up to her eye.

During the next three years (1944–47), O'Keeffe sporadically returned to the theme of pelvis and opening. These later works of the series repeated the compositions of the 1944 pictures – magnified sections framing the sky – but deviated from their naturalistic coloring to produce far more abstract statements in bold, vibrant colors. Instead of imitating the bleached gray color of the bones or the blue of the sky, these compositions were painted bright yellow, red, and blue (e.g., *Pelvis Series, Red with Yellow*, 1945). In December 1945 she wrote in a letter about "the blue and the red of the bone series": "It is a kind of thing that I do that makes me feel I am going off into space – in a way that I like – and that frightens me a little because it is so unlike what anyone else is doing."

89. **Tony Vaccaro**, *O'Keeffe holding up oval cut-out to her eye*, 1959. O'Keeffe's public persona did not reveal her sense of humor, which is evident in this candid photograph showing the artist looking through a hole in a piece of cheese.

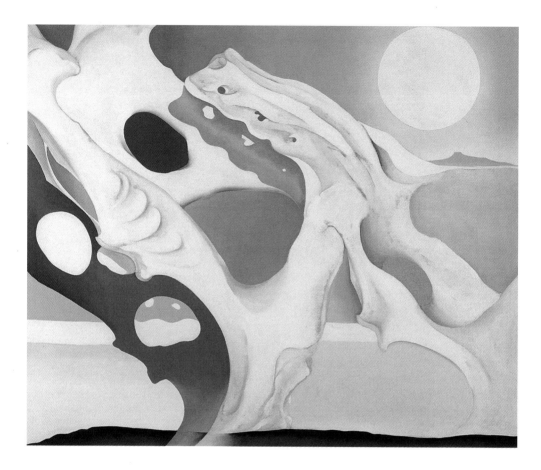

88 *Pelvis with Shadows and the Moon*, 1943. For five years, from 1943 to 1947, O'Keeffe explored the intricate shapes and surfaces of animal pelvis bones in a large series of paintings. The early canvases depicted the entire bone in a landscape, but subsequent pictures focused solely on the ovoid opening in the bone and the sky beyond.

89. **Tony Vaccaro**, *O'Keeffe and "Pelvis, Red and Yellow,"* 1960. In this painting, O'Keeffe interprets the pelvis bone motif with a fiery palette of reds and yellows, differentiating it from the more naturalistic coloring of the other pelvis pictures.

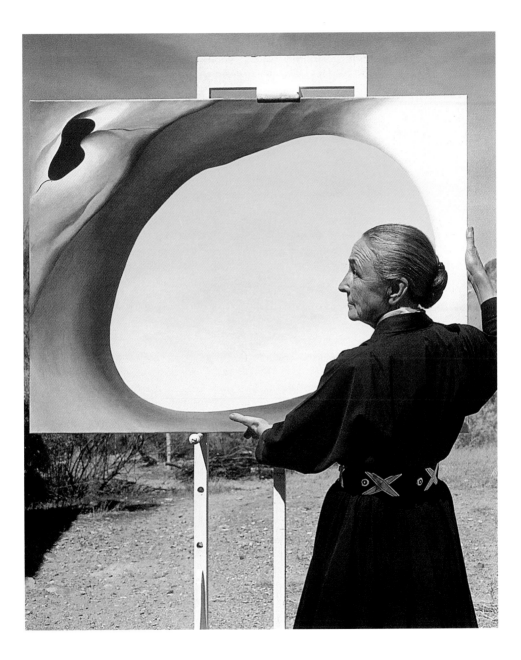

Chapter 8: The New Mexico Landscape:
Ghost Ranch

O'Keeffe's skeletal subjects were probably the most startlingly original images she produced during the 1930s and early 1940s, her period of greatest mature creativity. It was, however, the magnificent New Mexico landscape that endured in her art long after she had moved on from her experiments with skulls and pelvises. As she became increasingly familiar with the terrain, she often depicted particular sections of the landscape in close-up, as she had done with her flower subjects. Once again she ignored relative size and scale by juxtaposing the landscape with additional props, such as bones, flowers, and shells. *Red Hills and White Flower* (1937), a sumptuous pastel, and *Red Hills and Bones* (1941), a large oil painting of the same locale, are two such examples in which the exaggerated size of the objects competes with the actual size of the landscape. Ansel Adams described the area this way: "The skies and land are so enormous, and the detail so precise and exquisite that wherever you are, you are isolated in a glowing world between the macro and the micro – where everything is sidewise under you, and over you, and the clocks stopped long ago." The monumental visages of enormous mountain ranges and expansive sky were deeply impressed in her mind. Many of her later landscapes, in fact, were done from memory, attesting to her acute powers of observation and her intimate knowledge of the region.

One place that she knew well and that reappeared in her work was the area around her home at Ghost Ranch (owned since 1998 by the Georgia O'Keeffe Museum in Santa Fe). In 1934 O'Keeffe had begun to spend summers at Ghost Ranch, then a 21,000-acre dude ranch owned by the founder of *Nature* magazine, Arthur Pack and his wife Phoebe (who gave it to the Presbyterian Church in 1955, to be maintained as an educational-conference-mission center). For two summers she stayed with the other guests in the main house, located high up off the road, marked only with a skull and small sign. In May 1936, however, when she arrived for her annual visit without a prior reservation, she found the ranch filled to capacity. Pack offered her the use of his small U-shaped residence, known as Rancho de los Burros, located about 3 miles

90. **Myron Wood** photograph (n.d.) of the artist's house at Ghost Ranch which was nestled at the base of a long red and yellow rock wall that she called her "backyard."

away on a lower portion of the property. Set far back off the road-way, the simple adobe building was nestled almost invisibly at the base of huge cliffs. Still part of Ghost Ranch, but far enough away to ensure privacy, O'Keeffe recalled that "As soon as I saw it, I knew I must have it." Four years later, in October 1940, she pur-chased it with 8 acres of land from the Packs, and it remained her summer-fall residence even after she bought a hacienda in Abiquiu in 1945.

To the north, south, and west, her Ghost Ranch property in the Chama River Valley was surrounded by the 13,000 acres still owned by the Packs, to the east by Carson National Forest. The views were spectacular, especially from her large bedroom window and from the roof of the house. In 1942 she described the setting to Arthur Dove:

*I wish you could see what I see out the window — the earth pink
and yellow cliffs to the north — the full pale moon about to go down
in an early morning lavender sky behind a very long beautiful tree
covered mesa to the west — pink and purple hills in front and the
scrubby fine dull green cedars — and a feeling of much space —
It is a very beautiful world.*

The unusual colors and land formations caused her to paint them over and over again. In the summer of 1943 she began to record the cottonwood trees that she saw from the house (e.g., *Cottonwood Trees in Spring*, 1943). These were painted singly or in entire groves, in soft focus and in soft colors (primarily pale yellow, orange, pink, and tan). They emphasized the ethereal foliage of the trees rather than the solid elements of trunk and branches, which had previously structured her Lake George

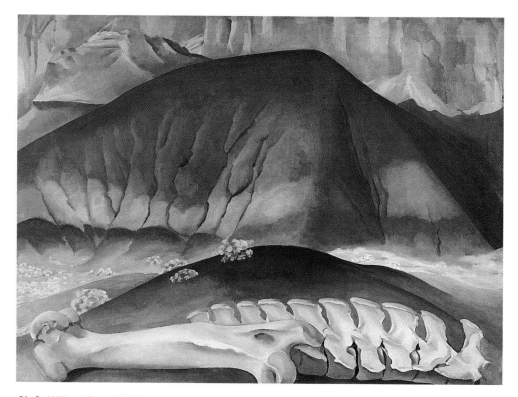

91. *Red Hills and Bones*, 1941.
The colors and images of the
American Southwest permeated
her paintings after 1929. Here
the shape of a found bone echoes
the ridges and curvature of the
surrounding landscape.

92. *Red and Yellow Cliffs*, 1940.
93. *Grey Hills*, 1942.
Two other close-up views of
favorite New Mexico sites – the
red and yellow cliffs at Ghost
Ranch, and the grey hills 150
miles away that contained the
"Black Place."

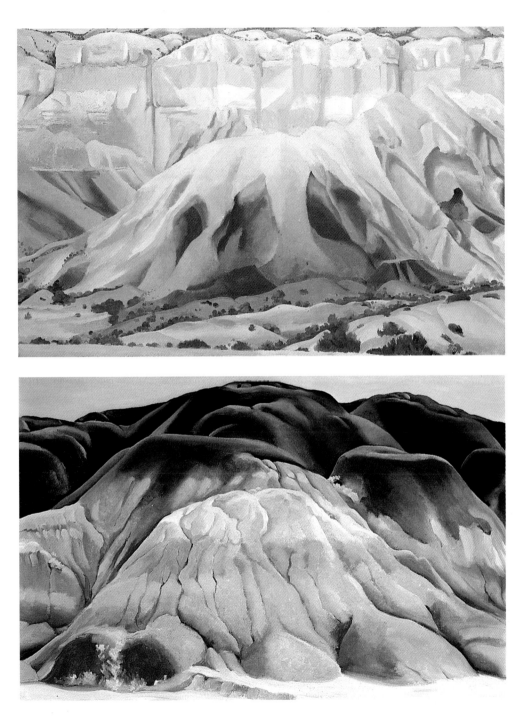

maples and birches, and D. H. Lawrence ponderosa pine. Through 1954 these diaphanous cottonwoods made ghostly appearances in numerous canvases that generally lacked the visual and psychological bite of her earlier trees.

The front of the house abutted a flat open plain filled with desert brush with a view toward the Cerro Pedernal in the distance. This large, flat-topped mesa dominated the skyline and appeared in many of her paintings. What she referred to as her "backyard" faced the immense striated cliffs that rose up about 700 feet behind her Rancho de los Burros house at Ghost Ranch. In a sequence of seven pictures completed between 1937 (the year after her first stay there) and 1945 (the year she bought the new Abiquiu house), O'Keeffe adjusted her focus in and out to record the details and the breadth of this colorful rock wall. Her painting *Red and Yellow Cliffs* of 1940, and its almost identical mate, persuasively convey the setting's physical enormity and natural coloration, but as the artist noted, "Out here, half your work is done for you." 92

In both of these paintings, the viewer is brought dramatically close to the cliffs that occupy almost the entire picture. Only her inclusion of the narrowest bit of ground and sky suggests that this site is part of a much larger environment. In the shallow space of this painting, the landscape elements recede in three distinct layers: in the foreground are the bare slopes dotted with green juniper bushes and piñon trees; in the mid-ground, the rounded and crevassed red hills; and finally, in the background the recession stops at the imposing wall of rock. Intense sunlight bathes the composition with a warm glow that seems almost to dissolve the upper yellow stripes of the cliffs.

In contrast to the exoticism of the surrounding landscape, her life at Ghost Ranch was austere and simple. Even food, water, and provisions had to be brought in from Santa Fe, 70 miles to the south. These tasks were managed for O'Keeffe by Maria Chabot, a rugged Texan whom she had met in October 1940 (when Chabot was working for Mary Wheelwright, owner of a ranch in Alcalde and founder of the Wheelwright Museum of the American Indian in Santa Fe). Chabot moved into the Ghost Ranch house the following June and remained O'Keeffe's assistant-companion there through 1945; a year later, Chabot began the renovations and rebuilding of O'Keeffe's new house in Abiquiu.

With Chabot, O'Keeffe went on frequent painting expeditions, often camping out in the wilderness, sleeping in tents and using her Model A Ford to paint in. For a makeshift studio she

would remove "the right-hand front seat, unbolt the driver's seat, turn it around, and sit there to paint with a canvas [as large as 30 x 40 inches] on the back seats." One of her favorite painting spots was a remote setting located about 150 miles northwest of Ghost Ranch that she nicknamed "the Black Place" and described as "some of our barest country." Over a period of fourteen years that lasted from 1935 to 1949, it sparked a torrent of work that was almost unparalleled in her career. She had first gone there in August 1935 during a motor trip through Navajo country, and returned the following August to paint the stretch of gray hills that contained the Black Place.

From a distance, the hills looked to her like "a mile of elephants," and several compositions featured the textural quality of the "evenly crackled" rock surface. She also concentrated on 93 the juncture of just two hills viewed up close, producing some of 94, 95 her most dramatic compositions. In some of them, the hills were sculpturally rounded, while in others they were reduced to flat shapes of color. By 1943 O'Keeffe had already produced at least six paintings and one drawing, yet her most intensive work on the subject occurred between 1944 and 1945, when she completed another six canvases, one very large pastel, and at least nine pencil sketches. Four years later, in 1949, she created two final paintings and another drawing, completing one of the largest cycles in her oeuvre.

What sustained O'Keeffe's interest through 1944-45 was her development of a compositional format that could express her intimate knowledge of the landscape's topology with its inherent visual drama, and serve in addition as a vehicle for various artistic interpretations. While earlier depictions of the Black Place and the gray hills had presented them from enough distance to show some sky and ground, her pictures of 19 . r-45 honed in on one particular section of the hills, eliminating nearly all references to the larger surroundings. As in some of her other New Mexico landscapes, this image is brought to the immediate foreground where it fills every available inch of canvas, giving the spectator a sense of being in the setting with the artist.

In all the works from 1944-49, our attention is riveted on the undulating topography, on the dramatic variances in light and dark, and particularly on the juncture of two hills. O'Keeffe's pencil sketches of 1944-45 reveal her careful study of this motif in all its possible variations. Her paintings, *Black Place III* (1944) 94 and its sequential partner, *Black Place IV* (1944), are the largest 95 and most theatrical statements of the theme to be created in 1944.

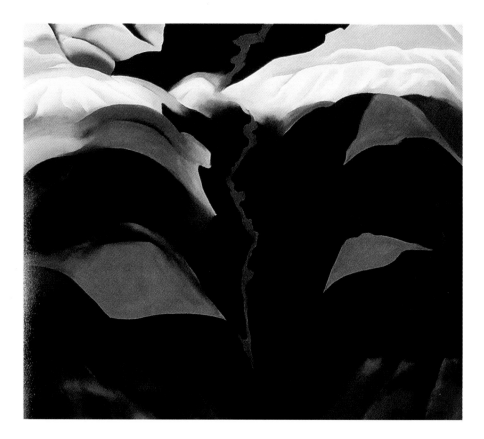

94. *Black Place III*, 1944.
95. *Black Place IV*, 1944.
Abstracted down to a series of
rolling hills and the dramatic
fissure that divides them, these
"Black Place" pictures captured
O'Keeffe's profound awe in the
face of such rugged beauty.
As with her other series, the
artist experimented with two
different color schemes – one
more naturalistic, the other
expressionistic.

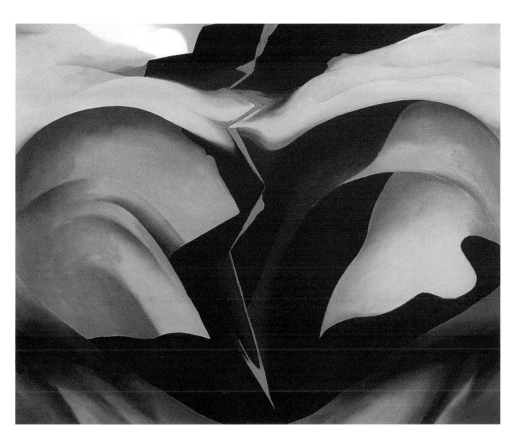

The former uses a palette of somber black, white, and gray-greens that characterizes much of the *Black Place* series, while the latter explodes into hot yellows and reds that are unique in this sequence, but color some of her pelvis paintings and occasionally appear elsewhere in her oeuvre. The extraneous and distracting details of the landscape have been eliminated so that the jagged cleft that divides the hills is accentuated. In both paintings, the landscape is so abstracted and flattened that the cleft becomes an independent shape in the composition – a zigzagging spearhead, accented in the center with a "lightning-bolt" line that plunges into the earth with driving force. Witnessing this drama, we sense the artist's great awe in the presence of such primeval power.

O'Keeffe's later versions of the Black Place were larger and considerably more abstracted. *Black Place Green* (1949), for example, extracts the plummeting arrow from the 1944 paintings as a separate element without the surrounding hills. In other canvases of 1945 and 1949 O'Keeffe offered a totally different interpretation of the same landscape. Rather than jagged lines and sharp color contrasts, works like *Black Place I* and *Black Place III* of 1945, and *Black Place, Grey and Pink* of 1949 emphasized softer tubular forms and muted tonalities. Noticeably, the tensions and darkness that characterized her earlier 1944 *Black Place* pictures have dissipated in her 1949 paintings, perhaps suggesting O'Keeffe's sense of peace, following her permanent move to New Mexico.

All the *Black Place* paintings of 1944–49 reflect the V-shaped composition that she had devised much earlier in her career. As noted before, this format could suggest dynamic movement as well as symmetry and balance, and signified a positive, metaphysical force. Just as she recycled subjects and forms throughout the decades, O'Keeffe also developed her own repertory of compositional formats that brought an extraordinary cohesion to her work. Antecedents for the V format can be found in earlier drawings and paintings of the 1910s and '20s – e.g., *Blue and Green Music* (1921) – and in her Hawaiian waterfall paintings of 1939 – e.g., *Waterfall, No. III – Iao Valley*. But it was in the work that followed the *Black Place* series, where a limited number of forms comprised the composition that the V-understructure was more readily apparent. These late works included the *Black Bird* and *Waterfall* series from the late 1940s-'50s, the aerial abstractions of rivers from the late 1950s, and the *Canyon* paintings from the mid–late 1960s.

26

99

111

Chapter 9: The Abiquiu House and Patio

The few new subjects that were generated during the last part of her life - patios, rivers, and clouds - were contemplative studies of her environment in quiet appreciation of nature's splendor. Most centered around the locations of her two homes. In 1945, five years after buying the Ghost Ranch house, O'Keeffe acquired another home in the village of Abiquiu, which became her winter-spring residence for the rest of her life. One reason for buying this property was a water supply that could sustain a large vegetable and flower garden, something she did not have at Ghost Ranch.

The Abiquiu house was an adobe structure set on top of a hill on three acres of fertile land overlooking the Chama River Valley. A place of simple elegance, it contained a meandering labyrinth of workspaces and living quarters, connected by narrow passage-ways and open courtyards. Some windows looked inward to private gardens and patios, while others faced outward to the perimeter wall, gardens, and wider landscape beyond. The original corral was turned into a large and sparsely decorated art studio, which she painted and carpeted white. In this empty space the artist said she could think better. Aside from her paintings, the only real color that entered this pristine environment came from the spectacular landscape outside her window, which she said was so large it was like being outdoors. Similarly, in her small, dark, monastic bedroom, she made the two floor-to-ceiling windows and the view outside the centerpiece of the room. Walled off from the neighboring villagers, and attended to by a loyal staff of local workers, the artist was able to work there undisturbed in almost complete privacy for almost 40 years. After O'Keeffe's death, this home became headquarters for the Georgia O'Keeffe Foundation, which maintains the furnishings and gardens just as the artist had left them, and in 1998 it was designated a National Historic Landmark.

One feature of the house in particular had held her fascination:

When I first saw the Abiquiu house it was a ruin with an adobe wall around the garden broken in a couple of places by falling trees.... I found a patio with a very pretty well house and bucket to draw up water. It was a good-sized patio with a long wall with a door on one side. That wall with a door in it was something I had to have.

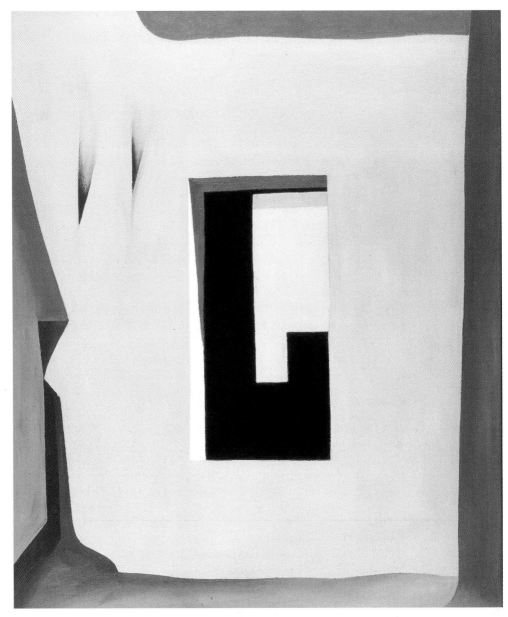

96. *In the Patio I*, 1946.
97. *My Last Door*, 1952-54.
For fourteen years (1946-60)
the patio doors of O'Keeffe's
Abiquiu house inspired more
than twenty-five paintings on
canvas and paper, drawings,
and photographs.

98. Photograph by O'Keeffe
of her Abiquiu house and patio,
c. 1955.

Doors had already featured in some of O'Keeffe's earlier works, such as *Flagpole* (1925) and the *White Canadian Barn* series (1932), but there they were always part of a larger architectural or landscape scene. Now the doors became the central and sometimes sole motif of her compositions. In some ways these patio doors derived from her earlier training with Dow and her own teaching experience in Texas, where she'd have students "draw a square and put a door in it somewhere – anything to start them thinking about how to divide a space." 28, 61

Between 1946 and 1960 the Abiquiu doors inspired twenty-three patio paintings and drawings, as well as an additional group of small black-and-white photographs that the artist took around 1955. These photographs are of documentary interest (besides showing O'Keeffe's abilities in a different medium) because they show the patio as it actually existed, before O'Keeffe's artistry reduced it to only two or three essential elements. In the photos we see all the extraneous details of the setting – the bushes, the architectural beams, and the cracks in the adobe walls that O'Keeffe chose to delete in her paintings. And obvious, even with these visual distractions, is the strikingly beautiful composition of the dark square door set in a long, horizontal wall. 98

Some years she produced just a single patio canvas; at other times she was moved to create suites of four to six paintings (her largest grouping dated from 1955). The earliest patio pictures – two sketchbook drawings and a small oil painting on paper – were made in the summer of 1946, when she was back in Abiquiu to begin renovations on the property, following the opening of her retrospective exhibition at The Museum of Modern Art in New York (May-August). These drawings are fully developed compositions that reflect O'Keeffe's initial observations of the site. Executed in soft graphite pencil on pages from a spiral sketchbook, each one is an intricate pattern of shaded rectangular planes that suggest a progression through inner and outer walls and hidden passageways. They are engaging studies of light-and-dark that relate closely to her painting of that summer, *In the Patio I*. The painting, however, is bathed in the bright glow of sunlight that dramatizes the naturalistic coloring of the blue sky, tan adobe walls and ground, and deep brown shadows. As in the sketches, the open door invites the viewer to look into the shallow space through a series of rectangular portals. 96 96

Although she had planned to stay longer in Abiquiu that summer, her time was cut short by the news that 82-year-old Stieglitz had suffered a serious stroke. She returned to New York

immediately, just days before he died on July 13, 1946; his ashes were buried at the base of a pine tree at the edge of Lake George. Since 1928, when Stieglitz had had his first severe angina attack, health worries posed a recurring problem that often led to O'Keeffe's playing nursemaid. By 1937 he was too weak to handle the heavy equipment he used to take photographs, and from then on until his death, he was plagued by serious heart problems and the general physical decline of old age.

After his death, O'Keeffe was left with the daunting task of settling his affairs. In view of this mammoth job, she hired Doris Bry in the fall of 1946 to help sort through Stieglitz's extensive correspondence and papers, and the hundreds of paintings, drawings, prints, sculptures, and photographs that were in his possession. Bry's close association with O'Keeffe lasted until 1973. She became a trusted assistant and later helped to catalogue the artist's own work, in addition to handling details about exhibitions, publications, and sales; eventually she became the artist's dealer from 1968 to 1973. All the while that O'Keeffe and Bry were working primarily in New York (1946-49), the house in Abiquiu was undergoing extensive renovations (undertaken by Chabot, and periodically visited by the artist). As O'Keeffe realized, "in an odd way the utter foolishness of doing that [renovation] seemed to keep me alive on that other impossible chore," the cataloguing and dissemination of Stieglitz's estate. At the same time, she helped to organize the exhibition of Stieglitz's collection, which was shown at The Museum of Modern Art in 1947.

Stieglitz's death and the final disposition of his collection brought to a close her ties to the East, and freed her to pursue a permanent life out West. She was freed from feeling torn between Stieglitz and New Mexico, but understandably, she was also left with a sense of immeasurable loss. With few exceptions, the works she produced after Stieglitz's death did not display the same emotional intensity that charged her earlier pictures. Particularly poignant is *A Black Bird with Snow-Covered Red Hills*, painted in 1946, which seems to epitomize her serenity, tinged with longing. When she wrote about this piece thirty years later, these two emotions were still evident: 99

One morning the world was covered with snow. As I walked past the V of the red hills, I was startled to see them white. It was a beautiful early morning — black crows flying over the white. It became another painting — the snow covered hills holding up the sky, a black bird flying, always there, always going away.

99. *A Black Bird with Snow-
Covered Red Hills*, 1946.
The year of Stieglitz's death,
O'Keeffe painted this mournful
image of a lone black bird circling
over pure white snow.

100. *In the Patio IX*, 1950.
Four years later, she geometricized
the black bird composition into
one of her patio wall series.

One feels in these later works the artist's sense of peace, both with herself and with her life in New Mexico – a life that would for the next forty years be almost completely unencumbered by the distractions of exhibitions and social obligations that characterized her years with Stieglitz. Her large, seven-foot-wide oil on canvas, *Spring*, painted in the summer of 1948, seemed to codify these feelings in a dreamlike fantasy. Veiled in misty shades of blue and white, the bones fly like birds or sprout up like trees, and pinwheel flowers float in the gauzy sky like large snowflakes. The stillness of the moment is as unbroken as the long mountain range and Pedernal that anchor the composition. Although New Mexico, in general, and particularly the areas around Taos and Santa Fe, remained large centers for art, O'Keeffe shied away from having much direct contact with these communities or their activities.

When she once again returned to the subject of her patio in 1948 and thereafter, she depicted the closed, exterior view of the patio doors, rather than the open portals she had painted in 1946. Her inventiveness was displayed in the new and interesting variations she was able to devise with this simple motif. Different color schemes, for example, produced quite different effects. The muted earth tones, suggested by real adobe walls, endowed even the most abstracted patio pictures with a naturalistic reality, while alternate palettes of pastel blues and pinks or intense reds and yellows evoked more spiritual or emotional associations. Likewise, by changing her vantage point – from frontal to angled – she radically altered the dynamics of the basic composition. Seen straight-on, the rectangular forms and horizontal bands of color assumed a static monumentality, while from an angled perspective the same forms created asymmetrical compositions that suggested movement into space. Including other elements with the doors, such as snow, clouds, leaves, and shadows, also contributed to the range of visual effects she achieved.

In 1950, O'Keeffe placed the patio door and wall in the context of their surroundings and in direct relationship with the sky. Curiously, one of these – *In the Patio IX* (1950) – reprised the composition of her 1946 *Black Bird* canvas, using the same black, white, and blue color scheme. Rather than illustrating a scene from nature, the black bird from the earlier painting has morphed into a flat V-shaped shadow, and the snow-covered hills have been converted into the walls of her Abiquiu house. In two other pictures of 1950 – *In the Patio VIII* and *Patio Door with Clouds* – the sky becomes even more prominent, filling over half the composi-

100

99

tion with ascending white clouds. A decade later, these cloudy patios evolved into one of her largest and most important New Mexico series, the *Sky Above Clouds*. 117,118

A very different interpretation of the Abiquiu patio is presented in *My Last Door* (1952-54) – misleadingly titled since 97
several more patio paintings followed over the next six years – and in *Black Door with* Red (1954) and *White Patio with Red Door* (1960). Painted on huge canvases measuring 48 x 84 inches, these images are extremely minimal and two-dimensional – simple, abstract arrangements of geometric shapes and colors. In each, the rectangular door floats in the center of a long field, framed top and bottom by two thin bands denoting the sky above the wall and the patio walk below. As in the *Pelvis* series, O'Keeffe 88, 89 departed from the naturalistic coloring of her first renditions of the subject, painting these canvases in three different color schemes: pale gray-blue; bright red and yellow; and soft rose. While the blue-gray and rose pictures are tranquil and meditative, the energy of the red and yellow one is entirely different. Once again, it was color, rather than subject matter or form that conferred the emotional content to her images.

Chapter 10: Late Work: Influenced by Travel

Periodically, during this last phase of her career, O'Keeffe reworked compositions that she had developed during her earliest years as an artist. *From the Plains* (1952-54) and its companion piece, *From the Plains II* (1954), for example, are based on two very similar, but much smaller compositions from 1919 – *Red & Orange Streak* and *Series I – From the Plains*, which described her impressions of Texas. By greatly expanding the size of these early images to mural-size canvases in the 1950s, she more aptly conveyed "that wide empty country" where the haunting sound of the lowing cows reverberated.

Canvases of this size were often used for her work after the 1950s. They were, in part, perhaps a response to the large-scale paintings being produced by the Abstract Expressionists (e.g., Jackson Pollock, Mark Rothko, and Willem de Kooning), which had gained such notoriety in the late 1940s and '50s. Although O'Keeffe was rarely affected by trends in contemporary art, she may have felt that the time was right to finally explore her own imagery in dramatically larger formats, an idea she had toyed with since the 1920s and '30s. Such monumental canvases were also an appropriate response to the expanded view of the world she was gaining from extensive world travel.

O'Keeffe traveled widely in the 1950s, '60s, and '70s, both within the United States and abroad, often in the company of friends or assistants. Her excursions at home were mainly related to her many museum and gallery exhibitions, honorary degrees and awards, and visits to friends and family. Among the honors she received were two conferred by Presidents of the United States – the Medal of Freedom received in 1977 from Gerald Ford, and the National Medal of Arts from Ronald Reagan in 1985.

O'Keeffe's first trip outside of the country (besides her recuperative stays in Bermuda in 1933 and 1934) occurred in 1951 when she was 63 years old. As she said, she went to Mexico for six weeks because she "wanted to see the murals the boys [Orozco, Rivera, and Siqueiros] have been doing." There she spent time with the Mexican artists Miguel Covarrubias, Diego Rivera and Frida Kahlo. Subsequent trips to France (1953) and Spain (1953

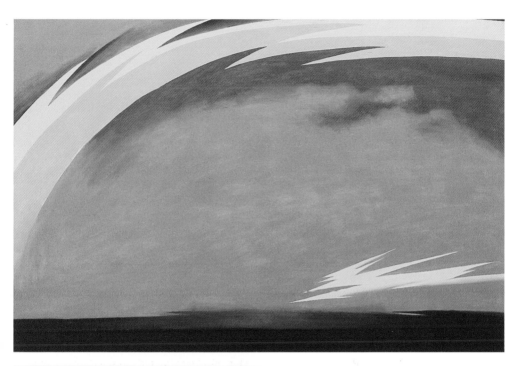

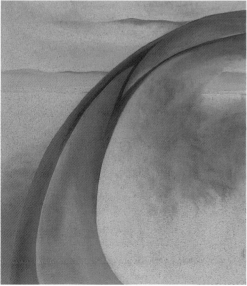

101. *From the Plains II*, 1954.
102. *Red and Orange Streak*,
1919. During her latter years,
O'Keeffe reprised images from her
earlier work, often offering new
interpretations on considerably
larger canvases.

and 1954) lasted two to three months each. Yet, judging by the existing paintings and drawings from this period, none of these places was immediately reflected in her art. It was not until she spent several months in Peru, from March to mid June 1956, that she processed the images from her travels into her work. The results, although less than exciting, were evidence of her openness to new visual material outside of her immediate home environs in New Mexico. In this group of some nineteen small pencil drawings mostly sketched *in situ*, four slightly larger watercolors, a preparatory charcoal sketch on canvas, and six oil paintings, O'Keeffe recorded the mountainous landscape around Machu Pichu and portions of the stone walls at Sacsayhuaman.

Between 1957 and 1979, she made twelve trips to the far corners of the globe – Southeast Asia, the Far East, the Near East, the Middle East, North Africa, Europe, Latin America, and the Caribbean – in sojourns that lasted anywhere from several weeks to several months. Her enthusiasm for travel was all the more remarkable because of her advanced years and eventual failing eyesight. Despite these obstacles, she continued to enjoy travel into her ninety-fourth year. More than the specific places she visited, however, it was flying in airplanes that altered her perception of the world, and inspired two of her last major subjects – aerial views of rivers seen from great heights and expansive paintings of the sky above the clouds.

It is breathtaking as one rises up over the world one has been living in ... – and looks down at it stretching away and away. The Rio Grande – the mountains – then the pattern of rivers – ridges – washes – roads – fields – water holes – wet and dry – Then little lakes – a brown pattern – then after a while as we go over the Amarillo country, a fascinating restrained pattern of different greens and cooler browns – on the square and on the bias with a few curved shapes and many lakes.... The world all simplified and beautiful and clear-cut in patterns like time and history will simplify and straighten out these times of ours – What we see from the air is so simple and beautiful I cannot help feeling that it would do something wonderful for the human race – rid it of much smallness and pettiness if more people flew.

Except for O'Keeffe's pictures of Peru and two paintings of Japan's Mt. Fuji (1960), the places she visited abroad were not specifically illustrated in her art. Instead, these experiences generally informed the choice of forms, colors, and aerial perspectives used in her next series of nature-derived abstractions. Between 1959 and 1960 she painted about fourteen large canvases

103. **Todd Webb**, *O'Keeffe's studio, New Mexico*, 1963. The aerial river views that O'Keeffe created in 1959-60 compare closely to the abstracted tree branches she painted at the same time, as this studio photograph shows.

based on the meandering paths of rivers seen from above, and additionally, produced several beautiful charcoal drawings of the same images, as well as a number of smaller pen and pencil sketches. These abstract designs so closely resembled her contemporaneous depictions of trees and single branches that it is often impossible to distinguish one series from the other. As expected in O'Keeffe's view of the universe, such unrelated images could be interchangeable.

For this group of river-and-tree paintings, O'Keeffe further enhanced nature's palette, which she said was already made up of "such incredible colors that you actually begin to believe in your dreams." Works like *Blue B* (1959) and *It Was Red and Pink* (1959) were expressionistic displays of strong color and strong emotions. While some in the series were dense and brooding, others wafted in soft pastel washes. The tight understructure, however, that had previously characterized her best works seemed to be missing from most of these paintings, resulting in pictures that were all about color and feeling, but with very little substance. The newness of this material (depicting aerial views seen from airplanes) no doubt contributed to her artistic uncertainty.

104

Like those artists who had been overwhelmed by the immensity of the New Mexico landscape, O'Keeffe now seemed temporarily overwhelmed by the challenge of infinite space, and unsure how to best translate her powerful, yet fleeting impressions into paint.

Her series of black-and-white charcoal drawings (executed on 24 x 18 inch sheets of paper), made at the same time and based on the same images, were more successful. Exploring a composition in both painted and drawn versions was something she had done before with other subjects, especially in the early years of her career. In this regard, conservator Judith Walsh astutely noted: "Throughout O'Keeffe's career episodes of charcoal use mark new starts. She returned to charcoal in 1926, when she first examined the skyscrapers of New York, in 1934 after New York 'broke' her, in 1959 after her first trips in an airplane, and finally in 1976 in Antigua and Big Sur when she courageously began to draw again despite her poor eyesight." Although lauded as a colorist, O'Keeffe's strength had always lain with her exceptional design abilities, which were rooted in her graphic skills.

Works such as *Drawing IV*, 1959 (a charcoal variation on *Blue B*) and the other seven to ten charcoals from this series are especially notable for being among the few full compositions on paper executed during the latter part of her career. They are not so much studies for her paintings, as they are separate compositions focused pointedly on line, shape, and structure. In them the meandering and angled lines of the rivers and trees are boldly silhouetted against lighter paper. Beautifully modulated sweeps of charcoal add shading and depth to these basically linear designs. The effect of these drawings is far more eloquent than their larger painted counterparts where the contours of the central forms are generally less differentiated from the colored ground. Once again, knowingly or unknowingly, O'Keeffe had recycled the abstract imagery from her earliest charcoal drawings and watercolors of the mid- to late-1910s, and those of her early paintings from the 1920s, and given it new meaning relevant to her current experiences.

Similarly, she recalled the sweeping curves of such early charcoal drawings as *Abstraction IX* in a series of pictures that featured the road near her Abiquiu house as it disappeared around the base of a mountain. In some nine paintings and numerous pencil and ink sketches created between *c.* 1952 and 1964, including The *Winter Road* (1963) and *Road to the Ranch* (1964), O'Keeffe depicted the ribbon-like road both within the context of the surrounding landscape and as an isolated abstract

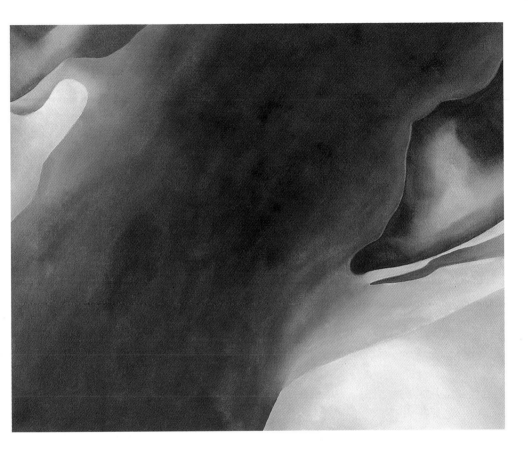

104. *Blue B*, 1959.
Airplane travel inspired some of
O'Keeffe's most original late work.
Meandering rivers seen from great
heights were presented in paint as
evocative color studies.

shape. By the artist's own admission, her conception for this series of highly graphic paintings and drawings derived from small black-and-white photographs she took in the early to mid-1950s:

Two walls of my room in the Abiquiu house are glass and from one window I see the road toward Espanola, Santa Fe and the world. The road fascinates me with its ups and downs and finally its wide sweep as its speeds toward the wall of my hilltop to go past me. I had made two or three snaps of it with a camera. For one of them I turned the camera at a sharp angle to get all the road. It was accidental that I made the road seem to stand up in the air, but it amused me and I began drawing and painting it as a new shape. The trees and mesa beside it were unimportant for that painting [Road to the Ranch, 1964] – *it was just the road.*

As she noted, the photographic print had unexpectedly flattened and tipped the picture plane forward, an effect she tried to replicate in her paintings and drawings of the scene, which, like the snapshots, were both verticals and horizontals. While playing with this image, she was moved to eliminate the extraneous details

105. *Drawing IV*, 1959.
106 *Drawing X*, 1959.
Large charcoal drawings, rich in texture and tonal nuance, were also part of the river series. Their imaginative configurations recalled the more linear imagery in her early charcoal drawings of c. 1915.

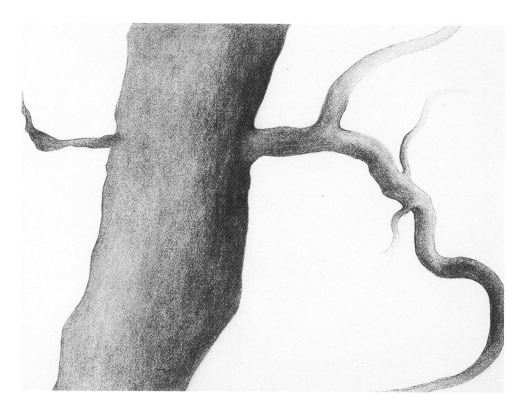

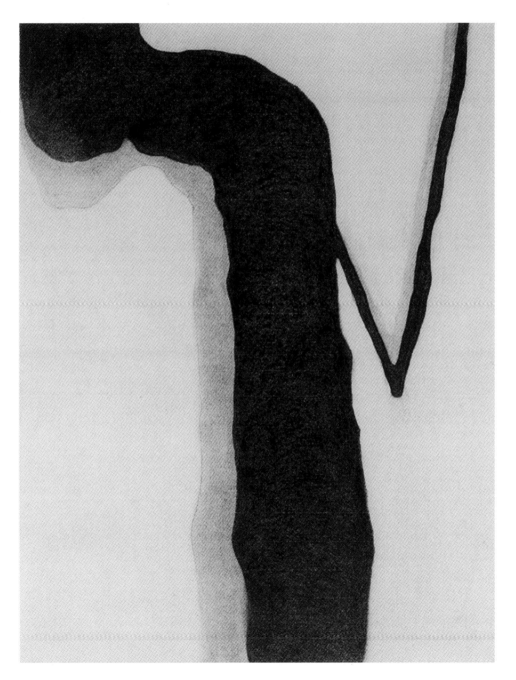

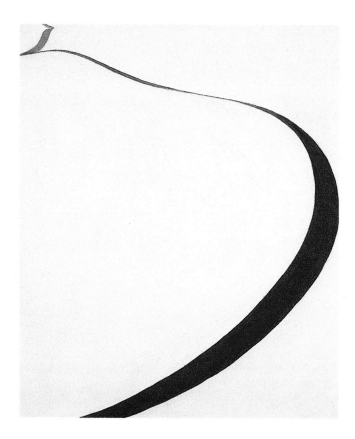

107. *Winter Road I*, 1963.
108. *Road to the Ranch*, 1964.
A graceful, calligraphic line
informed both her drawings and
paintings. In these two paintings
dating from the early 1960s
O'Keeffe depicts the ribbon-like
road that she saw from her
Abiquiu bedroom window. In the
one at left the road is reduced to
its barest linear symbol; in the one
at right it moves our eye through
an ethereal landscape.

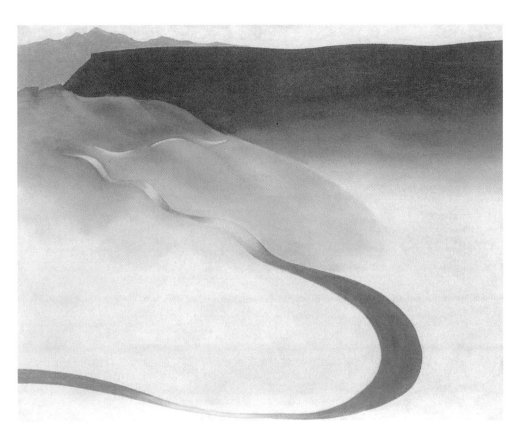

109. Photograph by O'Keeffe of the road in Abiquiu, early to mid-1950s. O'Keeffe's painted versions of the Espanola-Santa Fe road repeated the unexpected flattening of space which occurred in her photographs of this scene.

of the landscape and transform the road into a flowing river, a symbol that transcended the mundane world. Such road pictures of the 1960s as *Blue Road* (1962), *Winter Road I* (1963), *Road to the Ranch* (1964), and *Road Past the View* (1964) are among her most elegant late works. Although based on observed reality, the winding road can be seen as a metaphor for the artist's awareness of more spiritual realities, as she herself neared the end of life's road.

O'Keeffe, however, continued to challenge herself both physically and artistically well into her 90s. In the summer of 1961 at the age of 74, she went on a seven-day, 180-mile rafting trip down the Colorado River with a group of friends that included the photographers Eliot Porter and Todd Webb. Her subsequent forays down the river and her visits to Lake Powell suggested

110. **Todd Webb**, *O'Keeffe in Twilight Canyon, Lake Powell*, 1964. Undeterred by age or health problems, O'Keeffe made the first of several rafting trips down the Colorado River in 1961 when she was 74. Here, the artist walks among the dramatic landscape at Lake Powell.

vivid, bold imagery that appeared in her paintings and drawings of about 1965. In two large charcoal drawings and five oil paintings that constitute the major works of the *Canyon Country* suite, O'Keeffe used just a few large colored shapes to create radically modern compositions. These massive shapes represented sections of rocks and ledges along the river, magnified and viewed from various angles. Paintings like *On the River I* (*c.* 1965) and *Canyon Country* (*c.* 1965), and the black-and-white drawing *From a River Trip* (*c.* 1965) suggest a visual camaraderie with the more minimalist works being produced at the time by younger American artists like Ellsworth Kelly. O'Keeffe herself saw a connection to his work, saying to the art historian Barbara Rose, "You know every time I see that man's work, I think I did it."

111

113

111. *On the River I*, c. 1965.
Large, highly simplified paintings
like this capture the impressive
natural and human drama
that she experienced on the
Colorado River.

112. *Black Rock with Blue Sky
and White Clouds*, 1972. Black
rocks collected during her travels
were transformed into powerful
motifs in her late paintings. Their
dark, pear-shapes are reminiscent
of her much earlier and smaller
avocado paintings of the 1920s.

113. *From a River Trip*, c. 1965.
Like the aerial river pictures, the
Colorado River series included
several beautiful charcoal
drawings that demonstrated
her still masterful handling
of tonal gradations for
expressive purposes.

Also derived from her adventures on the Colorado River were
a small group of *Black Rock* pictures that the artist began in the
early 1960s, using the stones she collected there. O'Keeffe's habit
of picking up bits of nature – bones, shells, and rocks – for decora-
tion in her homes and as motifs in her art continued throughout
her life. Not surprisingly, the objects she chose showed her pen-
chant for certain shapes and textures. In terms of color and shape
the *Black Rock* pictures recalled her small alligator pear (avocado)
still-lifes from the early 1920s, but now painted on a much larger
scale. In 1944, she made a pastel drawing of two black rocks
(*My Heart*) that anticipated the type of smooth stones she would
later depict in the Black Rock series. And related, somewhat more
obliquely, are the pelvis paintings of the 1940s, where similar ovoid
shapes represent openings to the sky, rather than solid rocks.

At first, when she returned to the rock subject around 1963,
she produced only a single small painting and several small pencil

studies. A decade later, however, she developed this simple still-life motif more fully in four additional canvases of 1970-72. In all of them a single smooth, pear-shaped stone sits majestically on top of a cut tree stump, silhouetted against a colored backdrop. In view of her ability to make even the smallest object appear large, it is unclear whether this stone is actually a boulder or a magnified pebble, but in either case, the artist has endowed it with special importance. Although the rocks are flatly painted, their full weight and roundness are suggested through subtle color modulations, reflected light off the smooth curved surfaces, and the inclusion of cast shadows. Compared to O'Keeffe's other mature works, these images are stark and clumsy, yet there is power in their crudeness. O'Keeffe later noted:

The black rocks from the road to the Glen Canyon dam seem to have become a symbol to me – of the wideness and wonder of the sky and the world. They have lain there for a long time with the sun and the wind and the blowing sand making them into something that is precious to the eye and hand – to find with excitement, to treasure and love.

It was this same significance that forty years earlier she had attributed to the bleached-white animal bones of the New Mexico desert.

In the early 1970s, the rock forms of her paintings briefly reappeared in a series of clay pots that O'Keeffe made with the aid of her new assistant Juan Hamilton. Hamilton, a young potter-sculptor, came to work for O'Keeffe in 1973; he taught her techniques for making ceramics and built a kiln at her Ghost Ranch house where they could be fired. Although she was nearly blind at the time, the artist was grateful for this new creative outlet, which relied mostly on the sense of touch. Over the next thirteen years (until her death in 1986), O'Keeffe and Hamilton built a close personal and work relationship. It was to Hamilton's house in Santa Fe that the ailing artist moved in 1984 when she needed to be near medical facilities. During their time together they worked on a number of her exhibitions and publications, including the important book, *Georgia O'Keeffe*, published by the Viking Press in 1976.

Among the most dramatic and familiar images of her later years are her cloudscapes of the 1960s and '70s. In six of these pictures, including *Sky Above the Flat White Cloud II* (1960/64) the compositions are radically simplified into horizontal bands of pale color. In most of them, the bottom three-quarters of the canvas was left almost completely white, with thin strips of color

116

114

114. *Sky Above the Flat White Cloud II*, 1960/64. Her first sky paintings from the early 1960s, based on the views outside her airplane window, were rendered with an economy of means that conveyed the unending panorama of a solidly cloudy sky.

115. *From a Day with Juan IV*, *c*. 1976-77. Related to the minimal sky-above-cloud paintings, are her 1976-77 impressions of the Washington Monument that the sight-impaired artist saw only as mass and gradations of light.

116. **Dan Budnik**, Photograph of O'Keeffe in the studio with Juan Hamilton's pots, 1975. O'Keeffe's last assistant, Juan Hamilton (1973-86), taught her to make pottery and built a kiln that they both used at the Ghost Ranch house.

placed only at the top. Although such images were without immediately identifiable subject matter, they were generated by her flying experiences:

One day when I was flying back to New Mexico, the sky below was a most beautiful solid white. It looked so secure that I thought I could walk right out on it to the horizon if the door opened. The sky beyond was a light clear blue. It was so wonderful that I couldn't wait to be home to paint it....

Trying to re-create this effect, she used an extreme economy of design and applied thin paint on oversized canvases, producing pictures that on the surface paralleled the style of much younger Color-Field and Minimalist artists. In this regard, Barbara Rose noted that O'Keeffe "was especially fascinated by... Richard Serra's tall vertical corten piece with the slanting sides [illustrated in *Art in America*]," and she speculated that his work might have influenced O'Keeffe's 1976-77 series of abstractions based on the Washington Monument. In this group of late paintings and drawings, the artist made what Juan Hamilton called "a metaphysical statement, done in a very

simple way." Despite her extremely limited sight, she could discern the height of the monument against the sky, and "see gradations of light in the column….It was something simple, like a patio door." Painting only a center section of it, without the pointed top, she captured the structure's "upward bound feeling against the dark blue sky."

O'Keeffe's affinity for these minimal images spanned the seventeen-year period of her sky-and-cloud paintings (1960-77). Yet, it was another more patterned version of the cloudy sky that brought her notoriety during these same years. In this second, representational cycle, the enormous white puffs are easily identified as clouds surrounded by bright blue sky. Just as before, she observed this lively sight through the window of an airplane: "The next time I flew, the sky below was completely full of little oval white clouds, all more or less alike. The many clouds were more of a problem." One of her first tentative attempts to re-create the impression of "many clouds" resulted in the relatively small painting, *An Island with Clouds* (1962). While the image here is amusing, the clouds that hover over the small island and the illusion of space and perspective, are thoroughly unconvincing.

It was not until *Above the Clouds* (1962-63) that O'Keeffe devised a composition that successfully conveyed the effect she had seen through the window. In this painting, and in the ones that followed, the viewer is thrust into the upper reaches of the atmosphere. As in the very minimal versions, the canvas is divided unevenly, but this time the large bottom section is filled with a rich pattern of white clouds that leads the eye back into space. Roughly brushed, with areas of canvas around the clouds left unpainted, it is more like a working sketch than a finished picture.

By 1963, however, she had completed two fully developed compositions based on this idea that doubled the size of the original image – *Sky Above Clouds II* and *III* each measure 48 x 84 118 inches. The finesse of her brushwork in these paintings gave them an ethereal quality that was matched by their subtle manipulation of color. By gradually fading the blues and whites of the cloud-filled sky from front to back, while also reducing the size and spacing of the clouds in the distance, she finally achieved a sense of infinite space in this series.

Two year later, she again more than doubled the size of her previous sky pictures with *Sky Above Clouds IV*, which was painted 117 on a canvas measuring eight feet high by twenty-four feet wide.

117. *Sky Above Clouds IV*, 1965. This 24-foot-long canvas fulfilled the artist's desire to paint on a monumental scale. So large that it had to be painted in a garage with the aide of assistants, it was a particular challenge for an artist nearing 80 years of age.

118. *Sky Above Clouds II*, 1963. In this and other sky paintings O'Keeffe depicted the dense arrangement of puffy white clouds that lead our eye back towards infinity.

Since such a monumental work could not fit into her usual studio, it was painted that summer in her double garage at Ghost Ranch with the help of assistants. As she remarked: "Such a size is of course ridiculous but I had it in my head as something I wanted to do for a couple of years so I finally got at it and had a fine time – and there it is – Not my best and not my worst…." Working on it from dawn to dusk was an enormous challenge for any artist but a special feat for one nearing the age of 80.

Like other motifs in her late works, the clouds also had ante-cedents in her very early pencil sketches and charcoal drawings of 1916-17. In *No. 15 Special* (*c.* 1916-17), for exam- 119 ple, O'Keeffe incorporated a thin strip of clouds over the basin of Palo Duro Canyon. Although the shapes of the clouds are similar in both the early and late compositions, they are given very different emphases, and are viewed from very different perspectives. In the charcoal drawing, and its related painting, *No. 21 – Special* (*c.* 1916-17), the clouds are just one small deco-rative element in a more elaborate landscape. If you look up at them from below, they seem to illustrate her statement that at the canyon "the weather seemed to go over it." This is very dif-ferent from the *Sky Above Clouds* series where the clouds com-mand almost the entire composition, giving no evidence of the ground and leaving only a thin strip of empty atmosphere above. That O'Keeffe's last paintings should recall images from decades before is not surprising. There had always been an amazing continuity in her art, as visual ideas were recycled and reworked to meet each new situation. Revisiting old images often led her to new artistic interpretations, and through her work she had come to understand and appreciate the world around her.

119. *No. 15 Special, c.* 1916-17. In an early painting and drawing of 1916-17 O'Keeffe first broached the subject of a cloud-filled sky when she viewed it from the ground in Palo Duro Canyon. Decades later her perspective changed dramatically.

Although O'Keeffe continued to paint into the 1970s, her almost complete loss of eyesight and ill health during the last fifteen years of her life significantly curtailed her artistic productivity. Her eye problems began in 1968, and by 1971 macular degeneration caused her to lose all her central vision, leaving her, eventually, with only some peripheral sight. Unable to sufficiently study her favorite subjects, especially the landscape, she produced few works during these last years. The ones that she did create after 1972 were often painted with the aid of an assistant and were poorer quotations of her earlier work – images that had remained in her mind's eye. She executed her last oil paintings in 1977, and although she managed to work unassisted in water-color and charcoal until 1978 and in graphite until 1984, these works suffered in quality.

Yet even during these waning years O'Keeffe remained true to the spirit of her art through the life she led. Finding in nature a source of sanctuary and regeneration, she continued, well into her nineties, to enjoy early morning walks at sunrise with her two chow dogs, tending her garden, and being surrounded by the

New Mexico landscape. Her philosophy of life seemed to follow the advice given in one of her favorite books, Okakura's *The Book of Tea*: "It is to live with a refined attention to detail – the flowers of the season, the sound of water poured onto stone, the time at which evening turns to dusk – not because these things will enlarge the self, but because they bring our lives into harmony with that which transcends self."

For her, there had been fulfillment in an existence that almost totally revolved around her art. It was, after all, through painting that O'Keeffe filtered all experience.

120. **John Loengard**: *A Sunset Walk over Red Hills*, 1960s. Wedded to the New Mexico landscape since her first visit there in 1929, the artist continued to derive personal strength and artistic inspiration from its rugged terrain for the rest of her life.

One works because I suppose it is the most interesting thing one knows to do. The days one works are the best days. On the other days one is hurrying through the other things one imagines one has to do to keep one's life going. You get the garden planted. You get the roof fixed. You take the dog to the vet. You spend a day with a friend... You may even enjoy doing such things.... But always you are hurrying through these things with a certain amount of aggravation so that you can get at the paintings again because that is the high spot—in a way it is what you do all the other things for.... The painting is like a thread that runs through all the reasons for all the other things that make one's life.

On March 6, 1986 O'Keeffe died in St. Vincent's Hospital in Santa Fe, having almost reached her goal of living to 100; she was 98 years old. About this moment she had once surmised: "When I think of death, I only regret that I will not be able to see this beautiful country anymore...unless the Indians are right and my spirit will walk here after I'm gone." At her request, there was no funeral or memorial service, though her ashes were scattered from the top of the Pedernal over the landscape she had loved for more than half a century.

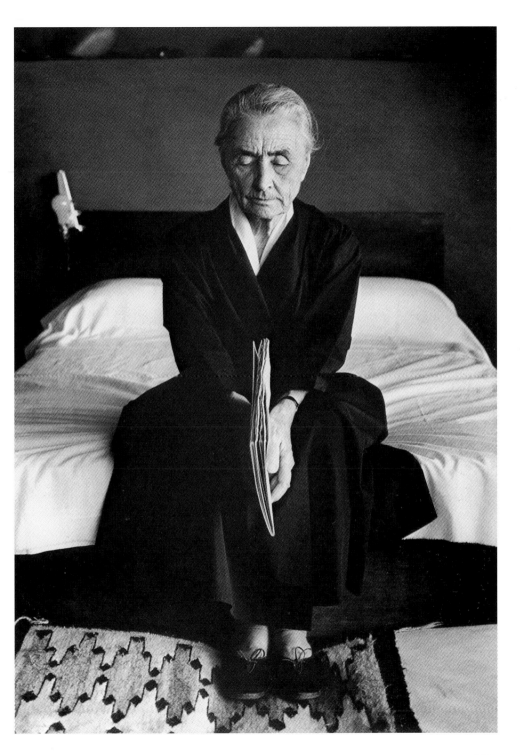

Sources of Quotations

(Complete references to publications cited here can be found in the Select Bibliography)

p.7 "I find that I have painted…" Georgia O'Keeffe, *Georgia O'Keeffe*, opp. pl.. 52.

p. 7 "Colors & line…" O'Keeffe letter to unidentified person, March 21, 1937; reprinted in Charles C. Eldredge, *Georgia O'Keeffe: American and Modern*, p. 164

p. 7 "I think I'd rather let…" O'Keeffe statement in *Contemporary American Painting and Sculpture*, Urbana 1955, p. 226; reprinted in Sarah Greenough, "From the Faraway," in Cowart, Hamilton, and Greenough, *Georgia O'Keeffe: Art and Letters*, p. 135

p. 8 "I am going to be an artist." O'Keeffe quoted in Eldredge, p.18

p.11 "I grew up pretty much …" O'Keeffe, Statement in *Alfred Stieglitz Presents One Hundred Pictures: Oils, Watercolors, Pastels, Drawings, by Georgia O'Keeffe, American*, exh. pamphlet, NY: The Anderson Galleries, 1923, n.p.; reprinted in Barbara Buhler Lynes, *O'Keeffe, Stieglitz and the Critics*, p. 184 (Appendix A, note 11)

p. 15 "I work on an idea for a long time…" O'Keeffe quoted in Lloyd Goodrich and Doris Bry, *Georgia O'Keeffe*, p. 19

p. 16 "form is the outward expression…" Clive Bell, *Art*, quoted in Fine, Glassman, Hamilton, *The Book Room*, p. 20

p. 16 "color directly influences the soul", "produce a correspondent spiritual vibration." Kandinsky, *Concerning the Spiritual in Art*, quoted in Eldredge, *op. cit.*, p. 164

p. 19 "it is the expression of the highest…" Nancy E. Green and Jessie Poesch, *Arthur Wesley Dow and American Arts & Crafts*, p. 57, note 4

p. 19 "The power is within…" Dow, *Composition: A Series of Exercises in Art Structure for the Use of Students and Teachers* (1997), p. 79

p. 19 "the death of art" *ibid.*, p. 97

p. 19 "…art lies in the fine choices…" Dow, "Talks on Appreciation of Art," *The Delineator*, January 1915, p. 15, quoted in Green and Poesch, p. 58

p. 20 "This man had one dominating idea…" O'Keeffe, interviewed in Katharine Kuh, *The Artist's Voice: Talks with Seventeen Artists*, p. 190

p. 20 "O'Keeffe claimed…" Elizabeth Hutton Turner, *Georgia O'Keeffe: The Poetry of Things*, pp. 5–6, Dow quoted from *Composition*, p. 74, and O'Keeffe quoted from letter to Anita Pollitzer, October 1915, in Pollitzer, *A Woman on Paper: Georgia O'Keeffe*, p. 29

p. 21 "It's a wonderful night…" O'Keeffe letter to Anita Pollitzer, October 1915; reprinted in Giboire (ed.), *Lovingly Georgia*, p. 71

p. 24 "purest, finest, sincerest things…" Stieglitz, quoted in Lowe, *Stieglitz: A Memoir*, p. 201

p. 24 "It is unlikely…" Lynes, *O'Keeffe, Stieglitz and the Critics*, pp. 5–6

p. 24 "One morning before daylight…" O'Keeffe quoted in *Some Memories of Drawings*, edited by Doris Bry, Albuquerque 1988 (originally published by Atlantis Editions, 1974), n.p.

pp. 26–27 "The one I want…" Stieglitz letter to O'Keeffe, July 13, 1916; reprinted in Lynes, *O'Keeffe, Stieglitz and the Critics*, p. 7, and p.322, note 24

p. 28 "Maybe a kiss…" O'Keeffe in Bry, *op. cit.*, n.p.

p. 30 "Eroticism!…" O'Keeffe quoted in Dorothy Seiberling, "The Female View of Erotica," *New York Magazine*, note 7, February 11, 1974, p. 54; reprinted in Lynes, *op. cit.*, p. 158

p. 30 "I found that I could say things…" O'Keeffe, Statement in *Alfred Stieglitz Presents One Hundred Pictures. . .*, reprinted in Lynes, *ibid.*, p. 184 (Appendix A, note 11)

p. 30 "great art could come…" Dow's theories expressed in *Composition* and restated in Turner, *op. cit.*, p. 2

p. 30 "typical heavenly color…" Kandinsky, *Concerning the Spiritual in Art*, quoted in Eldredge, *op. cit.*, p. 164

p. 31 "'Two Lives,' a man's and a woman's…" Henry Tyrrell, "New York Art Exhibition and Gallery Notes: Esoteric Art at '291'," *The Christian Science Monitor*, May 4, 1917; article reprinted in Lynes, *op. cit.*, p. 168 (Appendix A, note 3), see also p. 22 and p. 327, note 84

p. 33 "The plains – the wonderful great big sky …" O'Keeffe letter to Alfred Stieglitz, September 4, 1916, reprinted in Cowart, Hamilton, and Greenough, p. 155, note 13

p. 36 "I have painted portraits …" O'Keeffe in *Georgia O'Keeffe*, opp. pl. 55

p. 41 "thrilling imprisonment …" Edward Alden Jewell, "Georgia O'Keeffe in an Art Review," *New York Times*, Feb. 2, 1934, p. 15

p. 44 "…I've been wanting to tell you…" O'Keeffe letter to Paul Strand, written on the train from New York to Texas, June 3, 1917, reprinted in Cowart, Hamilton, and Greenough, p. 161, note 17

p. 44 "Paul Strand has added to photography…" O'Keeffe, "To MSS. and Its 33 Subscribers and Others Who Read and Don't Subscribe!," letter to the editor in *MSS.*, note 4, December 1922, pp.17–18; reprinted in Lynes, *op. cit.*, pp. 183–184 (Appendix A, note 10)

p. 45 "For me he was much more wonderful in his work…" O'Keeffe, "Introduction," in *Georgia O'Keeffe: A Portrait by Alfred Stieglitz*.

p. 45 "Nothing is less real than realism…" O'Keeffe quoted in "I Can't Sing, So I Paint! Says Ultra Realistic Artist; Art Is Not Photography – It is Expression of Inner Life!: Miss O'Keeffe Explains Subjective Aspect of Her Work," *New York Sun*, December 5, 1922; reprinted in Lynes, *op. cit.*, p. 180

p. 50 "Music that makes holes in the sky." O'Keeffe letter to Anita Pollitzer, January 14, 1916; reprinted in Cowart, Hamilton, and Greenough, p. 149, note 7

p. 50 "desire to make the unknown – known" O'Keeffe letter to Sherwood Anderson (September 1923), reprinted in Cowart, Hamilton, and Greenough, p. 174, note 29

p. 51 "I did not notice that they were alike…" O'Keeffe in *Georgia O'Keeffe*, opp. pl. 52

p. 52 "I wish you could see the place here…" O'Keeffe to Sherwood Anderson, c. September 1923, reprinted in Cowart, Hamilton, and Greenough, p. 173, note 29

p. 57 "by themselves [leaves]…" Marjorie P. Balge-Crozier in *Georgia O'Keeffe: The Poetry of Things*, p. 54

p. 57 "take a maple leaf…" O'Keeffe quoted in Calvin Tomkins, "The Rose in the Eye Looked Pretty Fine," *The New Yorker*, March 4, 1974, p. 42

p. 59 "tart harmonies", "curious, biting, pungent savor." Paul Rosenfeld, *Port of New York: Essays on Fourteen American Moderns*, New York 1924, pp. 203–204

p. 59 "self portrayed through flowers and fruits." Alfred Stieglitz letter to Paul Rosenfeld, November 9, 1924; reprinted in Lynes, *op. cit.*, p. 334, note 36

p. 67 "The growing corn was one of my special interests…" O'Keeffe in *Georgia O'Keeffe*, opp. pl. 34

p. 67 "…the dark green stalks…" Edmund Wilson, "The Stieglitz Exhibition," *The New Republic*, note 42, March 18, 1925; reprinted in Lynes, *op. cit.*, pp. 227-228 (Appendix A, note 37)

p. 70 "everyone has many associations…" O'Keeffe in *Georgia O'Keeffe*, opp. pl. 23

p. 70 "Well Georgia, I don't know how…" Stieglitz, quoted in Laurie Lisle, *Portrait of an Artist*, p. 171

p. 70 "Alfred was always a little timid…" O'Keeffe letter to William Howard Schubart, July 28, 1950, reprinted in Cowart, Hamilton,and Greenough, p. 253, note 102

p. 76 "You paint *from* your subject,…" O'Keeffe, interviewed in Kuh, p. 200

p. 80 "We live high up…." Alfred Stieglitz letter to Sherwood Anderson, December 9, 1925; reprinted in Sarah Greenough and Juan Hamilton, *Alfred Stieglitz: Photographs and Writings*, p. 214

p. 80 "paint New York", "told that it was an impossible idea" O'Keeffe in *Georgia O'Keeffe* , opp. pl. 17

p. 80 "I know it's unusual…" O'Keeffe quoted in B. Vladimir Berman, "She Painted the Lily and Got $25,000 and Fame for Doing It," *New York Evening Graphic Magazine Section*, May 12, 1928, p. 3M

p. 86 "I went out one morning…" O'Keeffe in *Georgia O'Keeffe*, opp. pl. 19

p. 91 "I loved running down the board walk…" *ibid.*, opp. pl. 46

p. 91 "a misty landscape…" *ibid.*, opp. pl. 52

p. 94 "exquisite precision…" Henry McBride in *The New York Sun*, January 14, 1933, quoted in Mitchell A. Wilder, ed., *Georgia O'Keeffe*, Fort Worth: Amon Carter Museum 1966, p. 17

p. 95 "It was surprising to me…" O'Keeffe in *Georgia O'Keeffe*, introduction, n.p.

p. 100 "a message for a friend…" O'Keeffe in *Georgia O'Keeffe*, opp. pl. 53

p. 100 "turn to the pages about flowers…." O'Keeffe quoted in Turner, *op. cit.*, p. vii

p. 101 "…the strange shapes and…" O'Keeffe in *Georgia O'Keeffe*, introduction, n.p.

p. 106 "…the most beautiful adobe studio …" O'Keeffe letter to Henry McBride, Summer 1929, reprinted in Cowart, Hamilton, and Greenough, p. 189, note 44

p. 106 "…at home in the East…" O'Keeffe letter to Henry McBride, Summer 1929, reprinted in Cowart, Hamilton, and Greenough, p. 189, note 44

p. 106 "When I saw my exhibition…" O'Keeffe letter to Ettie Stettheimer written on train from New Mexico to New York, August 24, 1929, reprinted in Cowart, Hamilton, and Greenough, p. 195, note 49

p. 106 "I am divided…" O'Keeffe letter to Russell Vernon Hunter, Spring 1932, reprinted in Cowart, Hamilton, and Greenough, p. 207, note 61

p. 108 "you lie under it…" O'Keeffe letter to Mabel Dodge Luhan, August 1929; reprinted in Cowart, Hamilton, and Greenough, p. 192, note 47

p. 113 "a thin dark veil of the Catholic Church." O'Keeffe quote written on the back of an envelope from the 1930s; reprinted in Fine, Glassman, Hamilton, p. 50

p. 113 "a way of painting the country." O'Keeffe in *Georgia O'Keeffe*, opp. pl. 64

p. 116 "It was the shapes of the hills…" O'Keeffe, quoted in Tomkins, *op. cit.*, p. 54

p. 117 "It is a beautiful white trumpet flower…" O'Keeffe in *Georgia O'Keeffe*, opp. pl. 84.

p. 120 "desire to paint something for a particular place…" O'Keeffe letter to Blanche Matthias, April 1929; reprinted in Cowart, Hamilton, and Greenough, p. 188, note 43

p. 122 "To me they are as beautiful…" Georgia O'Keeffe, "About Myself," in *Georgia o'Keeffe: Exhibition of Oils and Pastels*, New York: An American Place 1939, n.p.

p. 128 "there was a source in *America*…" William Carlos Williams, *In the American Grain*, New York 1925, p. 109

p.128 "to recognize his 'new locality'…" Rick Stewart, "Charles Sheeler, William Carlos Williams, and Precisionism: A Redefinition," *Arts Magazine*, November 1983, p. 105; quote by William Carlos Wllliams, *loc. cit.*

p. 128 "There was a lot of talk in New York…" O'Keeffe, quoted in Tomkins, pp. 48, 50

p. 129 "entirely and locally American" Herbert Seligman, "Georgia O'Keeffe," *Manuscripts*, note 4 (1923), p. 10

p. 129 "I am one of the few…" O'Keeffe letter to James Johnson Sweeney, June 11, 1945, reprinted in Cowart, Hamilton, and Greenough, p. 241, note 90

p. 129 "a new way of trying…" O'Keeffe letter to Russell Vernon Hunter, January 1932; reprinted in Cowart, Hamilton, and Greenough, p. 205, note 59

p. 132 "For Georgia / without whose being…" Alfred Stieglitz inscription in Waldo Frank, Lewis Mumford, Dorothy Norman, and Harold Rugg (eds.), *America & Alfred Stieglitz: A Collective Portrait* , New York 1934; reprinted in Fine, Glassman, Hamilton, p. 32

p. 132 "inevitable and natural…" Lewis Mumford, *Autobiographies in Paint*, p. 48

p. 133 "relationships are more real…" Ernest Fenollosa, *Chinese Written Character*; reprinted in Turner, *op. cit.*, p. 14

p. 133 "are not real; no deer or elk…" *ibid*, p. 65

p. 135 "a beautiful, untouched lonely-feeling place…" O'Keeffe in *Georgia O'Keeffe*, opp. pl. 60

p. 136 "no longer something not filled…" Laurence Binyon, *The Flight of the Dragon: An Essay on the Theory and Practice of Art in China and Japan* (1911), quoted in Fine, Glassman, Hamilton, p. 21

p. 136 "the universe through the portal of a bone." Jean Toomer, letter to O'Keeffe, January 29, 1945; reprinted in Eldredge, *op. cit.*, p. 175

p. 136 "hold up a card with a square hole in it…" William Merritt Chase quoted in D. Scott Atkinson and Nicolai Cikovsky, Jr., *William Merritt Chase: Summers at Shinnecock, 1891-1902*, Washington, D.C. 1987, p.26; reprinted in Turner, *op. cit*, p. 66

p. 137 "the blue and the red of the bone series…" O'Keeffe to Caroline Fesler, December 24, 1945, reprinted in Cowart, Hamilton, and Greenough, pp. 242-43, note 92

p. 140 "The skies and land are so enormous…" Ansel Adams letter to Alfred Stieglitz, September 21, 1937; reprinted in Eldredge, *op. cti.*, p. 204

p.141 "As soon as I saw it…"Georgia O'Keeffe, quoted in *Atlantic Monthly*, December 1971

p. 141 "I wish you could see what I see…" Georgia O'Keeffe, letter to Arthur Dove, September 1942, reprinted in Cowart, Hamilton, and Greenough, p. 233, note 83

p. 144 "Out here, half your work is done for you." O'Keeffe quoted in Tomkins, p. 53

p. 145 "the right-hand front seat, unbolt the driver's seat…" O'Keeffe in *Georgia O'Keeffe* , opp. pl. 59

p. 145 "some of our barest country." O'Keeffe letter to Carl Zigrosser, April 1944, reprinted in Cowart, Hamilton, and Greenough, p. 237, note 86

p. 145 "a mile of elephants," and "evenly crackled" O'Keeffe in *Georgia O'Keeffe*, opp. pl. 59

p. 149 "When I first saw…" O'Keeffe in *Georgia O'Keeffe*, opp. pl. 82

p. 152 "draw a square and put a door in it…" O'Keeffe quoted in Tomkins, p. 42

p. 153 "in an odd way the utter foolishness of doing that…" O'Keeffe letter to Margaret Kiskadden, Fall 1947; reprinted in Cowart, Hamilton, and Greenough, p. 247, note 96

p. 153 "One morning the world was covered with snow…." O'Keeffe in *Georgia O'Keeffe*, opp. pl. 86

p. 158 "that wide empty country" O'Keeffe in *Georgia O'Keeffe*, opp. pl. 3

p. 158 "wanted to see the murals…" O'Keeffe quoted in Fine, Glassman, Hamilton, p. 33

p. 160 "It is breathtaking…" O'Keeffe letter to Maria Chabot, written in midair, November 1941, reprinted in Cowart, Hamilton, and Greenough, p.231, note 81

p. 161 "such incredible colors…" O'Keeffe quoted in Kuh, p. 202

p. 162 "Throughout O'Keeffe's career…" Judith C. Walsh, "The Language of O'Keeffe's Materials: Charcoals, Watercolor, Pastel," in Ruth E. Fine and Barbara Buhler Lyne, *O'Keeffe on Paper*, p. 58

p. 164 "Two walls of my room…" O'Keeffe in *Georgia O'Keeffe*, opp. pl. 104

p. 169 "You know every time I see that man's work…" O'Keeffe quoted in Barbara Rose, "Opinion: The Truth about Georgia O'Keeffe," *The Journal of Art*, v. 2, No. 5, February 1990, p. 24

p. 173 "The black rocks…" O'Keeffe in *Georgia O'Keeffe*, opp. pl. 107

p. 176 "One day when I was flying…" O'Keeffe quoted in *Some Memories of Drawings*, n.p.

p. 176 "was especially fascinated by…" Barbara Rose, *loc. cit.*

p. 176–77 "a metaphysical statement…" Juan Hamilton, "In O'Keeffe's World," in Cowart, Hamilton, and Greenough, p. 11

p. 177 "see gradations of light…" *Ibidem*

p. 177 "upward bound feeling…" *Ibidem*

p. 177 "The next time I flew…" O'Keeffe in *Georgia O'Keeffe*, opp. pl. 106

p. 179 "Such a size is of course ridiculous…" O'Keeffe letter to Adelyn Dohme Breeskin, November 26, 1965; reprinted in Cowart, Hamilton, and Greenough, p. 269, note 119

p. 179 "the weather seemed…" O'Keeffe quoted in Bry, *op. cit.*, n.p.

p. 181 "It is to live with a refined attention…" Soshitsu Sen XV quoted in Kakuzo Okakura, *The Book of Tea*, New York 1923; originally published 1906) ; reprinted in Wood and Patten, *O'Keeffe in Abiquiu*, p. 28

p. 182 "One works because…" O'Keeffe, quoted in Lee Nordness, *Art USA Now*, Lucerne 1962; reprinted in Lisle, pp.403-404

p.182 "When I think of death…" O'Keeffe quoted in Henry Seldis, "Georgia O'Keeffe at 78: Tough Minded Romantic," *Los Angeles Times West Magazine*, January 22, 1967, p. 22; reprinted in Katherine Hoffman, *An Enduring Spirit: The Art of Georgia O'Keeffe*, Metuchen, New Jersey and London 1984, p. 128

Select Bibliography

Adato, Perry Miller. *O'Keeffe: Portrait of an Artist series* (videotape). WNET/Thirteen Production. Distributed by Home Vision, Chicago, 1977

Arrowsmith, Alexandra and Thomas West (eds). Essays by Belinda Rathbone, Roger Shattuck, and Elizabeth Hutton Turner. *Georgia O'Keeffe & Alfred Stieglitz: Two Lives, A Conversation in Paintings and Photographs.* Exh. cat. New York: Callaway Editions in association with The Phillips Collection, Washington, D.C., 1992

Arthur Wesley Dow: His Art and His Influence. Exh. cat. New York: Spanierman Gallery, Inc., 1999

Bry, Doris and Nicholas Callaway. *Georgia O'Keeffe: in the West.* New York: Knopf in association with Callaway Editions, 1989

Bry, Doris and Nicholas Callaway. *Georgia O'Keeffe: The New York Years.* New York: Knopf in association with Callaway Editions, 1991

Callaway, Nicholas (ed). *Georgia O'Keeffe: One Hundred Flowers.* New York: Knopf in association with Callaway Editions, 1987

Corn, Wanda M. *The Great American Thing: Modern Art and National Identity, 1915-1935.* Berkeley: University of California Press, 1999

Cowart, Jack, Juan Hamilton, and Sarah Greenough. *Georgia O'Keeffe: Art and Letters.* Exh. cat. Washington, D.C.: National Gallery of Art, in association with New York Graphic Society Books, Boston: Little, Brown and Company, 1987

Dow, Arthur Wesley. *Composition: A Series of Exercises in Art Structure for the Use of Students and Teachers.* First published in 1899 (Boston: J.M. Bowles); the first reprint was published in 1913 (New York: Doubleday, Page and Co., Inc.), and most recently it was reprinted in 1997 with an introduction by Joseph Masheck (Berkeley: University of California Press)

Eldredge, Charles C. *Georgia O'Keeffe.* New York: Harry N. Abrams in association with The National Museum of American Art, Washington, D.C., 1991

Eldredge, Charles C. *Georgia O'Keeffe: American and Modern.* New Haven and London: Yale University Press, 1993

Fine, Ruth E., Elizabeth Glassman, and Juan Hamilton, *The Book Room: Georgia O'Keeffe's Library in Abiquiu,* with entries by Sarah Burt. Exh. cat. Abiquiu, NM: The Georgia O'Keeffe Foundation and The Grolier Club, 1997

Fine, Ruth E. and Barbara Buhler Lynes, with Elizabeth Glassman and Judith C. Walsh. *O'Keeffe on Paper.* Exh. cat. Washington, D.C.: National Gallery of of Art, 2000

Georgia O'Keeffe: A Portrait by Alfred Stieglitz. Introduction by Georgia O'Keeffe. *Afterword* by Maria Morris Hambourg. Exh. cat. New York: The Metropolitan Museum of Art, 1997 (first published 1978; *Afterword* added in 1997 edition)

Giboire, Clive (ed). *Lovingly Georgia: The Complete Correspondence of Georgia O'Keeffe & Anita Pollitzer.* New York: Simon & Schuster/A Touchstone Book, 1990

Goodrich, Lloyd and Doris Bry. *Georgia O'Keeffe.* Exh. cat. New York: Whitney Museum of American Art, 1970

Green, Nancy E. and Jessie Poesch. *Arthur Wesley Dow and American Arts & Craft.* Exh. cat. New York: The American Federation of Arts, 1999

Greenough, Sarah. "From the American Earth: Alfred Stieglitz's Photographs of Apples," in *Art Journal,* vol. 41, Spring 1981, pp. 46-54

Greenough, Sarah and Juan Hamilton. *Alfred Stieglitz: Photographs & Writings.* Exh. cat. Washington, D.C.: National Gallery of Art, Callaway Editions, 1983

Hassrick, Peter H. (ed). *The Georgia O'Keeffe Museum,* Introduction by Mark Stevens. Essays by Lisa Mintz Messinger, Barbara Novak, and Barbara Rose. New York: Harry N. Abrams, Inc. in association with The Georgia O'Keeffe Museum, Santa Fe, NM, 1997

Homer, William Inness. *Alfred Stieglitz and the American Avant-Garde.* Boston: New York Graphic Society, 1977

Kornhauser, Elizabeth Mankin and Amy Ellis, with Maura Lyons. *Stieglitz, O'Keeffe & American Modernism.* Exh. cat. Hartford: Wadsworth Atheneum, 1999

Kuh, Katharine. *The Artist's Voice: Talks with Seventeen Artists.* New York: Harper & Row, 1962

Lisle, Laurie. *Portrait of an Artist: A Biography of Georgia O'Keeffe.* New York: Seaview Books, 1980

Loengard, John. *Georgia O'Keeffe at Ghost Ranch: A Photo-Essay.* New York: Neues Publishing Co., 1998

Lowe, Sue Davidson. *Stieglitz: A Memoir/Biography.* New York: Farrar Straus Giroux, 1983

Lynes, Barbara Buhler. *O'Keeffe, Stieglitz and the Critics, 1916-1929.* Ann Arbor & London: U.M.I Research Press, 1989

Lynes, Barbara Buhler. *Georgia O'Keeffe: Catalogue Raisonné, Volumes One and Two.* National Gallery of Art, Washington, D.C. and The Georgia O'Keeffe Foundation, Abiquiu, NM; published by New Haven and London: Yale University Press, 1999

Lynes, Barbara Buhler with Russell Bowman. *O'Keeffe's O'Keeffes: The Artist's Collection.* London and New York: Thames & Hudson, 2001

Merrill, Christopher and Ellen Bradbury (eds). *From the Faraway Nearby: Georgia O'Keeffe as Icon.* Reading, MA: Addison-Wesley Publishing Co., 1992

Messinger, Lisa Mintz. *The Metropolitan Museum of Art Bulletin: Georgia O'Keeffe.* New York: The Metropolitan Museum of Art, New York, Fall 1984

Messinger, Lisa Mintz. *Georgia O'Keeffe.* New York: Thames and Hudson and The Metropolitan Museum of Art, New York, 1988

O'Keeffe, Georgia. Edited by Doris Bry. *Some Memories of Drawings.* Albuquerque, NM: University of New Mexico Press, 1988 (originally published by Atlantis Editions, 1974)

O'Keeffe, Georgia. *Georgia O'Keeffe,* New York: Viking Press, 1976

Peters, Sarah Whitaker. *Becoming O'Keeffe: The Early Years.* New York: Abbeville Press, 1991

Pollitzer, Anita. *A Woman on Paper: Georgia O'Keeffe.* New York: Simon & Schuster, 1988

Rich, Daniel Catton. *Georgia O'Keeffe.* Exh. cat. Chicago: Art Institute of Chicago, 1943

Robinson, Roxana. *Georgia O'Keeffe: A Life.* New York: Harper & Row, 1989

Sims, Patterson. *Georgia O'Keeffe: A Concentration of Works from the Permanent Collection of the Whitney Museum of American Art.* Exh. cat. New York: Whitney Museum of American Art, 1981

Tomkins, Calvin. "Profiles: The Rose in the Eye Looked Pretty Fine," in *The New Yorker,* vol. 50, March 4, 1974, pp. 40-66

Turner, Elizabeth Hutton, with essay by Marjorie P. Balge-Crozier. *Georgia O'Keeffe: The Poetry of Things.* Exh. cat. Washington, D.C.: The Phillips Collection and Yale University Press, 1999

Wagner, Anne Middleton. *Three Artists (Three Women): Modernism and the Art of Hesse, Krasner, and O'Keeffe.* Berkeley: University of California Press, 1996

Webb, Todd. Photographs by Todd Webb. *Georgia O'Keeffe: The Artist's Landscape.* Pasadena, CA: Twelvetrees Press, 1984

Wood, Myron. Photographs by Myron Wood. Text by Christine Taylor Patten. *O'Keeffe at Abiquiu.* New York: Harry N. Abrams, Inc., 1995

List of Illustrations

All works by Georgia O'Keeffe © ARS, NY and DACS, London 2001 except for illustrations 50, 74 and 83 which are copyright © The Art Institute of Chicago

Dimensions of works are given in centimeters and inches, height before width

Frontispiece: Alfred Stieglitz, *Georgia O'Keeffe: A Portrait - Head*, 1920. Photograph. National Gallery of Art, Washington, D.C. Photograph © 2001 Board of Trustees, National Gallery of Art, Washington, D.C.; **2** Georgia O'Keeffe, *Dead Rabbit with Copper Pot*, 1908. Oil on canvas, 50.8 x 61.0 (20 x 24). The Art Students League of New York (CR 39); **3** Edward Steichen, *Alfred Stieglitz at "291,"* 1915. Gray pigment gum-bichromate over platinum or gelatin-silver, 28.8 x 24.2 (11⅜ x 9⁹⁄₁₆). The Metropolitan Museum of Art, Alfred Stieglitz Collection, 1933 (33.43.29). Photograph © The Metropolitan Museum of Art. Reprinted with permission of Joanna T. Steichen; **4** Henri Matisse, *Nude*, 1908. Pencil on paper, 30.5 x 23.2 (12 x 9⅛). The Metropolitan Museum of Art, Alfred Stieglitz Collection, 1949 (49.70.8). Photograph © The Metropolitan Museum of Art. © Succession H. Matisse/DACS 2001; **5** Alfred Stieglitz, *Georgia O'Keeffe*, 1918. Platinum print, 11.7 x 9.0 (4⅝ x 3½). The Metropolitan Museum of Art, Gift of Georgia O'Keeffe through the generosity of The Georgia O'Keeffe Foundation and Jennifer and Joseph Duke, 1997 (1997.61.25). Photograph © The Metropolitan Museum of Art; **6** Georgia O'Keeffe, *Drawing XIII*, 1915. Charcoal on paper, 62.2 x 48.3 (24½ x 19). The Metropolitan Museum of Art, Alfred Stieglitz Collection, 1950 (50.236.2). Photograph © 1997 The Metropolitan Museum of Art (CR 157); **7** Arthur Dove, *Sentimental Music*, 1917. Pastel on paper, mounted on plywood, 54.0 x 45.4 (21¼ x 17⅞). The Metropolitan Museum of Art, Alfred Stieglitz Collection, 1949 (49.70.77). Photograph © The Metropolitan Museum of Art; **8** Vincent van Gogh, *Cypresses*, 1889. Oil on canvas, 93.4 x 74.0 (36⅞ x 29¼). The Metropolitan Museum of Art, Rogers Fund, 1949 (49.30). Photograph © The Metropolitan Museum of Art; **9** Georgia O'Keeffe, *Abstraction IX*, 1916. Charcoal on paper, 61.5 x 47.5 (24¼ x 18¾). The Metropolitan Museum of Art, Alfred Stieglitz Collection, 1969 (69.278.4). Photograph by Malcolm Varon. Photograph © 1984 The Metropolitan Museum of Art (CR 99); **10** Pamela Colman Smith, *The Wave*, 1903. Watercolor on paper, 26.0 x 45.1 (10¼ x 17¾). Collection of Whitney Museum of American Art, New York, Gift of Mrs. Sidney N. Heller. Photograph © 2000: Collection Whitney Museum of Art, New York; **11** Alfred Stieglitz, *Georgia O'Keeffe: A Portrait - Painting and Sculpture*, 1919. Palladium print, 23.3 x 19.4 (9⁹⁄₁₆ x 7⅝). National

Gallery of Art, Alfred Stieglitz Collection. Photograph © Board of Trustees, National Gallery of Art, Washington, D.C.; **12** Georgia O'Keeffe, *Blue Lines X*, 1916. Watercolor on paper, 63.5 x 48.3 (25 x 19). The Metropolitan Museum of Art, Alfred Stieglitz Collection, 1969 (69.278.3). Photograph by Malcolm Varon. Photograph © 1987 The Metropolitan Museum of Art (CR 64); **13** Georgia O'Keeffe, *Canyon with Crows*, 1917. Watercolor and graphite on paper, 22.5 x 30.5 (8⅞ x 12). Private Collection (CR 197); **14** Arthur Wesley Dow, *August Moon*, c. 1905. Color woodcut, 11.4 x 18.1 (4½ x 7⅛). Collection Theodore A. Donson and Marvel M. Griepp; **15** Georgia O'Keeffe, *Evening Star No. IV*, 1917. Watercolor on paper, 22.5 x 30.5 (8⅞ x 12). Private Collection (CR 202); **16** Georgia O'Keeffe, *Evening Star No. V*, 1917. Watercolor on paper, 22.2 x 30.2 (8¾ x 11⅞). Collection of McNay Art Museum, Bequest of Helen Miller Jones (CR 203); **17** Edward Steichen, *The Little Round Mirror*, 1902. Gum bichromate print. The Metropolitan Museum of Art, Gift of Alfred Stielgitz, 1933 (33.43.32). Photograph © The Metropolitan Museum of Art. Reprinted with permission of Joanna T. Steichen; **18** Georgia O'Keeffe, *Untitled ("Portrait of Paul Strand")*, 1917. Watercolor on paper, 30.5 x 22.5 (12 x 8⅞). Michael and Fiona Scharf, New York (CR 189); **19** Georgia O'Keeffe, *Seated Nude XI*, 1917. Watercolor on paper, 30.2 x 22.5 (11⅞ x 8⅞). The Metropolitan Museum of Art, Purchase, Mr. and Mrs. Milton Petrie Gift, 1981 (1981.194). Photograph © 1982 The Metropolitan Museum of Art (CR 179); **20** Georgia O'Keeffe, *A Storm*, 1922. Pastel on paper 46.4 x 61.9 (18¼ x 24⅜). The Metropolitan Museum of Art, Purchase, Anonymous Gift, 1981 (1981.35). Photograph by Malcolm Varon. Photograph © 1984 The Metropolitan Museum of Art (CR 385); **21** John Marin, *Storm, Taos Mountain, New Mexico*, 1930. Watercolor on paper, 40.0 x 54.9 (15¾ x 21⅝). The Metropolitan Museum of Art, Alfred Stieglitz Collection, 1949 (49.70.144). Photograph © The Metropolitan Museum of Art. © ARS, NY and DACS, London 2001; **22** Georgia O'Keeffe, *Pink and Green Mountains IV*, 1917. Watercolor on paper, 22.9 x 30.5 (9 x 12). Spencer Museum of Art, The University of Kansas, Museum Purchase, Letha Churchill Walker Memorial Fund (CR 221); **23** Paul Strand, *Bay Shore, Long Island, New York*, 1914. Platinum photograph with gouache, 18.9 x 31.6 (7⁷⁄₁₆ x 12⅛). The J. Paul Getty Museum, Los Angeles. © The Aperture Foundation Inc., Paul Strand Archive; **24** Georgia O'Keeffe, *Music - Pink and Blue No. 2*, 1918. Oil on canvas, 88.9 x 74.0 (35 x 29¼). Collection of Whitney Museum of American Art, New York, Gift of Emily Fisher Landau in honour of Tom Armstrong. Photo by Geoffrey Clements. Photograph © 2000: Whitney Museum of American Art, New York (CR 258);

25 Georgia O'Keeffe, *Grey Lines with Black, Blue and Yellow*, c. 1923. Oil on canvas, 121.9 x 76.2 (48 x 30). Museum of Fine Arts, Houston, Museum Purchase with funds provided by the Agnes Cullen Arnold Endowment Fund (CR 447); **26** Georgia O'Keeffe, *Blue and Green Music*, 1921. Oil on canvas, 58.4 x 48.3 (23 x 19). Art Institute of Chicago, Alfred Stieglitz Collection, gift of Georgia O'Keeffe, 1969.835. Photograph © 2001 The Art Institute of Chicago, All Rights Reserved (CR 344); **27** Georgia O'Keeffe, *Flower Abstraction*, 1924. Oil on canvas, 121.9 x 76.2 (48 x 30). Collection of Whitney Museum of American Art, New York, 50th Anniversary Gift of Sandra Payson. Photography by Steven Sloman © 1987. Photograph © 1997: Whitney Museum of American Art, New York (CR 458); **28** Georgia O'Keeffe, *Flagpole*, 1925. Oil on canvas, 88.9 x 46.0 (35 x 18⅛). Georgia O'Keeffe Museum, Gift of the Burnett Foundation and an Anonymous Donor © The Georgia O'Keeffe Foundation (CR 481); **29** Alfred Stieglitz, *Little House, Lake George*, c. 1934. Photograph. National Gallery of Art, Washington, D.C. Photograph © 2001 Board of Trustees, National Gallery of Art, Washington, D.C.; **30** Charles Sheeler, *Bucks County House, Interior Detail*, 1917. Gelatine silver print, 22.8 x 16.6 (9 x 6⁹⁄₁₆). The Metropolitan Museum of Art, Alfred Stieglitz Collection, 1933 (33.43.260). Photograph © The Metropolitan Museum of Art; **31** Alfred Stieglitz, *House and Grape Leaves*, 1934. Gelatin silver print, 58.4 x 48.3 (23 x 19). Gift of Miss Georgia O'Keeffe, 1950. Courtesy, Museum of Fine Arts, Boston. Reproduced with permission. © 2000 Museum of Fine Arts, Boston. All Rights Reserved; **32** Georgia O'Keeffe, *Farmhouse Window and Door*, 1929. Oil on canvas, 101.6 x 76.2 (40 x 30). The Museum of Modern Art, New York. Acquired through the Richard D. Brixey Bequest. Photograph © 2001 The Museum of Modern Art, New York (CR 653); **33** Georgia O'Keeffe, *Apple Family – 2*, 1920. Oil on canvas, 20.6 x 25.7 (8⅛ x 10⅛). Georgia O'Keeffe Museum, Gift of the Burnett Foundation and The Georgia O'Keeffe Foundation © The Georgia O'Keeffe Museum (CR 315); **34** Alfred Stieglitz, *Lake George*, 1922. Silver gelatin print, 11.4 x 9.1 (4½ x 3⅝). Art Institute of Chicago, Alfred Stieglitz Collection, 1949.728. Photograph © 2000, The Art Institute of Chicago, All Rights Reserved; **35** Georgia O'Keeffe, *Untitled (Self-Portrait - Torso)*, c. 1919. Oil on canvas, 31.1 x 25.7 (12¼ x 10⅛). Joanne Kuhn Titolo, Indiana (CR 309); **36** Alfred Stieglitz, *Georgia O'Keeffe: A Portrait – Breasts*, 1919. Palladium print, 24.4 x 19.3 (9⅝ x 7⅝). The Metropolitan Museum of Art, Gift of Georgia O'Keeffe through the generosity of The Georgia O'Keeffe Foundation and Jennifer and Joseph Duke, 1997 (1997.61.23). Photograph © The Metropolitan Museum of Art; **37** Charles Demuth, *Poster Portrait: Georgia O'Keeffe*,

1923-24. Poster paint. Collection of American Literature, Beinecke Rare Book and Manuscript Library, Yale University; **38** Georgia O'Keeffe, *Autumn Trees - The Maple*, 1924. Oil on canvas, 91.4 x 76.2 (36 x 30). Georgia O'Keeffe Museum, Gift of the Burnett Foundation & Gerald and Kathleen Peters © The Georgia O'Keeffe Museum (CR 474); **39** Georgia O'Keeffe, *Grey Tree, Lake George*, 1925. Oil on canvas, 91.4 x 76.2 (36 x 30). The Metropolitan Museum of Art, Alfred Stieglitz Collection, Bequest of Georgia O'Keeffe, 1986 (1987.377.2). Photograph by Malcolm Varon. Photograph © 1997 The Metropolitan Museum of Art (CR512); **40** Charles Demuth, *Trees*, 1917. Watercolor on paper, 34.3 x 24.1 (13½ x 9½). Private Collection; **41** Georgia O'Keeffe, *Corn, Dark I*, 1924. Oil on canvas, 80.5 x 30.4 (31¾ x 11⅞). The Metropolitan Museum of Art, Alfred Stieglitz Collection, 1950 (50.236.1). Photograph by Malcolm Varon. Photograph © 1984 The Metropolitan Museum of Art (CR 455); **42** Georgia O'Keeffe, *Black and Purple Petunias*, 1925. Oil on canvas, 50.8 x 63.5 (20 x 25). Private Collection, Hillsborough, CA (CR 490); **43** Georgia O'Keeffe, *Petunia and Glass Bottle, c. 1924–25*. Oil on canvas, 50.8 x 25.4 (20 x 10). Denver Art Museum Collection, Gift of the Hendrie Sisters in memory of their father, Charles F. Hendrie, 1966.44 © Denver Art Museum 2001 (CR 489); **44** Edward Weston, *Artichoke Halved*, 1930. Gelatin silver print, 10.0 x 24.1 (7½ x 9½). The Museum of Modern Art, New York. Gift of David McAlpin. Copy Print © The Museum of Modern Art, New York © 1981 Center for Creative Photography, Arizona Board of Regents; **45** Imogen Cunningham, *Leaf Pattern*, 1920s. Gelatin silver print. The Metropolitan Museum of Art, Dorothy Levitt Beskind Gift, 1973 (1973.540.2). Photograph © The Metropolitan Museum of Art. © The Imogen Cunningham Trust; **46** Georgia O'Keeffe, *Black Iris III*, 1926. Oil on canvas, 91.4 x 75.9 (36 x 29⅞). The Metropolitan Museum of Art, Alfred Stieglitz Collection, 1969 (69.278.1). Photograph by Malcolm Varon. Photograph © 1987 The Metropolitan Museum of Art (CR 557); **47** Georgia O'Keeffe, *Black Petunias and White Morning Glory*, 1926. Oil on canvas, 91.0 x 75.5 (35⅞ x 29⅞). © The Cleveland Museum of Art, Bequest of Leonard C. Hanna, Jr., 1958.42 (CR 561); **48** Alfred Stieglitz, *Old and New New York*, 1910. Photograph. The Metropolitan Museum of Art, Alfred Stieglitz Collection, 1949 (49.55.17). Photograph © The Metropolitan Museum of Art; **49** Charles Sheeler, *Skyscrapers*, 1922. Oil on canvas, 50.8 x 33.0 (20 x 13). The Phillips Collection, Washington, D.C.; **50** Georgia O'Keeffe, *The Shelton with Sunspots, NY*, 1926. Oil on canvas, 123.2 x 76.8 (48½ x 30¼). Art Institute of Chicago, Gift of Leigh B. Block, 1985.206. Photograph © 2000, The Art Institute of Chicago. All Rights Reserved (CR 527); **51** Marius de

Zayas, *Alfred Stieglitz, c. 1912–13*. Charcoal on paper. The Metropolitan Museum of Art, Alfred Stieglitz Collection, 1949 (49.70.184). Photograph © The Metropolitan Museum of Art; **52** Georgia O'Keeffe, *Radiator Building - Night, New York*, 1927. Oil on canvas, 121.9 x 76.2 (48 x 30). Fisk University Galleries, Alfred Stieglitz Collection, Nashville, Tennessee, Gift of the Artist (CR 577); **53** Georgia O'Keeffe, *New York Street with Moon*, 1925. Oil on canvas, 121.9 x 76.2 (48 x 30). Museo Thyssen-Bornemisza, Madrid (CR 483); **54** Georgia O'Keeffe, *East River from the 30th Story of the Shelton Hotel*, 1928. Oil on canvas, 76.2 x 121.9 (30 x 48). New Britain Museum of American Art, Connecticut, Stephen B. Lawrence Fund. Photograph E. Irving Blomstrann (CR 620); **55** Charles Sheeler, *American Landscape*, 1930. Oil on canvas, 61.0 x 78.8 (24 x 31). The Museum of Modern Art, New York. Gift of Abby Aldrich Rockefeller. Photograph © 2001 The Museum of Modern Art, New York; **56** Georgia O'Keeffe, *Wave, Night*, 1928. Oil on canvas, 76.2 x 91.4 (30 x 36). 1947.33 Addison Gallery of American Art, Purchased as the gift of Charles L. Stillman (PA 1922) © Addison Gallery of American Art, Phillips Academy, Andover, Massachusetts (CR 644); **57** Edward Weston, *Eroded Rock, Point Lobos*, 1930. Gelatin silver print, 19.0 x 24.9 (7½ x 9¹³⁄₁₆). The Metropolitan Museum of Art, David Hunter McAlpin Fund, 1957 (57.519.10). © 1981 Center for Creative Photography, Arizona Board of Regents; **58** Georgia O'Keeffe, *Shell and Old Shingle II*, 1926. Oil on canvas, 76.8 x 46.0 (30¼ x 18⅛). Alfred Stieglitz Collection, Bequest of Georgia O'Keeffe, 1987. Courtesy, Museum of Fine Arts, Boston. Reproduced with permission. © 2000 Museum of Fine Arts, Boston. All Rights Reserved (CR 541); **59** Georgia O'Keeffe, *Shell and Old Shingle VII*, 1926. Oil on canvas, 53.3 x 81.3 (21 x 32). Alfred Stieglitz Collection, Bequest of Georgia O'Keeffe, 1987. Courtesy, Museum of Fine Arts, Boston. Reproduced with permission. © 2000 Museum of Fine Arts, Boston. All Rights Reserved (CR 546); **60** Georgia O'Keeffe, *Clam Shell*, 1930. Oil on canvas, 60.8 x 91.2 (24 x 36). The Metropolitan Museum of Art, Alfred Stieglitz Collection, 1962 (62.258). Photograph © 1995 The Metropolitan Museum of Art (CR 707); **61** Georgia O'Keeffe, *White Canadian Barn II*, 1932. Oil on canvas, 30.5 x 76.2 (12 x 30). The Metropolitan Museum of Art, Alfred Stieglitz Collection, 1964. (64.310). Photograph © 1980 The Metropolitan Museum of Art (CR 807); **62** Charles Sheeler, *Barn Abstraction*, 1917. Black conté crayon on paper, 35.9 x 49.5 (14⅛ x 19½). Philadelphia Museum of Art, Louise and Walter Arensberg Collection; **63** Georgia O'Keeffe, *Black and White*, 1930. Oil on canvas, 91.4 x 61.0 (36 x 24). Collection of Whitney Museum of American Art, New York, 50th Anniversary Gift of Mr. and

Mrs. R. Crosby Kemper. Photo by Geoffrey Clements, New York © 1992 (CR 700); **64** Georgia O'Keeffe, *Black Abstraction*, 1927. Oil on canvas, 76.2 x 102.2 (30 x 40¼). The Metropolitan Museum of Art, Alfred Stieglitz Collection, 1949 (69.278.2). Photograph © The Metropolitan Museum of Art (CR 574); **65** Edward Weston, *The Ascent of Attic Angles, c. 1921*. Platinum print, vintage print, 23.5 x 19.0 (9¼ x 7½). Collection of Margaret Weston, Weston Gallery, Carmel, California. © 1981 Center for Creative Photography, Arizona Board of Regents; **66** Georgia O'Keeffe, *Jack-in-the-Pulpit, No. 3*, 1930. Oil on canvas, 101.6 x 76.2 (40 x 30). National Gallery of Art, Alfred Stieglitz Collection, Bequest of Georgia O'Keeffe. Photograph © Board of Trustees, National Gallery of Art, Washington, D.C. (CR 717); **67** Georgia O'Keeffe, *Jack-in-the-Pulpit, No. 4*, 1930. Oil on canvas, 101.6 x 76.2 (40 x 30). National Gallery of Art, Alfred Stieglitz Collection, Bequest of Georgia O'Keeffe. Photograph © Board of Trustees, National Gallery of Art, Washington, D.C. (CR 718); **68** Miguel Covarrubias, *O'Keeffe as a Calla Lily*. caricature from *The New Yorker*, July 6, 1929. Courtesy *The New Yorker*, Condé Nast Publications Inc. All Rights Reserved; **69** *Georgia O'Keeffe near "The Pink House," Taos, New Mexico*, 1929. Photograph courtesy Museum of New Mexico, Santa Fe; **70** Georgia O'Keeffe, *D.H. Lawrence Pine Tree*, 1929. Oil on canvas, 78.7 x 99.4 (31 x 39¼). Wadsworth Atheneum, Hartford. The Ella Gallup Sumner and Mary Catlin Sumner Collection Fund (CR 687); **71** Georgia O'Keeffe, *Ranchos Church, Taos*, 1929. Oil on canvas, 61.3 x 91.8 (24⅛ x 36¼). The Phillips Collection, Washington D.C. (CR 662); **72** Georgia O'Keeffe, *Ranchos Church*, 1930. Oil on canvas, 60.8 x 91.0 (24 x 36). The Metropolitan Museum of Art, Alfred Stieglitz Collection 1961 (61.258). Photograph by Malcolm Varon. Photograph © 1984 The Metropolitan Museum of Art (CR 704); **73** Paul Strand, *Church, Ranchos de Taos, New Mexico*, 1931. Platinum print, 48.3 x 38.1 (19 x 15). Sophie M. Friedman Fund, 1977.784. Courtesy, Museum of Fine Arts, Boston. Reproduced with permission. © 2000 Museum of Fine Arts, Boston. All Rights Reserved. © Aperture Foundation Inc., Paul Strand Archive; **74** Georgia O'Keeffe, *Black Cross, New Mexico*, 1929. Oil on canvas, 99.2 x 76.3 (39 x 30). Art Institute of Chicago, Art Institute Purchase Fund, 1943.95. Photograph © 2000, The Art Institute of Chicago. All Rights Reserved (CR 667); **75** Georgia O'Keeffe, *Black Mesa Landscape, New Mexico/Out Back of Marie's II*, 1930. Oil on canvas, 61.6 x 92.1 (24¼ x 36¼). © Georgia O'Keeffe Museum (CR 730); **76** Georgia O'Keeffe, *The Mountain, New Mexico*, 1930-31. Oil on canvas, 76.4 x 91.8 (30¹⁄₁₆ x 36¼). Collection of Whitney Museum of American Art, New York. Purchase. Photography by Sheldan C. Collins, Photograph © 1996 (CR 790);

189

77 Georgia O'Keeffe, *Black Hollyhock with Blue Larkspur*, 1929. Oil on canvas, 91.4 x 76.2 (36 x 30). The Metropolitan Museum of Art, George A. Hearn Fund, 1934 (34.51). Photograph by Malcolm Varon. Photograph © 1994 The Metropolitan Museum of Art (CR 713); **78** Georgia O'Keeffe, *Jimson Weed*, 1932. Oil on canvas, 121.9 x 101.6 (48 x 40). Georgia O'Keeffe Museum, Gift of the Burnett Foundation © The Georgia O'Keeffe Foundation. Photo Wendy McEahern (CR 815); **79** Georgia O'Keeffe, *Pineapple Bud*, 1939. Oil on canvas, 48.3 x 40.6 (19 x 16). Private Collection (CR 965); **80** Page from *Life* magazine, February 14, 1938, page 28: "Georgia O'Keeffe Turns Dead Bones into Live Art," illustrated with photographs by Ansel Adams, top, © 2001 by the Trustees of the Ansel Adams Publishing Rights Trust. All Rights Reserved, Kurt Severin, bottom left, Kurt Severin/Black Star, and Carl Van Vechten, bottom right, Carl Van Vechten Trust/Black Star. Courtesy *Life* magazine © Time Warner Inc.; **81** Alfred Stieglitz, *Georgia O'Keeffe* (hands and horse skull), 1930. Gelatin silver print, 19.2 x 24.0 (7¹⁵/₁₆ x 9⁷/₁₆). The Metropolitan Museum of Art, Gift of Georgia O'Keeffe Foundation and Jennifer and Joseph Duke, 1997 (1997.61.37). Photograph © The Metropolitan Museum of Art; **82** Georgia O'Keeffe, *Cow's Skull: Red, White and Blue*, 1931. Oil on canvas, 101.3 x 91.1 (39⅞ x 35⅞). The Metropolitan Museum of Art, Alfred Stieglitz Collection, 1952 (52.203). Photograph © 1994 The Metropolitan Museum of Art (CR 773); **83** Georgia O'Keeffe, *Cow's Skull with Calico Roses*, 1931. Oil on canvas, 92.2 x 61.3 (36¼ x 24¼). Art Institute of Chicago, Gift of Georgia O'Keeffe, 1947.712. Photograph © 2000, The Art Institute of Chicago, All Rights Reserved (CR 772); **84** Georgia O'Keeffe, *Ram's Head, White Hollyhock - Hills*, 1935. Oil on canvas, 76.2 x 91.5 (30 x 36). Brooklyn Museum of Art, Bequest of Edith and Milton Lowenthal 1992.11.28 (CR 852); **85** Georgia O'Keeffe, *From the Faraway Nearby*, 1937. Oil on canvas, 91.2 x 102.0 (36 x 40¼). The Metropolitan Museum of Art, Alfred Stieglitz Collection, 1959 (59.204.2). Photograph by Malcolm Varon. Photograph © 1984 The Metropolitan Museum of Art (CR 914); **86** Georgia O'Keeffe with sculpture, San Francisco Museum of Modern Art, 1982. Photograph by Ben Blackwell; **87** Tony Vaccaro, *O'Keeffe holding up oval cut-out to her eye*, photograph 1959. Photo AKG, London; **88** Georgia O'Keeffe, *Pelvis with Shadows and the Moon*, 1943. Oil on canvas, 101.6 x 121.9 (40 x 48). Private Collection, Los Angeles, CA, 1994 (CR 1052); **89** Tony Vaccaro, *O'Keeffe placing a canvas of "Pelvis, Red and Yellow" on an easel*, photograph, 1960. Archive Photos; **90** Georgia O'Keeffe house at Ghost Ranch. Photograph by Myron Wood; **91** Georgia O'Keeffe, *Red Hills and Bones*, 1941. Oil on canvas, 76.2 x 101.6 (30 x 40).

Philadelphia Museum of Art, The Alfred Stieglitz Collection (CR 1025); **92** Georgia O'Keeffe, *Red and Yellow Cliffs - Ghost Ranch*, 1940. Oil on canvas, 61.0 x 91.4 (24 x 36). The Metropolitan Museum of Art, Alfred Stieglitz Collection, Bequest of Georgia O'Keeffe, 1986 (1987.377.4). Photograph © 1987 The Metropolitan Museum of Art (CR 997); **93** Georgia O'Keeffe, *Grey Hills*, 1942. Oil on canvas, 76.2 x 99.1 (30 x 39). Indianapolis Museum of Art, Gift of Mr. and Mrs. James W. Fesler (CR 1024); **94** Georgia O'Keeffe, *Black Place III*, 1944. Oil on canvas, 91.4 x 101.6 (36 x 40). Private Collection, on extended loan to Georgia O'Keeffe Museum © The Georgia O'Keeffe Foundation (CR 1082); **95** Georgia O'Keeffe, *Black Place IV*, 1944. Oil on canvas, 76.2 x 91.4 (30 x 36). Parrish & Reinish, New York (CR 1083); **96** Georgia O'Keeffe, *In the Patio I*, 1946. Oil on paper attached to board, 75.6 x 60.3 (29¾ x 23¾). San Diego Museum of Art, Gift of Mr. and Mrs. Norton S. Walbridge (CR 1146); **97** Georgia O'Keeffe, *My Last Door*, 1952-54. Oil on canvas, 121.9 x 213.4 (48 x 84). Georgia O'Keeffe Museum, Gift of the Burnett Foundation © The Georgia O'Keeffe Foundation. Photo Wendy McEahern (CR 1263); **98** Georgia O'Keeffe, *Patio with Black Door, Abiquiu, NM*, c. 1955. Gelatin silver print, 11.6 x 15.9 (4⁹/₁₆ x 6¼). The Metropolitan Museum of Art, Anonymous Gift, 1977 (1977.657.1). Photograph © The Metropolitan Museum of Art; **99** Georgia O'Keeffe, *A Black Bird with Snow-Covered Red Hills*, 1946. Oil on canvas, 88.9 x 121.9 (35 x 48). Private Collection (CR 1148); **100** Georgia O'Keeffe, *In the Patio IX*, 1950. Oil on canvas, 76.2 x 101.6 (30 x 40). Private Collection, 1987 (CR 1213); **101** Georgia O'Keeffe, *From the Plains II*, 1954. Oil on canvas, 122.0 x 183.0 (48 x 72). Museo Thyssen-Bornemisza, Madrid (CR 1274); **102** Georgia O'Keeffe, *Red and Orange Streak*, 1919. Oil on canvas, 68.6 x 58.4 (27 x 23). Philadelphia Museum of Art, The Alfred Stieglitz Collection, Bequest of Georgia O'Keeffe. Photo by Eric Mitchell, 1990 (CR 287); **103** Todd Webb, *Georgia O'Keeffe's studio, New Mexico*, photograph 1963. © Todd Webb. Courtesy Evans Gallery, Portland, Maine; **104** Georgia O'Keeffe, *Blue B*, 1959. Oil on canvas, 76.2 x 91.4 (30 x 36). Milwaukee Art Museum, Gift of Mrs. Harry Lynde Bradley. Photo by Larry Sanders (CR 1357); **105** Georgia O'Keeffe, *Drawing IV*, 1959. Charcoal on paper, 47.3 x 62.7 (18⅝ x 24¹⁰/₁₆). Collection of Whitney Museum of American Art, New York. Gift of Chauncey L. Waddell in honour of John I. H. Baur. Photograph © 2000: Whitney Museum of American Art, New York (CR 1352); **106** Georgia O'Keeffe, *Drawing X*, 1959. Charcoal on paper, 63.2 x 47.3 (24⅞ x 18⅝). The Museum of Modern Art, New York. Gift of Abby Aldrich Rockefeller (by exchange). Photograph © The Museum of Modern Art, New York

(CR 1340); **107** Georgia O'Keeffe, *Winter Road I*, 1963. Oil on canvas, 55.9 x 45.7 (22 x 18). The National Gallery of Art, Washington, Gift of The Georgia O'Keeffe Foundation. Photo by Bob Grove (CR 1477); **108** Georgia O'Keeffe, *Road to the Ranch*, 1964. Oil on canvas, 61.0 x 75.9 (24 x 29¾). Bedford Family Collection (CR 1487); **109** Georgia O'Keeffe, *Looking from Bedroom at Abiquiu towards Espanola, NM*, c. 1955. Gelatin silver print, 11.0 x 15.8 (4⁵/₁₆ x 6¼). The Metropolitan Museum of Art, Anonymous Gift, 1977 (1977.657.5). Photograph © The Metropolitan Museum of Art; **110** Todd Webb, *O'Keeffe in Twilight Canyon, Lake Powell*, photograph 1964. © Todd Webb. Courtesy Evans Gallery, Portland, Maine; **111** Georgia O'Keeffe, *On the River I*, c. 1965. Oil on canvas, 76.2 x 101.6 (30 x 40). © 1998 The Georgia O'Keeffe Foundation. Photograph by Malcolm Varon (CR 1503); **112** Georgia O'Keeffe, *Black Rock with Blue Sky and White Clouds*, 1972. Oil on canvas, 91.4 x 76.8 (36 x 30¼). Art Institute of Chicago, Alfred Stieglitz Collection, Bequest of Georgia O'Keeffe, 1987.250.3. Photograph © 2000, The Art Institute of Chicago. All Rights Reserved (CR 1580); **113** Georgia O'Keeffe, *From a River Trip*, c. 1965. Charcoal on paper, 61.6 x 47.0 (24¼ x 18½). Janie C. Lee, Houston (CR 1500); **114** Georgia O'Keeffe, *Sky Above the Flat White Cloud II*, 1960/64. Oil on canvas, 72.6 x 101.6 (30 x 40). The Georgia O'Keeffe Foundation. © 1998 The Georgia O'Keeffe Foundation. Photograph by Malcolm Varon (CR 1460); **115** Georgia O'Keeffe, *From a Day with Juan IV*, c. 1965. Oil on canvas, 121.9 x 91.4 (48 x 36). Art Institute of Chicago, Alfred Stieglitz Collection, Bequest of Georgia O'Keeffe, 1987.250.4. Photograph © 2000, The Art Institute of Chicago. All Rights Reserved (CR 1627); **116** Dan Budnik, *Georgia O'Keeffe in the studio with Juan Hamilton's pots*, 1975. Gelatin silver print. © Dan Budnik/Woodfin Camp/Focus; **117** Georgia O'Keeffe, *Sky Above Clouds IV*, 1965. Oil on canvas, 243.8 x 731.5 (96 x 288). Art Institute of Chicago, Restricted gift of the Paul and Gabriella Rosenbaum Foundation, Gift of Georgia O'Keeffe, 1983.821. Photograph © 2000, The Art Institute of Chicago. All Rights Reserved (CR 1498); **118** Georgia O'Keeffe, *Sky Above Clouds II*, 1963. Oil on canvas, 121.9 x 213.4 (48 x 84). Private Collection (CR 1478); **119** Georgia O'Keeffe, *No. 15 Special*, c. 1916-17. Charcoal on paper, 48.3 x 62.2 (19 x 24 ½). Philadelphia Museum of Art, Purchased with the gift (by exchange) of Dr. and Mrs. Paul Todd Mackler (Marilyn Steinbright and the Arcadia Foundation), and gift of The Georgia O'Keeffe Foundation. Photo by Lynn Rosenthal, 1997 (CR 154); **120** John Loengard, *A Sunset Walk over Red Hills*, 1960s. Rex Features, London; **121** John Loengard, *In the Bedroom at Abiquiu*, late 1960s. Rex Features, London.

Index

Illustration numbers are in *italic* and come after the page numbers.